To My wonderful, amazing mom
(d "boomah" "boominator,"
"the booms")

We are so proud to
be your "kids & grandkids."
The memories from Dublin
have been so great to be a part
of, especially when we visited
with you! to think it all began
on "40"!! When I saw this
site & saw pictures of grandpa
& Uncle Thomas, I knew I had
to buy their first book for
you. I hope it brings you
some smiles & more memories
(with Auntie Mary too)!
We love you,
Mary, Tony,
Thomas &
Kevin

The 50 Francis Street Photographer

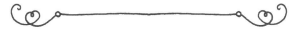

The 50 Francis Street Photographer

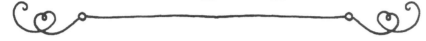

A fascinating view of Dublin and its people
through the photographs of John Walsh

Suzanne Behan

HACHETTE
BOOKS
IRELAND

ISBN 978 1 473661691

Design and typeset by redrattledesign.com

Printed and bound in Germany by Mohn Media GmbH

Hachette Books Ireland policy is to use papers that are natural, renewable and recyclable

products and made from wood grown in sustainable forests. The logging and manufacturing

processes are expected to conform to the environmental regulations of the country of origin.

Hachette Books Ireland

8 Castlecourt Centre

Castleknock

Dublin 15

Ireland

A division of Hachette UK Ltd

Carmelite House, 50 Victoria Embankment, EC4Y 0DZ

www.hachettebooksireland.ie

Contents

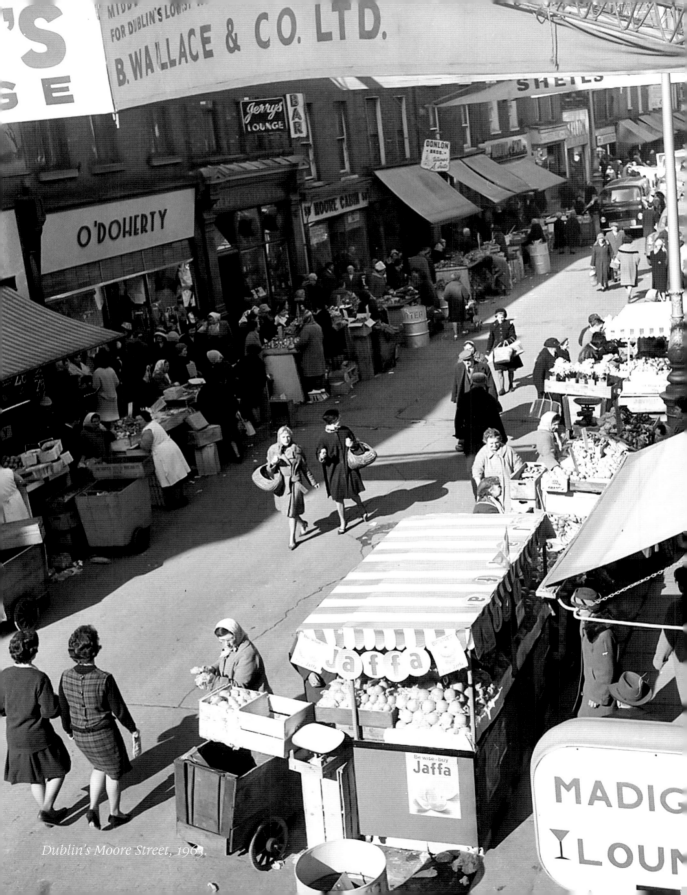

Dublin's Moore Street, 1963.

For my beautiful grandmother Suey, although I have never met you I feel I have known you a lifetime…

Introduction

They say certain smells will remind you of specific occasions, people or places, and, for me, smelling the chemicals used in a photographer's darkroom instantly take me back to my childhood and memories of my granddad and his home and studio at 50 Francis Street. Growing up, I spent a lot of time with my granddad and my aunt Maureen, who lived at number 50 too. My two older brothers were in the scouts and weekends for them meant hiking or camping, but I chose to spend my weekends being cared for in Francis Street.

When I start to think about my grandfather, John Walsh, warm, funny and loving memories come flooding back to me. He was a great man. When I reflect on his life, the words that come to mind are *hard-working*, *respectful*, *humble*, *ingenious*, *family man* and *total legend* – though it is impossible to summarise just how kind and special he really was. I never thought I would be writing a book about him and his work, but I am so

totally grateful and proud to be able to share his passion for photography and his life's work with others. Every photograph featured in this book has come from his archive.

My earliest memories of my grandfather are of him taking me by the hand when I was two years of age and walking me down the aisle of the church at my aunt Pauline's wedding. I was the flower girl but, being only two, I still needed to be minded and Granddad was given the job. This is such a vivid memory for me. I can remember him holding my hand tightly and trying to entertain me so that I would keep quiet during the ceremony. It had been my second birthday the day before, and as soon as the church music began, I decided to join in with a version of 'Happy Birthday to Me' – I imagine he was probably a little irritated at having to head outside with me rather than staying and taking as many pictures as he would have liked.

Growing up, he was *always* taking our picture. We would run and hide from him, saying, 'Oh, here's Granddad again with the camera. How many cars or people will he move out of the way this time to make sure the picture is perfect?' To this day, this is a standing joke in my family: when someone steps up to take a photograph, we say they are 'doing a Granddad'. Little did we realise then just how many photographs and wonderful memories he would leave us and many, many other families.

As a child, the house at 50 Francis Street was a curious and sometimes scary place. It had been the home of Archbishop John Thomas Troy in 1787 and had big, heavy doors that led into the back room and bedrooms and a huge wooden staircase that now reminds me of the film *Annie*. This staircase went up two flights with a landing in the middle and on the sides of the steps were boxes and picture frames with my granddad's work stored in them. My mam and aunts recall being made to scrub these stairs by their granny.

The rooms were also huge with high ceilings. The upstairs rooms were decorated with elaborate plasterwork showing religious emblems and bunches of grapes. One room had a large, ornate, Italian marble fireplace with the Lamb of God and figures carved into it, all put in place for the bishop during his time there. When my grandparents moved in, this room became their sitting room and my granny placed her ornaments and trinkets lovingly on the mantelpiece. That room was her family sitting room when my aunts were growing up. The remnants of my mam's and my aunts' teenage years still remained when I was a child, with a Beatles poster stuck inside the wardrobe door. The bed I slept in was cast iron with a candlewick bedspread. When it got dark, that house scared the life out of me.

At the front of the house was the shop and my granddad's sacred space, his darkroom.

This small but magical place had a green light bulb that I found fascinating as a child. My granddad had partitioned off this room from the shop and took great measures to ensure that no light could get in; every nook and cranny was filled in or blacked out so that the process of developing the film wouldn't be ruined. There were bottles and jars filled with all sorts of chemicals, including developer, stop bath and fixer. There were metal trays, timers and his enlarger, all his tools of his trade.

He would always have his latest batch of negatives and photographs hanging up to dry on lines of string going from one side of the small room to the other. I still remember the pure magic of being allowed to help develop a photo, of watching the image suddenly appear on the paper in the tray of chemicals, with a loving nudge from him to take it out of the developer quickly so I didn't overexpose the photo. This was better than any toy I could have been given. He would tell me to go find

objects and trinkets, and showed me how to make photograms – the process of placing the objects on the photo paper which was then exposed to light, resulting in a silhouette-type picture with the shape of your object clearly visible on the photo paper. This taught me how light and shadows worked. I loved making these and probably wasted lots of his photo paper, but he never minded. Of course, health and safety probably went out the window but this was my introduction to photography and something that has stayed with me for life.

My grandfather always had time for people, and he took such great joy in trying to teach us things. He wasn't the kissy-huggy type of granddad: he was practical and had a philosophical approach to life – if there was a lesson to be learned from something, it was worth doing. Growing up around him, he would tell you the truth about life, he didn't sugar-coat things and would tell you the about the hardships people faced in his day, and there was always a lesson in there somewhere. 'A bargain is only a bargain if it's a necessity' was one of his sayings.

He had great perspective about getting the little things right, and he never showed impatience or anger with us children. By the time I was at secondary school, I had developed a keen interest in photography and my granddad was intent on teaching me about the darkroom basics – how to mix the chemicals correctly, timing my developer – and, of course, showing me how to use a camera. He passed on several books he had used himself which I still have today. I didn't fully appreciate it then or take it all in but, looking back, he had a gift in his approach to teaching, and it was really wonderful how much time and attention he gave me. If I could have this time over with him again, I would have a million questions.

My granddad had such an adventurous spirit and nothing held him back if he had his mind set on doing something. Only now, as an adult, can I admire his achievement of raising his four daughters after my grandmother died at the young age of fifty-two, but my granddad got on with it and worked hard to look after his family.

Spending my childhood weekends in the Liberties meant a Friday-evening stop at Bill Parker's and May Smith's on the corner of Francis Street for a quarter of cola cubes and a comic. Bill was such a lovely, kind man and would lift you up so you could see over the counter to choose from all the jars of loose sweets he had on offer. Friday night was spent watching *The Late Late Show* with Gaybo, an institution that could not be missed by my aunt Maureen. My granddad would work away quietly at the table mounting or framing prints for orders, meticulously screwing the eyelets into the backs of the frames so they could be hung in pride of place by the new owners. Eyelets of all different sizes would be stored in an ornate box with his favourite pliers. He had a large guillotine with a long, sharp blade and brown handle for sizing and cutting the pictures and he would tell me the same story of a man that had chopped his fingers off on a similar implement. I remember being fascinated by the thoughts of the man's fingers rolling away with my granddad re-enacting the accident, laughing at my reaction to the gruesome tale. This was probably to make sure I didn't touch this simple but lethal apparatus.

On Saturday mornings, my aunt Maureen and I would take a trip to Meath Street, stopping at the Bullring and the Liberty Market. This area was renowned for its butchers' – bacon, pigs' feet, pigs' tails, tongues, ribs and tripe were all on sale, along with cows' tongues and sheep's hearts. I was always fascinated

looking in the windows. I was always aware of how these poor souls met their fate, as my granddad told me stories about the abattoirs in the area and showed me where they had been. The butchers' were a huge contrast to the amazing smell of freshly baked bread coming from the local bakeries on Saturday mornings. I remember the hustle and bustle of the dealers with their prams lined up along Thomas Street selling their bargains. A shopping trip wasn't complete without a stop into Frawley's department store.

After our shopping was complete, we'd visit the Myra Bakery on the way home for an apple tart for my granddad's tea. I never got out of there without Mr Joyce making me add up how much change I should have and telling me all sorts of wonderful tales. In the evening, we'd walk to Stephen's Green to feed the ducks and I would happily play for hours in the playground. Some Saturdays, there would be a treat and we would walk to Burdock's for a single of chips with extra crispy bits (for those who have not experienced this delicacy, *crispy bits* were bits of batter that were thrown on top of your chips). Saturday nights had their ritual too: my aunt would go across to the pub to get her large bottle of Guinness and my granddad would go ballroom dancing.

Sunday was a different story. My cola cubes were hidden by my aunt Maureen until after mass – as she had a rule, no doubt inherited from her granny, that you weren't allowed to eat sweets before mass. The St Nicholas of Myra Church was a few doors down from my granddad's shop and, every Sunday, no matter what was happening, we went to mass. If it was raining, I would be forced to wear a plastic see-through rain hat that tied under my chin, the embarrassment of which was significant as a child. After mass, we'd walk down Hanover Lane

to St Patrick's Park, where the flowerbeds were immaculately laid out. In the summer, you could actually get in the fountains with your swimsuit on and nobody batted an eyelid. After this, we'd go to the pet shop on Patrick's Street to see the racing pigeons and budgies and then walk home again through the side entrance of the church, where I would run so fast past the old iron doors in the ground that led to the crypts where the priests had been laid to rest. On Sunday evenings, I would return to my family home in Kimmage and my normal life would resume.

All of these memories are so clear and vivid to me, and they are such happy memories of freedom and just being a kid and being allowed to experience life and the hidden places and many faces of the Liberties. My granddad was very well known in the area because of his work, so people would stop to chat and drop in to the shop. He would let me sit on the counter, so that I could watch the people pass, always stopping to take a glance in his window at the latest photographs for sale.

My grandfather passed away in 1998, and his lifetime's work of negatives and photographs were stored in my parents' shed in Kimmage. For eighteen years, these boxes just sat there and were in the way of the presses and cupboards in my mam's workshop. Every now and again she would say, 'One of these days, I must sort out those boxes,' but that day never came, as everyday life, work and raising a family got in the way.

In November 2014, I was diagnosed with a rare and aggressive form of cancer, and my life took a different turn for a little while. After the operations, hospital stays and medications, my body began to recover from the physical trauma it had been through, but my emotional scars ran a little deeper.

It's hard to understand the mental and emotional impact of

what a cancer diagnosis puts you through and the lasting effect of the changes it brings.

When the doctors told me 'we are not quite sure how this will pan out for you', I went into fight-or-flight mode. Facing an uncertain future became an entity in itself, the fear and uncertainty took on a form of its own and I could either take control of the rollercoaster or lose the plot entirely – and there were days when I did. Weirdly, I did accept it and found peace with the situation I was in.

I decided that, whatever way things were going to go, it was going to be on my terms. Because of the rarity of the type of cancer I had, the doctors were unsure about just how fast it would take hold. I had no time to stop and think: they were adamant that surgery and treatment should start immediately. As I recovered from surgery, tiredness and fatigue – along with the monthly MRI scans, blood tests and other check-ups – I was left worn out and just fed up. I had neither the motivation nor the energy to do anything, and I was starting to grieve the life I would have had if cancer had not changed everything. Grieving is a vital part of the healing process, it's certainly not pleasant and every day had its ups and downs, but I am one of the lucky ones. I survived and for that I am grateful.

During this time, our family was hit with deep sadness when my younger cousin Bianca passed away unexpectedly. A talented, funny and clever young woman who was not only my cousin but also my friend, Bianca had also inherited a love for photography and particularly enjoyed taking family photos at every occasion. This was a very hard time for me, as I was the one who was sick battling cancer; there was no fairness or logic to the situation.

I knew I had to get myself out of the sadness and depression I was feeling, so one day, while visiting my parents' home, I decided to take a box of my granddad's negatives and finally start to file

them in some sort of order. This wasn't too physically strenuous, so I could sit at the computer and do it without exerting energy that I just didn't have. I didn't have to face people and be polite and say, 'I'm fine,' when really I wasn't, I could just sit in peace and solitude, and wallow and feel sorry for myself with these boxes of negatives.

There were days that were spent crying, even though I didn't know why, but there were days when I had a little more energy and enthusiasm. Each negative needed to be scanned and digitised with some post-processing. When I had finished restoring a few dozen, I decided to start a Facebook page to share the images that were coming to life from the negatives. My granddad stored everything with precision and order – from 1953 every negative was filed by year and his diaries tell the story of his work with every booking and event marked in and cross-checked.

When I had shared a few photographs on Facebook, word got around about them, and quickly messages of support from followers of the page started to pour in. This spurred me to keep going on the bad days, and, slowly but surely, this project has helped me to feel better. There is a real sense of community spirit and friendship from the Facebook page. People have happily shared their memories of my grandfather and reminisced about the times the photos were taken, with some of those memories being used in this book.

When you open a box of negatives, you just don't know what you are going to find, and the social history that was documented by my granddad is immense. Due to the age of the photographs and the different types of film used, some images have fared better than others but I wanted to include a variety to capture life in Dublin and the Liberties at the time. I have learned so much about the life and times of the people in his photographs, and so much more about my grandfather and his own life, and the

fantastic childhood my mother and aunts had growing up – I will be eternally jealous that I have never swung on a lamp post. I had only ever heard stories of my granny Suey's shop and of her customers, and now the photographs I have uncovered have brought all of this history to life, for me and my cousins to share, and for the next generations to learn from. They say every cloud has a silver lining, and I guess this project has been mine.

When you write about your grandparents or people of a bygone era, I believe you are truly leaving a gift for future generations. These photographs have connected families and brought tears of happiness and joy to those who may never have known or seen their relatives.

The greatest gift my granddad gave me was the ability to see the world as a photographer and for that I am eternally grateful. Whether it is genetics or just coincidence that I have a love for photography, I don't know, but I like to think it's a little bit of him passed on to me. My granddad will never see the photographs I have had published or the photographic awards and achievements I have received, but I am a believer that none of it would have been possible without that little divine intervention and encouragement he gives me every now and again. I wish he could see how much his photography has touched people and how grateful they are to him for storing and keeping everything so that I can now share it with the world.

My wish for my granddad would be that he is happy and that he forgives me for having my fingers all over his negatives. Each one has been lovingly scanned, processed and converted to share and archive. That old familiar smell has come back to me of developer and fixer and it hits me every time I open the door where these negatives are stored, and that makes me feel just a little bit closer to him.

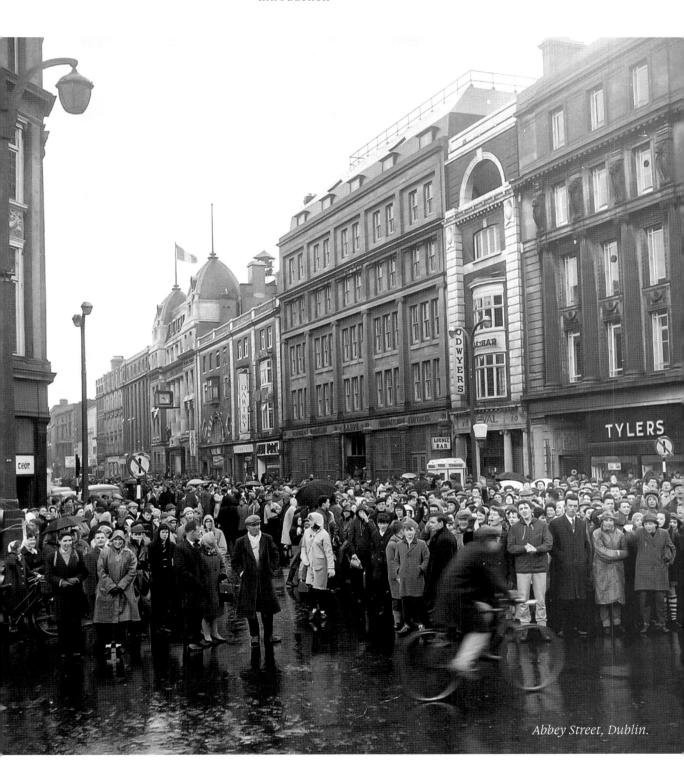

Abbey Street, Dublin.

J. WALSH
PHOTOGRAPHER
COLOUR & B & W

The making of a photographer

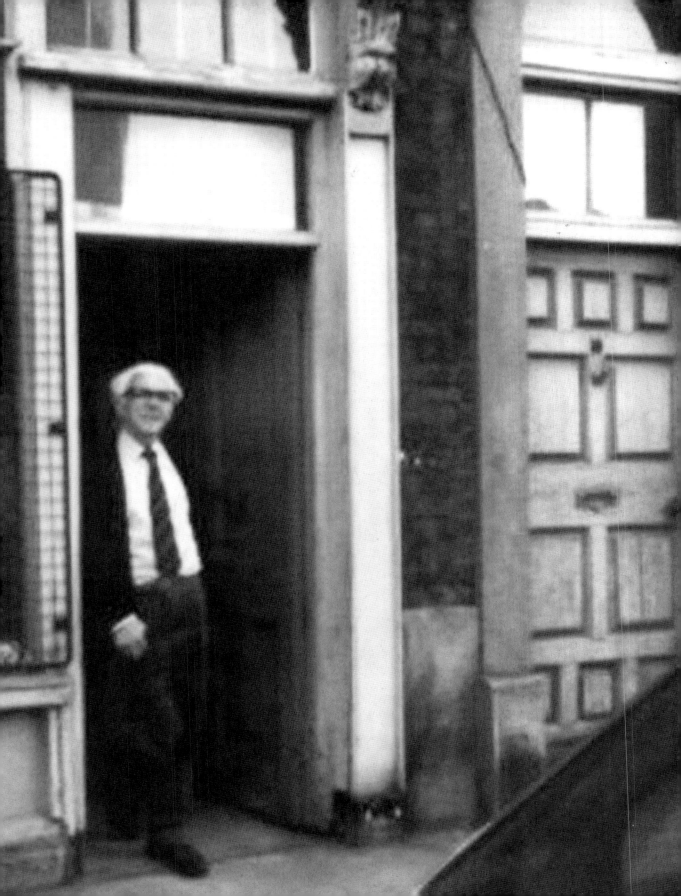

The man behind
the lens

John Walsh, my grandfather, was born in 1915 on Stafford Street in Dublin's north inner city, to Julia Ann (McCann) and William Walsh. He was the oldest of nine children, eight of whom survived to adulthood; his sister Angela died at the age of two.

He was among good company as 44 Stafford Street was the birthplace and home of Theobald Wolfe Tone, the leading Irish republican and one of the founders of the United Irishmen, and after whom the street was renamed after Irish independence.

By 1920, the family had moved to Ushers Quay, an area on Dublin's south quays near the Guinness brewery. Perhaps this move was due to a change in the living conditions in Stafford Street or because of their growing family.

By 1921, Civil War had broken out in Ireland. My granddad used to tell me stories about having to walk behind barricades as a young boy, just beyond the Four Courts on the north quays.

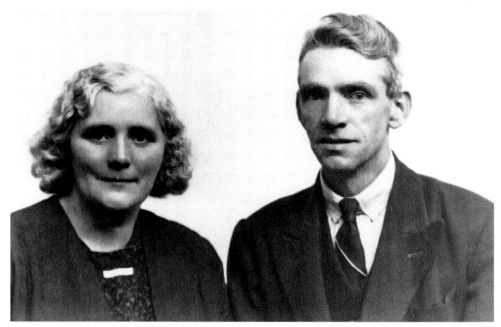

Julia Ann and William Walsh, my great-grandparents, who were married at Meath Street Church on 24 May 1914.

He could remember the soldiers with their guns and the GPO being bombed. Like most boys of the time, my granddad left school at a young age to find a job. He worked as a messenger boy, cycling through the streets of Dublin, delivering parcels and messages for shops and offices. When he was seventeen, he got an apprenticeship to a photographer on Capel Street named Mr Russell, a Jewish man whose real name was Mr Rubenstein and who lived on Clanbrassil Street. It's possible my grandfather had worked as Mr Russell's messenger boy before going on to become his apprentice, but we will never know if my granddad already had an interest in photography or whether it developed because of this job.

Either way, it was what he learned in this studio that set in my granddad on the road to becoming a photographer. He was Mr Russell's darkroom assistant and learned his trade from the ground up.

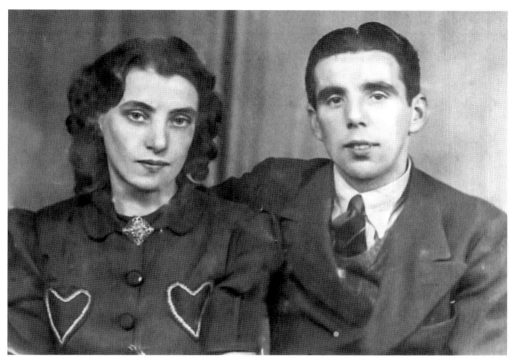

After finishing his apprenticeship, my granddad left his photography job behind him for a while but continued a lifelong friendship with Mr Russell. He started work in Petrie's factory at 36 Usher's Quay, which made sacks and canvas bell tents. Granddad got this job through his father, William, who was employed there, and it was during his time at Petrie's that Granddad met Susan Guy, a good friend and workmate of his father's and the woman who would become his wife.

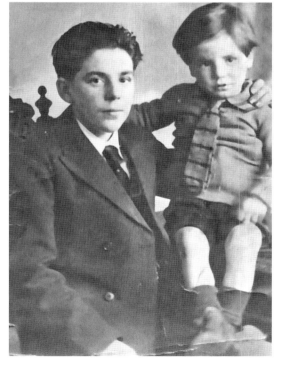

My granddad, aged seventeen, and his brother, Josie. The photograph was taken by Mr Russell just after my granddad had started working for him, 1932.

A shot taken with the 'box brownie' my granddad used to take on trips.

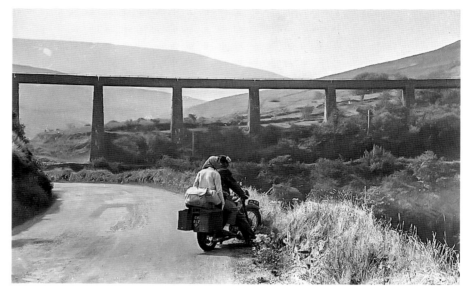

My granddad was a keen cyclist and Suey joined his cycling club, and they travelled around Ireland with their friends. During this time, my granddad had a small box camera that he took with him. Some of his earliest photographs were taken on their many trips across Ireland.

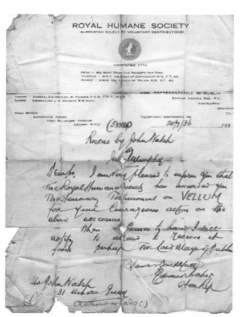

In 1936 at the age of twenty-one, my granddad was walking along the quays in Dublin when he saw a man was drowning in the River Liffey. Without hesitation, he jumped into the river to rescue the man, named John Murphy. My granddad was awarded a Testimonial on Vellum from the Royal Humane Society, presented by the Lord Mayor of Dublin Alfie Byrne, for his bravery and 'courageous action'. My granddad's sister, May, recalls that he almost lost his life as he dived twice to save John Murphy.

John and Suey were married in 1941 in St Nicholas of Myra church on Francis Street in

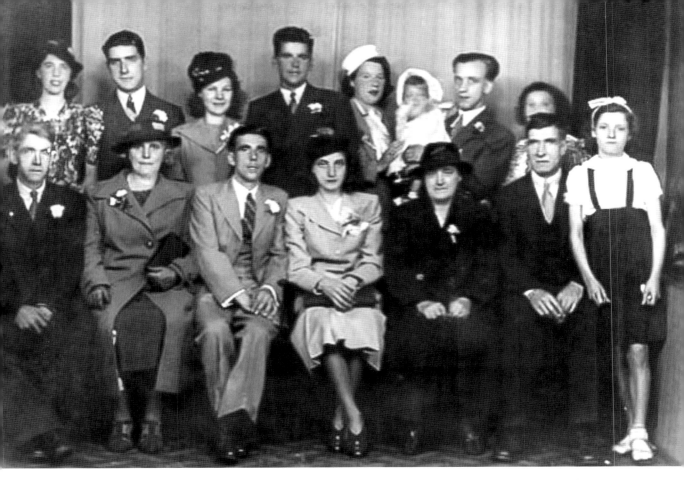

John and Suey's wedding photograph, taken at Mr Russell's studio on Capel Street in 1941. John's parents, Julia Ann and William, are on the left, and Suey's parents, Jane and James Guy, are on the right.

the Liberties, a stone's throw from St Patrick's Cathedral. My granddad returned to the studio of his friend and previous employer, Mr Russell, to have his and Suey's wedding photograph taken.

Their love of cycling took them to Galway for their honeymoon on a tandem bike and, on their return, the newlyweds moved into their new home on 56 Francis Street. For years after this, my granddad continued to take photos of many couples getting married in the same church as he had been married himself.

By 1942, my granddad had to leave Petrie's factory. He had fought for an improvement to workers' rights and had started

a union, but he was threatened and told he would lose his job if he didn't give up his involvement in the union. He finally left when the management threatened to fire his father.

During the 1940s, the economic impact on Ireland of the Second World War became more acute. There was increased unemployment and the cost of living index for food rose by 70 per cent, making it more and more difficult for working-class families to cope. As a result, many Irish men and women went to Britain to work or join the armed forces. During the course of the Second World War, nearly 250,000 new passports and travel permits were issued to Irish citizens to travel to Britain to work or enlist, including to my granddad.

Although, in the majority of cases, just like my granddad, they were motivated by economic forces rather than political idealism. This movement of people was accepted as necessary by the Irish government, which feared political instability from the rise of unemployment. According to one government official, 'the placing of Irish unemployed workers in employment in Great Britain would provide a very welcome mitigation of the difficulties at home'.

By 1942, the war was in full swing and my granddad had gone to work at a munitions factory near Wolverhampton. I don't know exactly what made him go to England, but given that there wasn't much work in Dublin and that my grandmother was pregnant, he probably thought it was his best hope of earning a living.

My granddad travelled back to Ireland to see his wife Suey, and each time he returned to England, his travel documents show that he was sent to where workers were needed, and he had ended up in London. I remember my granddad talking about the 'doodle bugs' and air-raid sirens and about his work as an air-raid warden. 'You would go out in the morning and

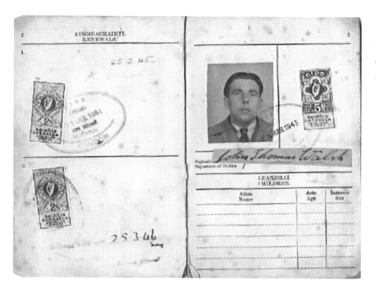

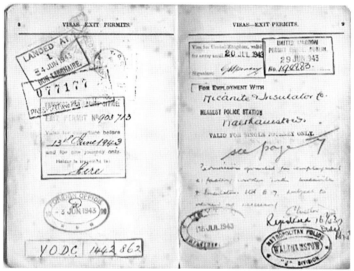

Travel documents issued to my granddad for travel to and from England during the Second World War.

there would be someone waiting to get into your bed in the digs and you could come home at night to a pile of rubble where your digs had stood. You always had to carry a flashlight with you in case the lights were put out during the air raids. At night, after you finished work, you would volunteer to help search the rubble if a bomb had hit. You would search for missing people or families.'

It was while John was away that Suey gave birth to their first daughter, Maureen, in 1942. Maureen like many other children at the time was known as a 'war baby', and my granddad did not see her until she was six months old.

He was still working in England on VE Day – Victory in Europe Day, 8 May 1945 – and no doubt celebrated the end of the war and the unconditional surrender of the Nazi forces with his neighbours and friends.

He came home to Ireland for good shortly after that, but life in the Ireland to which he returned was tough. Trade relationships with England were damaged due to the war and jobs were scarce. The majority of my granddad's siblings went to live in England to find work to help feed their growing families, something that was not uncommon. My granddad considered going over again, but Suey wouldn't leave her home and her ties to Francis Street.

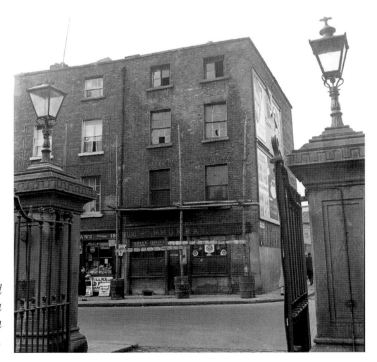

Maggie Murray's shop situated opposite the St Nicholas of Myra Church. My granny Suey was born in a room above the shop in 1916.

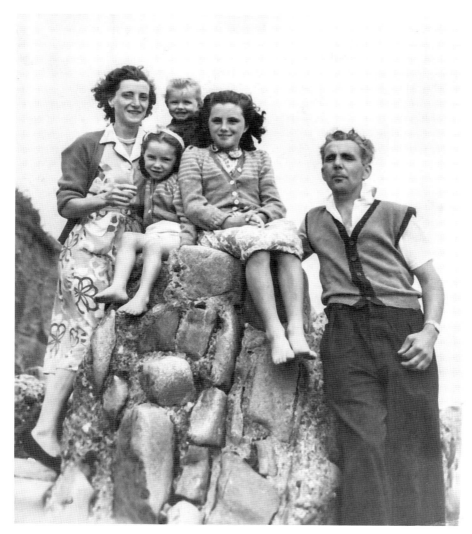

John, Suey and their daughters: Maureen (aged twelve), Rita (aged six) and Patti (aged two), enjoying a family holiday at the seaside in Shankill in 1954. Every summer, Suey rented accommodation, which was an old single-decker bus that had been converted into a caravan, in a field in Shankill for a holiday.

Between 1942 and 1947, Suey gave birth to three stillborn babies, all boys. I can only imagine the trauma and heartbreak they went through as a couple. In 1948, Suey was expecting again, and gave birth to my mother, Rita. After this, Suey had two more failed pregnancies and, in 1952, they adopted a beautiful baby girl, my aunt Patti. Four years later, in 1956, their family was complete when Suey gave birth to their youngest daughter, Pauline.

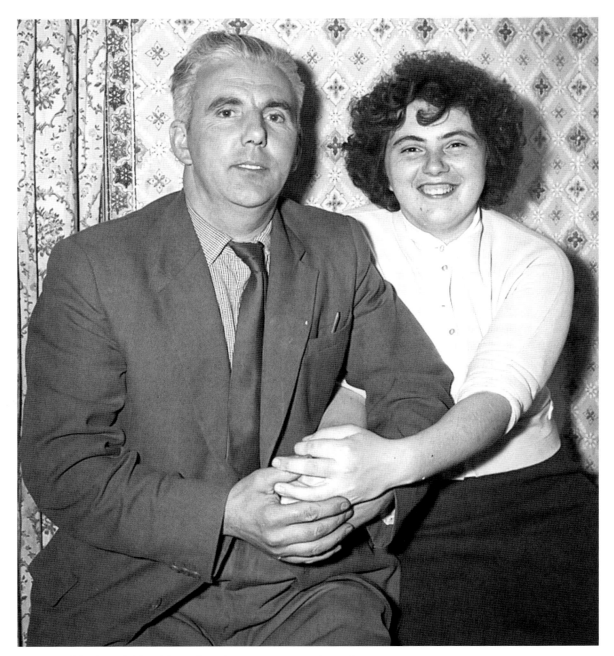

My granddad and his oldest daughter, Maureen, in 1960.

'My dad was a very special man. He was always so kind and loving and he always cared for me throughout his life. I loved him dearly.' MAUREEN

My mam, Rita, and my granddad on Dollymount Strand in 1961.

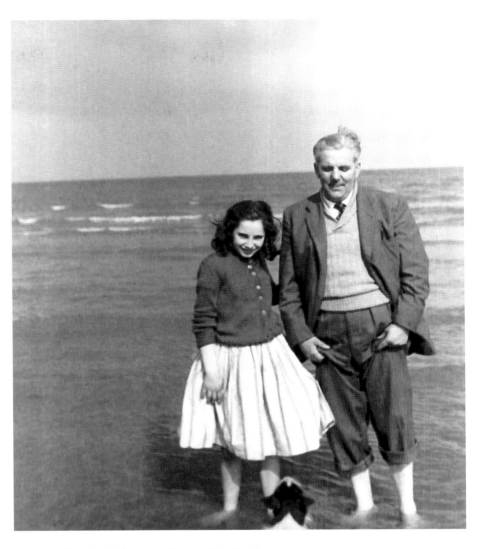

'My dad was always very fond of the outdoors. He had a tandem with a sidecar and many an evening was spent on Dollymount Strand. The tandem was later replaced by a motor bike but that meant he could only bring one of us at a time. Later on, we got a family car, and every Sunday, he would gather us up and we'd set off into the unknown. He would say, "Come on and we see what's up this road." I am very proud to say that my dad gave me a great sense of adventure and I thank him for that, as it has taken me on many adventures in my adult life.' RITA

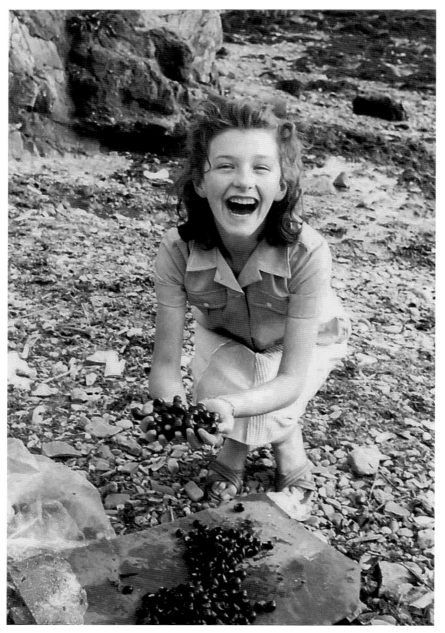

'I came into the lives of John and Suey Walsh in February 1952, when I was just a couple of days old. I was cared for and loved unconditionally and eventually adopted. It goes without saying that I was so lucky to have been brought into their family. The 1950s were very hard times, as everyone knows. Mam and Dad already had two daughters when I came along, and Pauline was born four years later. They were truly exceptional people and I loved them dearly.' PATTI

My aunt Patti collecting winkles at Red Rock Beach at Sutton, a well-known Dublin tradition. The winkles were boiled in a large pot and a darning needle was used to pick them out of their shells to eat them. So many Dubliners adore this tradition but it's definitely not my cup of tea. I still remember the smell of them boiling while on caravan holidays as a child – the smell would linger for days.

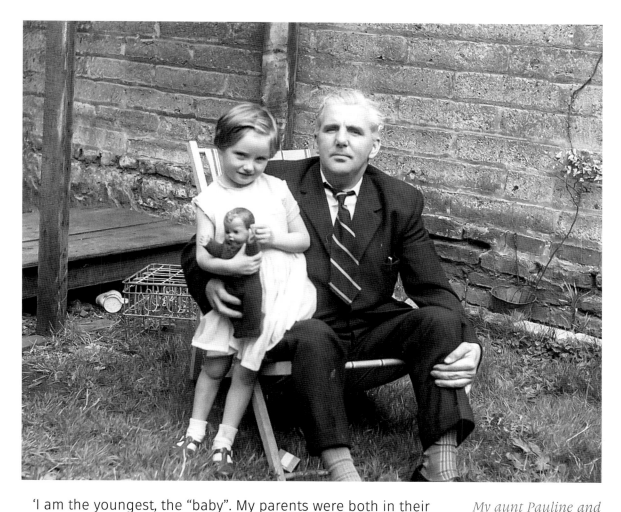

'I am the youngest, the "baby". My parents were both in their forties when I was born, and, for as long as I can remember, I was forever being told, "You were supposed to be a boy." The story goes that my mam was very ill when she was expecting me and was hospitalised for a couple of months before my birth. Mam had lost five babies before I was born, all boys. In those days, expectant fathers were not expected to be around for the birth, so when Dad received word from the hospital he was given the wrong information. He was told, "It's a boy." I suppose after the heartbreak of losing five baby boys he must have been a little disappointed when he arrived at the Coombe Hospital to find daughter number four – though if he was, it never showed.'
PAULINE

*My aunt Pauline and
my granddad.*

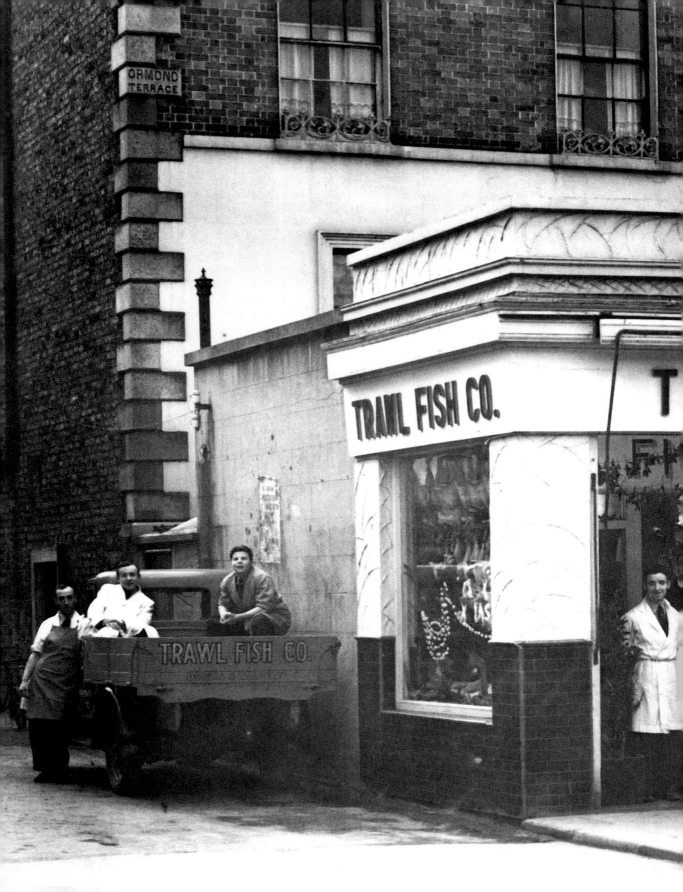

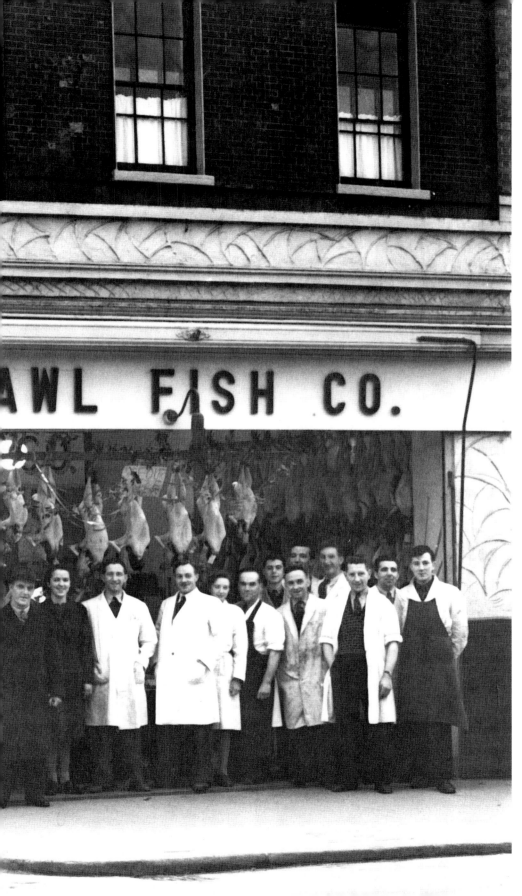

My granddad worked in the fish and poultry shop over Christmas 1948. He is second on the right. His good friend, Andy Hyland, also worked there.

AWL FISH CO.

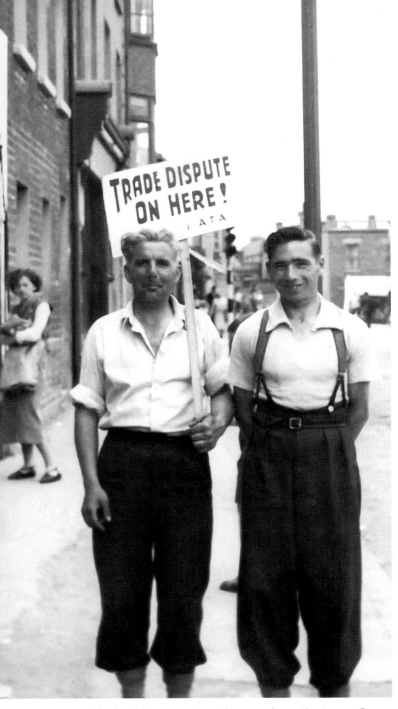

My granddad taking part in a barmen's strike in 1958. Strikers would be sent to different pubs and locations in the city so they never picketed the areas where they lived or worked. The union made the decision where each man would be posted.

After returning from England in 1945, my granddad had several jobs. He worked as a barman in Drogheda, travelling up and down on his BSA motorbike, then, in 1948, he got some part-time work for Christmas in a fish and poultry shop on Charlemont Street in Dublin 8.

After his experiences fighting for workers' rights in Petrie's factory, my granddad continued to support the unions wherever he could. He became a union rep when he worked as a barman. From 1950 to 1956, he worked in Maher's Pub in Dolphin's Barn as a bottleman. At that time, Guinness was delivered in barrels and pubs would bottle and label their own stout. My granddad worked in the pub's cellar, bottling Guinness.

The brewery was often on strike, and with no strike pay and a family to look after, my granddad returned to his skill as a photographer and started

to take people's wedding photographs on a part-time basis. Many people who drank in the pub got to know him as a photographer and word of mouth spread and people would contact him to take photographs.

At this time, my granny Suey was working in the small family shop on Hanover Lane that belonged to her mother, Jane Guy, which sold sweets, penny bags and sticks for lighting the fire. My great-granny was known for her specialty of selling broken rock, a boiled sugar confectionery. She collected a one-stone bag of rock in a pillow case from a factory on Brabazon Row near the Coombe, which she smashed with small hammers and bagged for selling at the price of one pence. My great-grandfather, James Guy, sold coal from another premises on the same street. With his faithful horse, Bob, he delivered coal to the families in the Liberties area. When he passed away in 1951, Suey continued to run the coal business, though without the faithful horse.

My great-granny Guy kept a jug of water on the counter of her shop and, as a kid, if you came in to the shop for sweets on a Sunday morning, it was perfectly acceptable to be made drink the water before you got your sweets. God forbid what might happen to you if you ate sweets after receiving Holy Communion without rinsing your mouth.

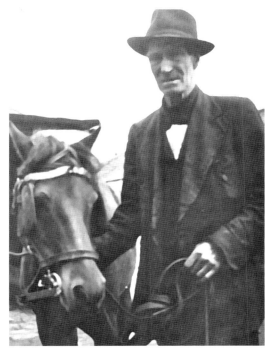

My great-grandfather, James Guy, with his horse and cart, delivering coal in the Liberties area, circa *1949.*

My great-granny Guy.

Dublin Corporation's reply to Miss Geraghty and Miss Reape, the exsisting tenants of 50 Francis Street, in response to their letter that they had new people who were interested in taking over as tenants to run the shop.

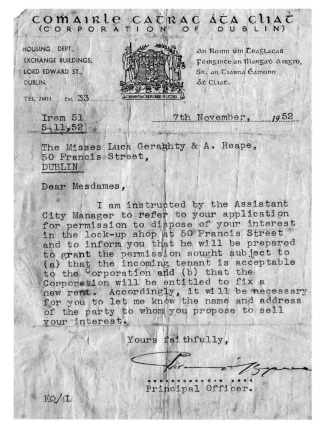

In 1953, my grandparents acquired the premises at 50 Francis Street from Dublin Corporation. Mrs Geraghty, the previous tenant, had decided to give up her lease and my granny Suey took this opportunity to continue the grocery business that Mrs Geraghty had been running from there. Shopkeeping was not a new concept for my grandmother – it was in her blood.

The premises at 50 Francis Street had once been home to Archbishop John Thomas Troy (1786–1823), who was the last archbishop to use the Francis Street Chapel as his Pro-Cathedral.

One of Troy's last big achievements was his involvement in the building of today's Pro-Cathedral. The site at Marlborough

Street was purchased in 1803 but progress was extremely slow. Troy continued to pursue the cause until, in 1821, the foundation stone was finally laid. Archbishop Troy continued with his work, including fundraising to finish the cathedral, and moved from Francis Street to North King Street. With the new Pro-Cathedral work coming to completion, the Pro-Cathedral status of the Francis Street Chapel ended.

The rooms of 50 Francis Street were very large, with high ceilings. My mam, Rita, remembers them being great for games of hide and seek. While my grandparents and their four daughters made it their home, these large rooms were often very cold and hard to heat.

On each side of number 50, there were families living in tenement housing. The poverty of the time was evident, as my aunt Pat remembers. 'Nobody had much, but everyone was the same. We helped each other's families and neighbours shared what they had.'

'We were very lucky, we had the luxury of not having to share a toilet with other families and not living in a tenement building.' PAULINE

To others on the street, my mam and aunts may have appeared to be well off, being shopkeepers' daughters, but, in reality, my granny was the worst businesswoman they knew. Everything was 'on tick' to customers in the shop. She always tried to share her groceries with the many hungry families on the street, and sent groceries and supplies on a daily basis to people who did not have as much as her family. My granddad would be heard saying, 'Suey we will never be rich.'

'It was just the way back then, people helped each other. You gave half of what you had to help a neighbour.' PATTI

My granny and her daughter Pauline, aged two, in the Myra Dairy in 1958.

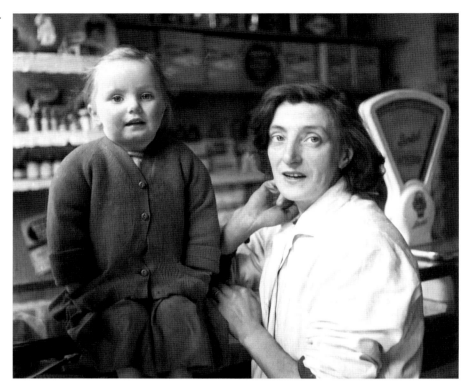

'If someone came in to pay their bill, they might pay a few pound off their bill and take the same amount away with them on tick, so she was never in profit.' RITA

Basics, such as milk, bread, jam and sugar, were given to neighbours to feed their families. She had such a kind heart and my granddad would sigh and graciously leave her to her ways.

At the time, married women were not entitled to benefits or to collect them for the family, so they relied on being given money by their husbands, either from wages or from what was collected on dole day – though there was no certainty that they would get any. As in most parts of Dublin, the culture of men drinking was a regular sight on Francis Street. The Barley Mow and Clarke's were a stone's throw from my granny's shop, and women would often wait outside to meet their husbands, hoping to get a few shillings to buy the groceries. Times were very hard for people then.

My granny would hide money for women who had borrowed from the money lender. Very often this was borrowed to pay for Communion or Confirmation clothes for their children or just to keep the family going. Many women did not want their husbands to know they had gone to a money lender as this could lead to trouble, so my granny helped these women by allowing them to leave the weekly repayment with her in the shop to pass on to the lender. As a child my mam, Rita, was sent down Hanover Lane to meet the agent for the money lender and hand over the payments as my granny didn't want the agent calling to the shop. This was something my granddad never knew about. My granny would also help those who could not read or write and people would call with their letters for her to read and she would then help them write a reply.

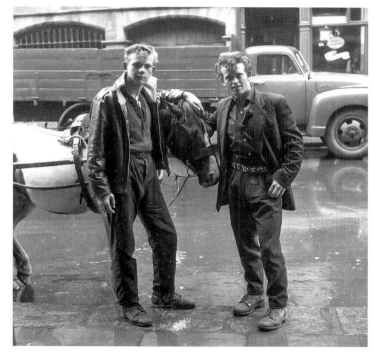

Young men and some members of the Travelling community would call to my granny for help with letters – she would assist in any way she could.

23

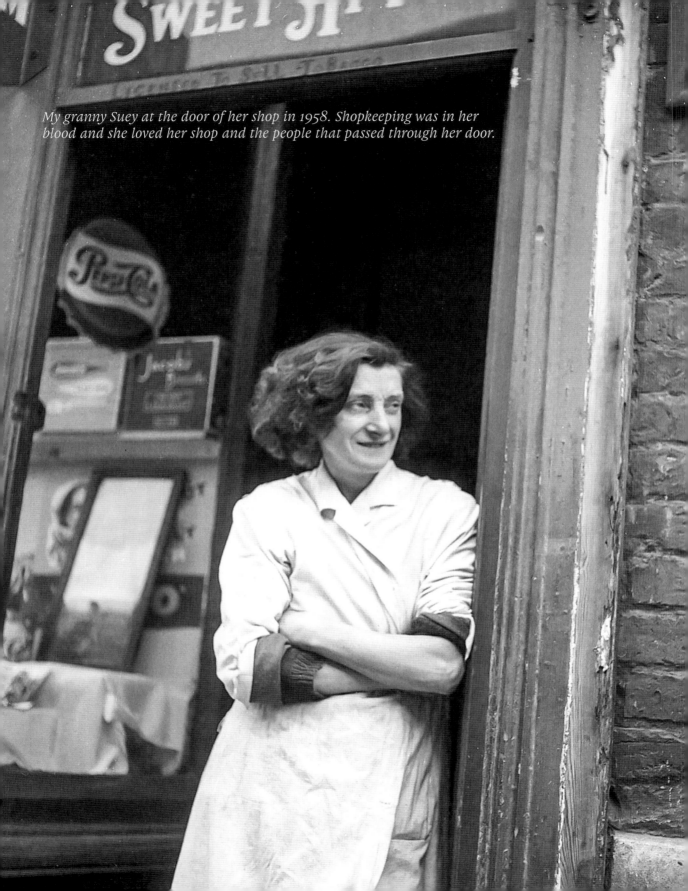

My granny Suey at the door of her shop in 1958. Shopkeeping was in her blood and she loved her shop and the people that passed through her door.

He employed local workers from the area – Paddy O'Keefe, John McNamee, Willie Quinn, Christy Lunny and Martin McNamee – but his drivers lived in Kildare, close to the briquette factories. His brother Willie was at his side for over thirty years and was well known in the area, especially in the Myra Bakery, whose hot Eccles cakes he loved. My father died in 1994 and is well remembered.

Today, his three sons – myself, Michael and Liam – continue his business, which is now one of the longest established businesses on the street.

PETER A. NORTON

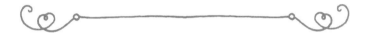

Mr Farrington, the cabinet maker, had his shop next door to my granny's, and when the first televisions came out, he displayed them in the window. Every kid on the street would stand outside the window in amazement when he turned one on, dreaming that one day they would have a TV at home. This was a luxury item, with many of the tenement buildings having no electricity only gas lamps to light them.

'When you went to call for your friends that lived in the tenements, you would shout up the stairwell from the bottom and someone would come out from the top and hang the oil lamp on a nail on the landing and you would follow the light up the dark stairwell until you got to the landing your friend lived on.' RITA.

'I remember waiting and waiting to watch the moon landing, waiting on the hatch to open and watching Neil Armstrong step out and then suddenly the bulb went. My dad ran and grabbed the green bulb he used in his darkroom and put it in the lamp. There we all were in the backroom waiting on this moment with a green glow around us like something out of space.' RITA

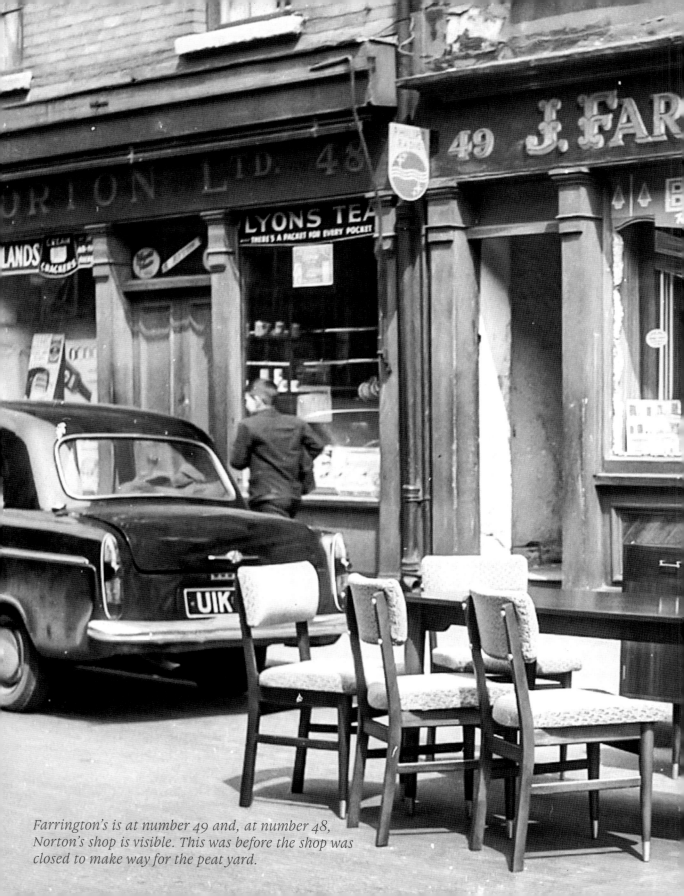

Farrington's is at number 49 and, at number 48, Norton's shop is visible. This was before the shop was closed to make way for the peat yard.

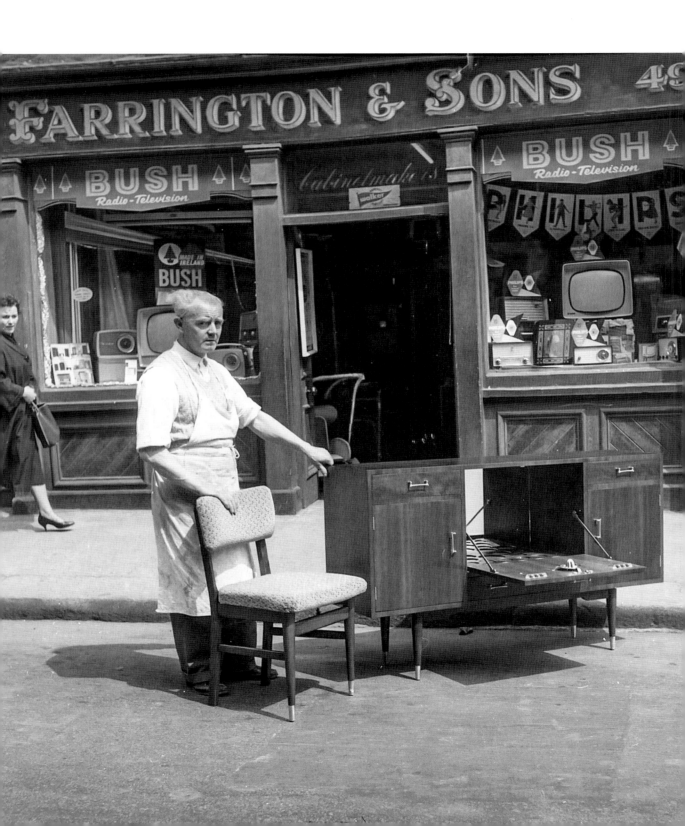

The most famous of all the shops on Francis Street was Mr Mushatt's Apothecary at number 3. Mushatt's sold medicinal compounds that were personalised medications and people came from far and wide to get 'the cure' for whatever ailed them.

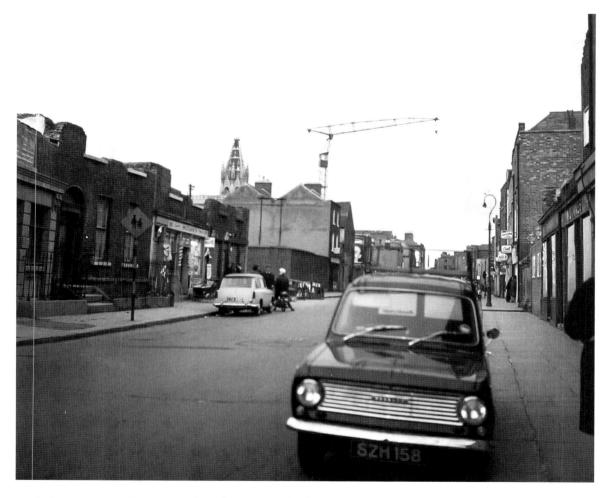

A view up Francis Street taken from outside the premises of 50 Francis Street, circa 1965. On the left, the remains of my granny's Suey's birthplace at Maggie Murray's and the remains of what was once Mr Meenan's newsagents, the place to go for your Judy or your Bunty comics. Tenement housing and Kehoe's bacon factory's offices were on this side of the street too. All of this has been knocked down and the cranes are a sign of Dublin's changing skyline. Mr Norton's peat yard is just visible on the right, and it is still there today.

Mr Mushatt senior had come to Ireland from Lithuania in 1886 and settled in Dublin where he married and had five children. His son, Louis, qualified as a chemist when he was twenty-one and it was a few months later that his father started his 'chemist shop' at 3 Francis Street.

They were an institution in the Liberties. People trusted Mr Mushatt and flocked to his shop because they could not afford to go to a doctor. Mr Mushatt locked his secret recipes in a safe on the premises, and they could make a lotion or potion to cure whatever ailed you – pastes and lotions were used for removing corns, the cure for a hangover was a black draft (a mixture of senna and epsom salts), with worm powders for children and hair restorer for baldness, he made it all. Mr Mushatt's No.9 was his bestselling product and today this is still sold under this label.

When Mr Mushatt passed my granny Suey's shop, which he did every day, she'd say, 'There goes oul Mushatt, with his bandy feet and bald as a coot, selling corn cream and hair restorer' – a term of edearment of course.

My mam, Rita, recalls being sent to this shop. 'We were sent to Mr Mushatt's to buy methylated spirits for our dad for his darkroom, so he could clean his negatives. He would say, "Tell Mr Mushatt to put them in a brown paper bag and come straight home don't stop," for fear that a wino would rob the methylated spirits from us to drink.'

'Sputnik, the family dog, was sent with us as our bodyguard to Captains on Meath Street to buy the cigarettes for the shop. I remember the order clearly – 200 Players, 100 Woodbines and 100 Sweet Afton.' RITA

My granny's shop served as a social outlet for many residents on the street with many of them dropping in for a chat with my granny or granddad. On Sunday mornings, my granny would cook a fry and the policemen from Kevin Street Garda Station would drop in for their breakfast. She would also keep the shop open late as the Tivoli Picture House opened late and the young men on their way home would buy a bottle of milk and snowcake and stand in the shop and have their supper before heading home.

'As soon as we could add two and two together, we served in the shop. My friends would say with envy, "You're so lucky, your family have a shop." My sisters and I didn't think so. I remember many evenings when customers came into the shop, my sisters and I would argue over whose turn it was to serve. The loser might end up having to give up their warm seat at the fire or miss their favourite programme on the television.'
PAULINE

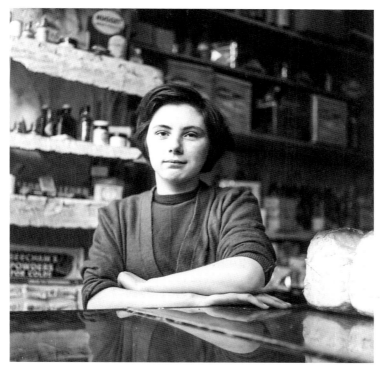

My aunt Maureen, aged sixteen, working in the family shop in 1958. There is fresh turnover bread on the counter for sale — my granny would often have to stay open late to sell all her bread and milk as there were no fridges then to keep your stock fresh.

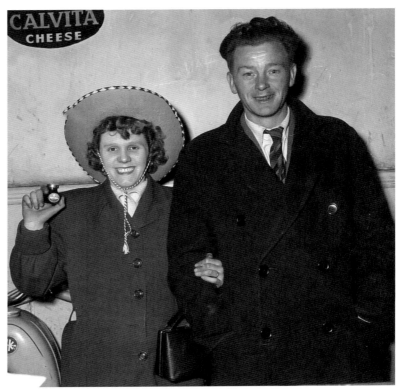

Stopping off for Bovril from the Myra Dairy in 1957.

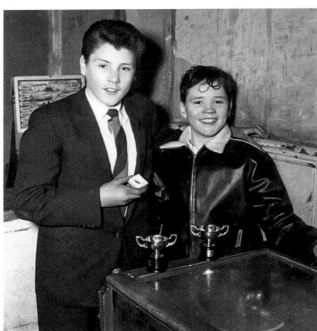

In the late fifties, the Hyland brothers were regular visitors to the shop to play the hockey machine.

Advert for ice-creams on sale in the shop in 1958. The Patsi Pop was a favourite of local kids.

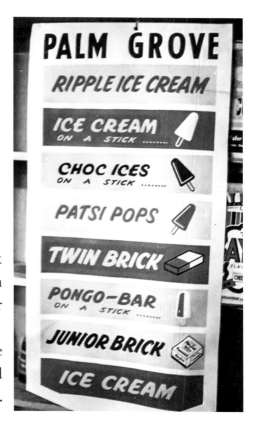

'Gaye, a neighbour on Francis Street, had an awful cough and one day my mam heard noises coming from the shop – she thought it was Gaye coughing in the shop. She shouted out from the kitchen, "I'll be with you now, Gaye." When she went out, Jack Ass's ass had got loose and was standing in the shop. Such a pantomine we had that day trying to get the ass to leave the shop.'
MAUREEN

As my granddad's photography work increased, he also used the Myra Dairy as an outlet for people to come in and collect their photographs.

During the 1960s, my granny Suey became very ill and, much to her dislike, my granddad insisted that she stop working in the shop.

The Myra Dairy, 50 Francis Street.

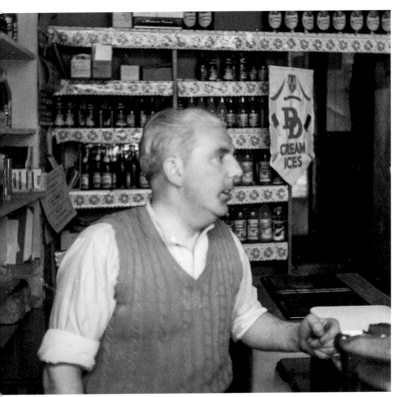

My granddad working in the family shop in 1958. The doorway in the background led to the family residence, where you could look out from the kitchen to see if anyone needed serving. Just before the door to the left, behind the jars, my granddad partitioned off a small space where he made a darkroom. At the other side of the building, there was another hallway where he created a small studio for people calling in to have their photo taken.

Eventually, her illness left her bedbound. About the same time, their two oldest daughters, Maureen and Rita, started working full-time in other jobs, and with the opening of new large shops like Dunnes Stores on George's Street, the grocery business started to fade.

In 1968, when she was fifty-two, my granny Suey passed away. She suffered with a heart condition from having rheumatic fever when she was a child. My aunts – who ranged in age from twenty-six-year-old Maureen to twelve-year-old Pauline – lost their mother, and my granddad lost his soulmate.

The family was joined in their mourning by neighbours and friends from Francis Street and across the Liberties. Suey was a much-loved character on the street and a friend to many, and was always up to high jinks of some sort. She was a fantastic musician

and accordion player. She loved her gramophone and records and had taught herself to play music just from listening to it.

After Suey's passing, and with the grocery business not doing well, my grandfather closed the Myra Dairy and continued to use the shop premises for his photography business – 50 Francis Street was now a photographer's shop and studio.

'I can remember the day my dad came to tell me that my mam had passed away. He had received a call during the night and had gone to the Mater Hospital, but Mam had passed away before he got there. It came as a huge shock to us all. I had visited her two days earlier and I vividly remember the doctors saying to me, "You will have your mam home with you soon." Sadly, this was never to be and it emerged she had taken a fit of coughing and her heart could not cope with the strain. The biggest regret is that she never got to meet any of her lovely grandchildren as she would have just loved being a grandmother, telling them stories of days gone by and getting up to mischief with them as she did with us as children. She gave me and my sisters the best childhood anyone could ask for.'
RITA

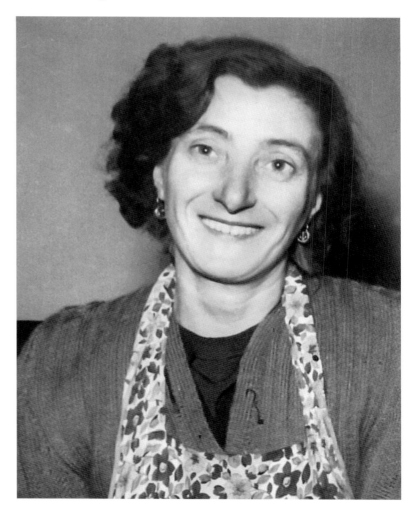

39

Growing up in The Liberties

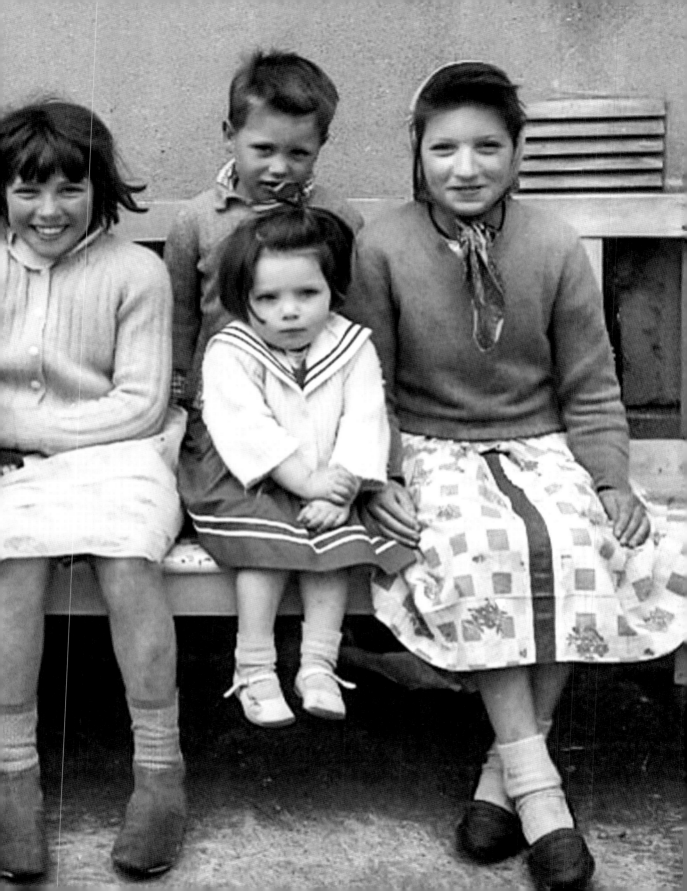

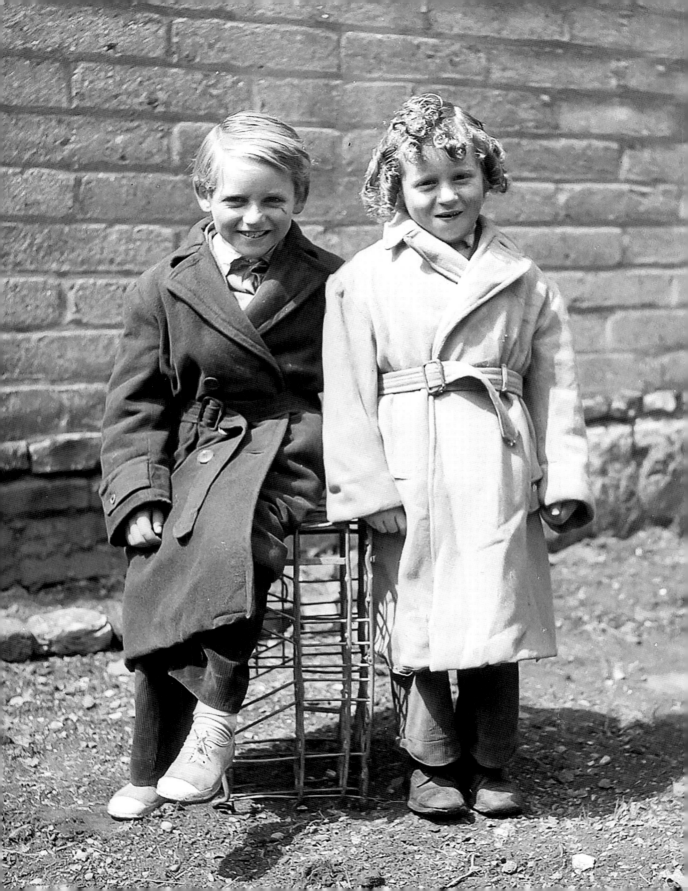

'The wider the path, the better the swing'

There was one area of waste ground on the corner of Francis Street and Hanover Lane that the kids made their own – The Ouler. Many hours were spent playing there and on the street itself, with games such as Relievio, Simon Says, Red Rover and playing ball against the wall, a speciality for the girls, who sang 'Dashey a packet of Rinso' as they played.

'"Vote, vote, vote for de Valera. In comes Charlie at the door" ... Many a great game of skipping was had while singing this song. But my favourite was Chaney Graves, I loved that game. We collected all the bits of broken china and pottery, and arranged them in a lovely pattern in the ground, then we placed the end of a broken bottle over them and they would sparkle and shine in the light. When we'd finished, we'd cover them over with soil – and you had your secret Chaney Grave to go back to. No such thing as health and safety – all we had was our imaginations.' PATTI

There were lots of characters around the Liberties when my aunts were children – including Bang Bang, Luggs Branigan the policeman and Jack Ass – and they all used Francis Street on a daily basis. The men on the Guiness carts with their drey horses would stop their carts, along with the farmers from Tallaght who would be passing by on their way to buy the spent hops from Guinness's to feed to their pigs, and have a shootout with Bang Bang, grown men playing like they were kids. Bang Bang used his big, old hall-door key as a gun. Growing up there can only have been a mischievous and wonderful experience.

The boys in their short trousers playing on the street weren't the only ones who climbed onto the roof of a parked car on Francis Street. Ned the bread man from Boland's Bakery often did the same and would give his tuppence worth on de Valera's latest political actions. Ned and my granny Suey often discussed politics and what de Valera was doing – they loved to put the world to rights.

My granny and great-granny were great admirers of de Valera, and my mam remembers being pushed in a pram from place to place when word went round that he was going to give an impromptu speech from the back of a lorry somewhere in the city.

'Kids played on the streets and everyone looked out for you. Someone's mammy was always keeping an eye on you – back then someone else's mammy could give out to you if you misbehaved, it was the done thing.' PATTI

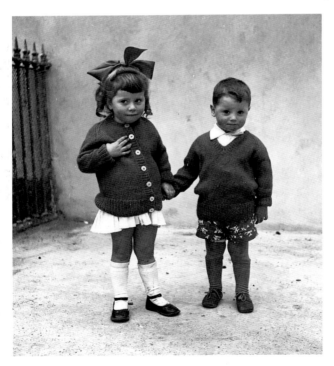

Liberties siblings with hand-knitted jumpers, circa *1960.*

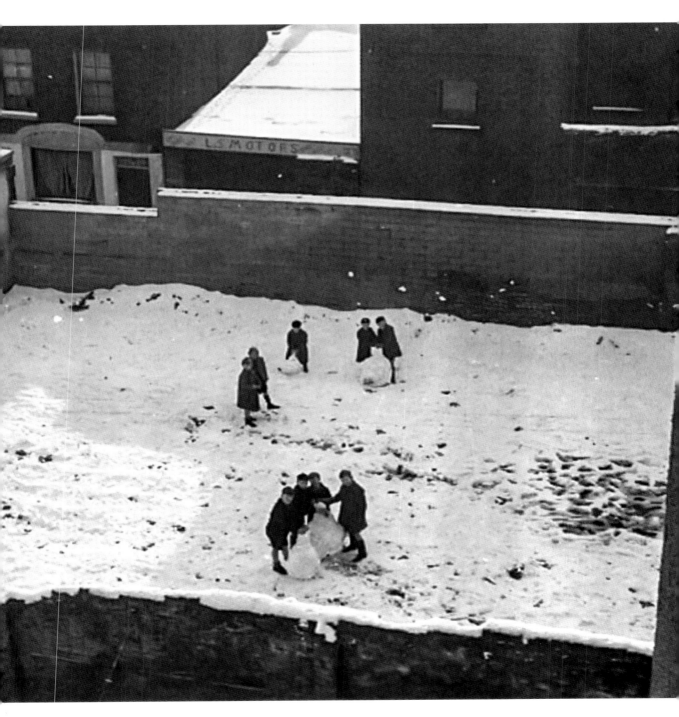

The Ouler taken from the roof of 50 Francis Street in 1960.

Children playing on a van outside Clarke's pub, with some older boys looking on.

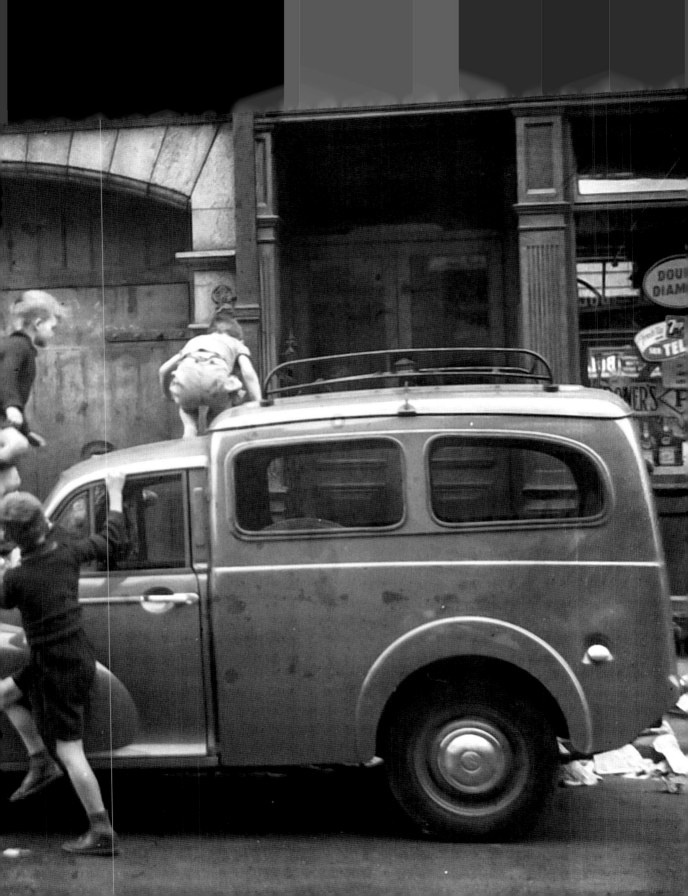

'We were all champion skippers. If you were lucky enough to get a rope from someone from Guinness's, you were made up, as this was also the best rope for swinging on the lamp post. Many a summer evening was spent doing this until your mam called you in at night. The wider the path, the better the swing, and we would wait patiently for our turn. Neighbours would sit out talking, some putting a pillow on the window sill to lean out and chat to each other. Those were the days.' RITA

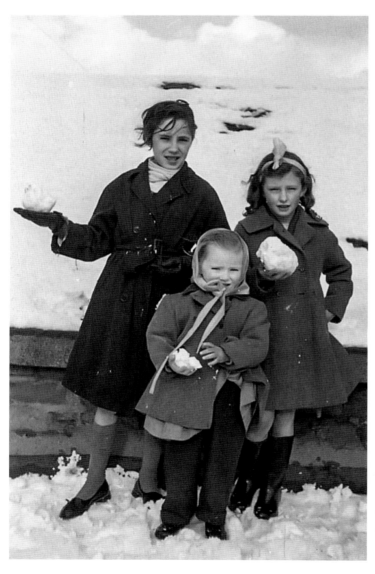

My mam, Rita, and her sisters, Patti and Pauline, playing on the roof of 50 Francis Street in 1960.

Birthdays and parties

Jelly and ice-cream, custard, fairy cakes, Taylor Keith Lemonade, raspberry cordial and a paper hat – the making of a magical birthday party when you were a kid. A simple game of pass the parcel or pin the tail on the donkey and you were happy out. Life was a little simpler and hard-working people made the best of what they had.

The Lyons family from Bride Street celebrate baby Rosaleen's first birthday. A simple spread that kept every kid happy.

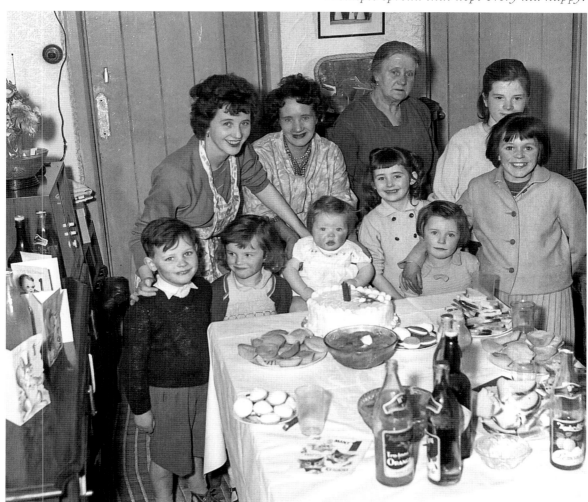

Celebrating his second birthday, the birthday boy is a little dazed by the fuss and having his picture taken.

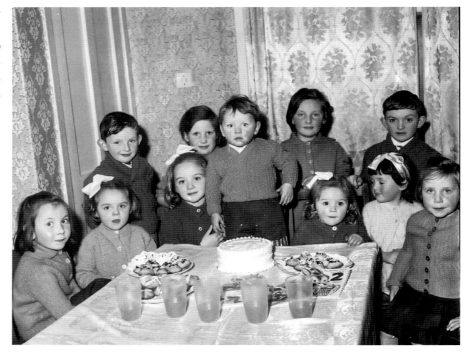

Cousins and friends gather to celebrate a ninth birthday. Grandparents were an integral part of these celebrations, with your nanny lending her expertise in trifle making.

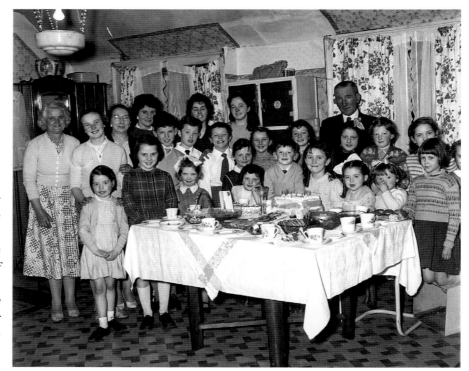

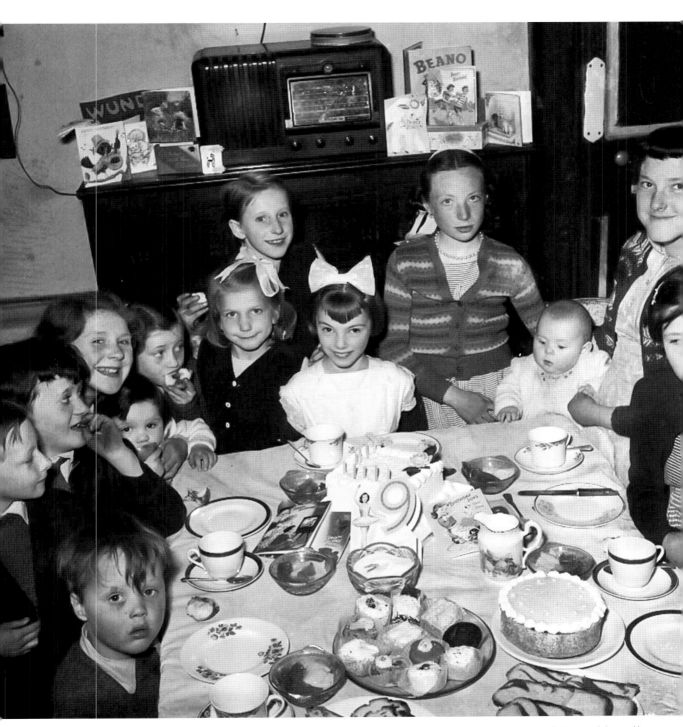

A birthday girl enjoying her ninth birthday tea of fancy buns and marble cake followed by jelly and custard. The Beano annual and the wireless radio on the sideboard behind.

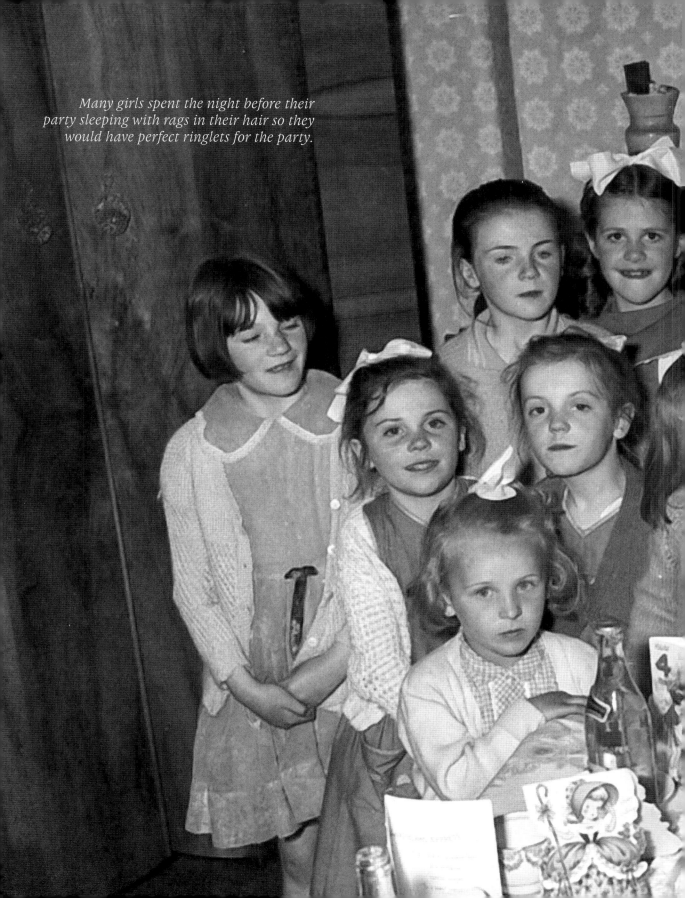

Many girls spent the night before their party sleeping with rags in their hair so they would have perfect ringlets for the party.

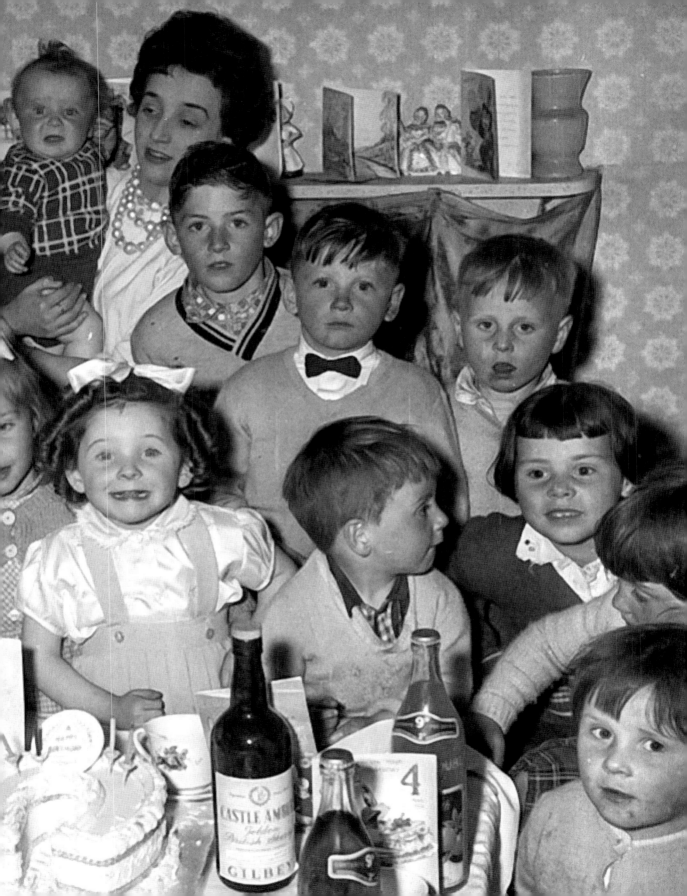

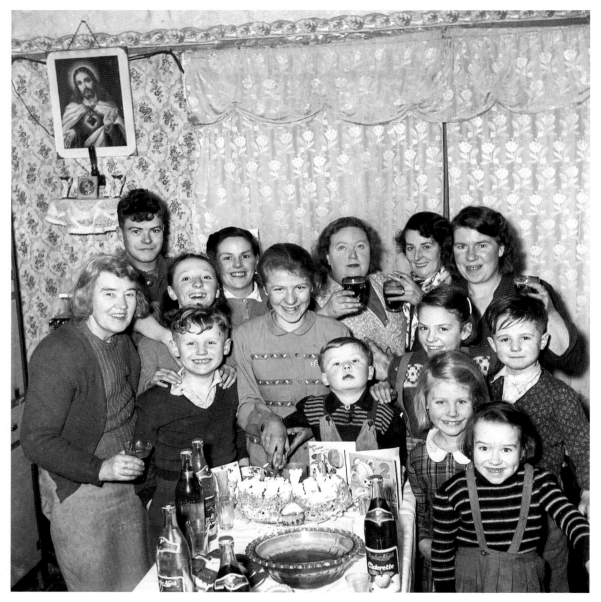

Happy times and memories of your second birthday to treasure.

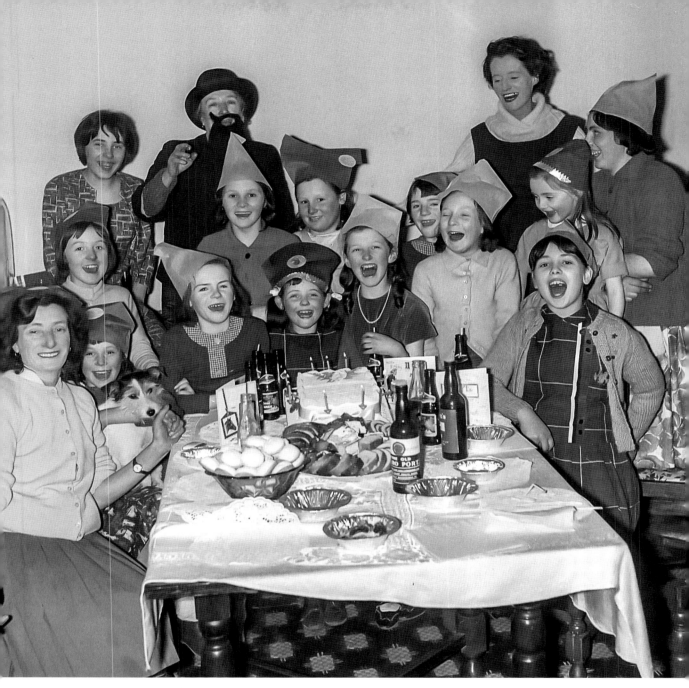

My aunt Patti's eleventh birthday party at 50 Francis Street. Kimberley biscuits were a real treat, taken out of the big box of loose biscuits from the shop. The entertainment came from my great-granny Jane Guy, who dressed up with a beard and men's clothes, always ready for fun and laughter. Patti's pals include Breda and Bernie Welsh, Irene Malon and Teresa Johnston.

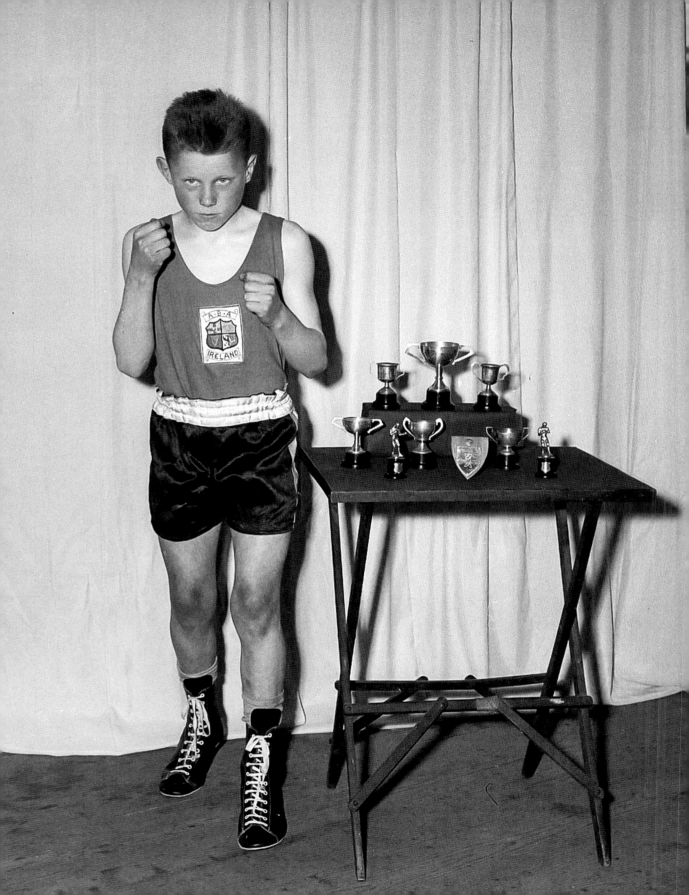

Liberties clubs

Swinging on a lamp post wasn't the only past-time for kids in the Liberties: there were many clubs and societies that they could join.

Music and dancing

Learning to play an instrument, such the accordian, was a very popular hobby for many young people. Fortunately, it was possible to rent your accordian rather than having to buy it upfront, which was helpful to many families on low incomes. A very successful accordian school opened on Dean Street at the bottom of Francis Street and turned out many fine accordian players.

If you were lucky enough to have a dad who was working, you may have had the opportunity to go to singing or dance class. Variety clubs and Irish dancing were very popular in the halls, such as the Marymount Hall in Harold's Cross, Archbishop Byrne's Hall and St Anthony's Hall on the quays.

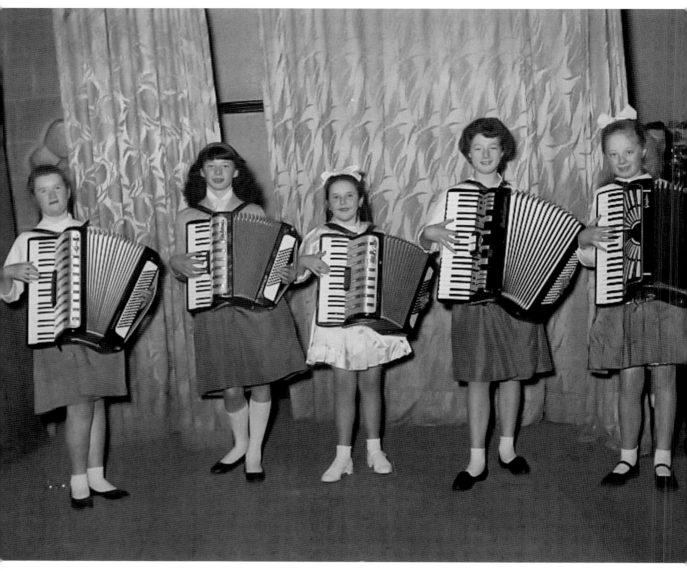

Many Liberties children learned to play the accordian at a school on Dean Street.

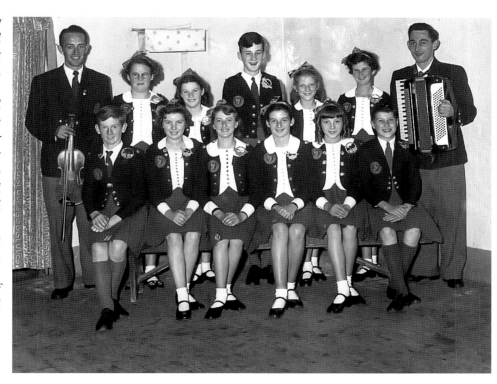

The Lily Comerford Irish Dancing Troupe in 1957. It was usual then for the music for dancing practice to be played live by local musicians, usually the accordion and a fiddle, or a piano if the room had one.

Children from the Liberties were also lucky to have Lily Comerford as a dance teacher. She was born in Dublin and was a famous Irish dancer, at a time when Irish dancing was not as popular outside of Ireland as it is now. Lily danced at the London Palladium and the Albert Hall on several occasions, and won the Feis Átha Cliath Irish Dancing Shield for ten years in a row. She travelled to many countries showcasing Irish dancing, including a tour of Germany in the thirties when she was asked to dance for Adolf Hitler. On her return to Ireland, Lily set up a dance school for children and charged a penny a lesson. She was a legend in her own lifetime and people sent letters to the GPO simply addressed to 'Lily Comerford' and they were all forwarded to her.

Traditional costumes were steeped in history. Boys wore a plain kilt and jacket and a brat, which was a folded cloak that hung from a shoulder and was pinned with a celtic brooch. The brat was a symbol of rebellion during the suppression, since it enabled the rebels to keep warm during the worst Irish weather while they were in hiding in the mountains. Red costumes were often avoided because of the connection of that colour to England, while green and brown were favoured.

Traditional Irish dancing costumes from the sixties, which are very different from the sequined dresses and hairpieces worn today.

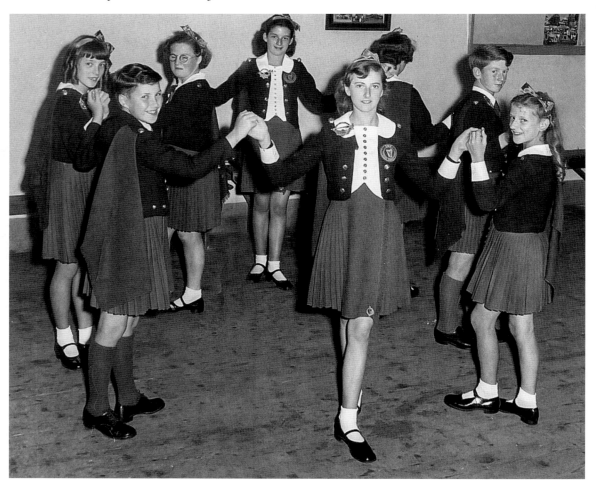

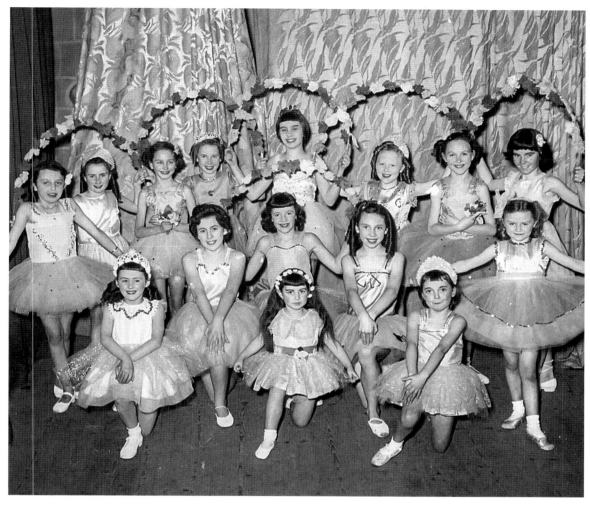

Many variety shows were themed to the time of the year, with summer shows and Christmas pantomimes.

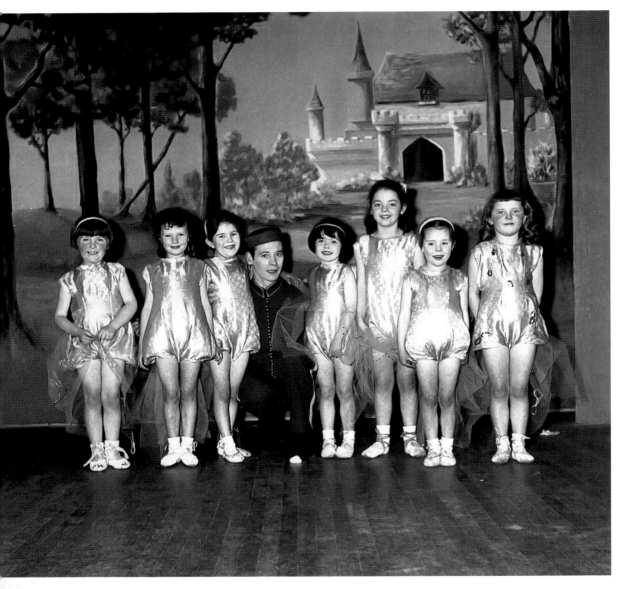

Pantomime time in the sixties.

As well as children being in shows, variety groups and amateur dramatic societies were very popular and put on shows for local children and adults. Pictured here are Kay Delaney, Tommy and Joe Poland, and Olive Pringle.

The Liberty Belles was a variety group of singers from the area that formed in 1969 out of the Francis Street Parish Club. Fr Foley helped with this group and gave great encouragement and support to them. They were a very successful group, and went on to make a record as well as continuing to sing at community events. Many young girls and very talented singers performed with this group over the years.

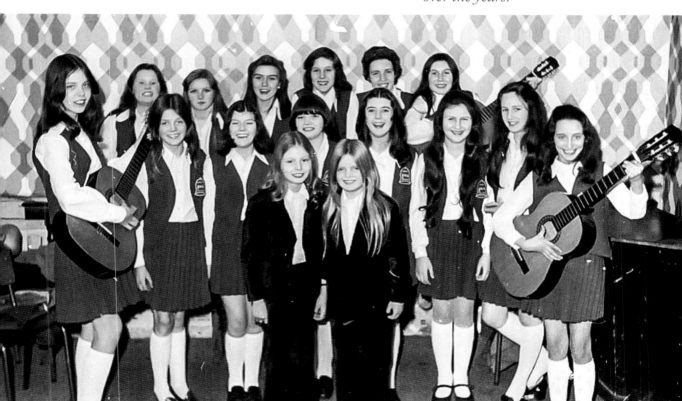

Myra Boys Club

Many of the boys attended the St Nicholas of Myra Boys Club on Kevin Street, which was a haven where they could enjoy games and social activities. Saturdays at the club was film day, and my granddad supplied the sweets for the tuck shop. Westerns were popular choices for the Saturday movie.

'My memory of St Nicholas of Myra Boys Club dates back to the mid-sixties when I joined with a few pals. It was in a very old building that doubled as a picture house at weekends. The club was run by a couple of men who we addressed as "brother". They supervised the indoor games – table tennis, football, rings and a variety of board games. The membership subscription was a shilling a week, and that was marked in your card every week. As a treat, we got tea-cake and some sweets, and, on occasion, we got to see a film on the pull-down picture screen. The club catered for various age groups and we had a soccer team that I played for in the CYC – the Catholic Youth Council – League on Saturdays.

The highlight of the year was the summer camp that was held in Rathdangan in County Kildare. A busload of kids from the Liberties headed off for a week in the countryside accompanied by the brothers and the parish priest, Fr Foley, from the Francis Street Church. We slept in dormitories that had iron, army-type beds. Prayers were said every morning before breakfast, which was porridge. Our week was occupied with arranged sports, such as races, tug of war and soccer tournaments – there was never an idle moment. If you won anything, you didn't get a medal, just a little religious statue – mine was the Child of Prague. It was all very innocent stuff and very typical of how other local boys clubs were run. They were great days.' JOE GEOGHAN

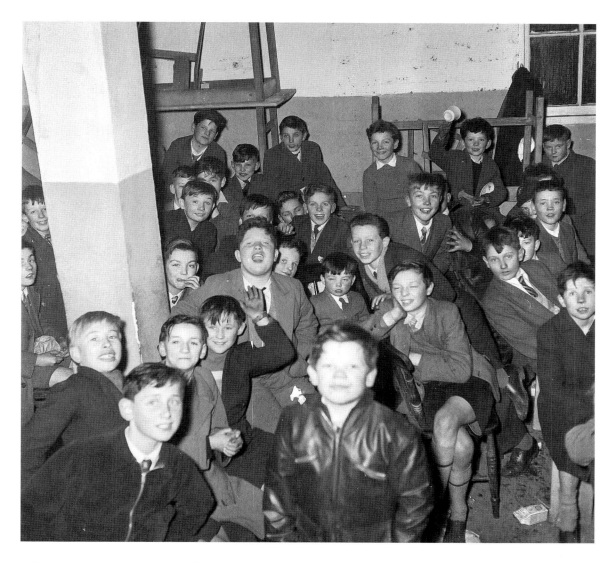

'I spent every Saturday afternoon selling the sweets for my dad to the boys in the club, penny bags and icepops. I don't think I made any profit as some boys had no money and they still got a penny bag – and I ate the rest of the sweets. I was only a kid myself and did this to get some pocket money. It would be pitch dark when the films were on and there was great excitment when the cowboy fims were being shown. It was a real thrill to watch a movie on a big screen then.' RITA

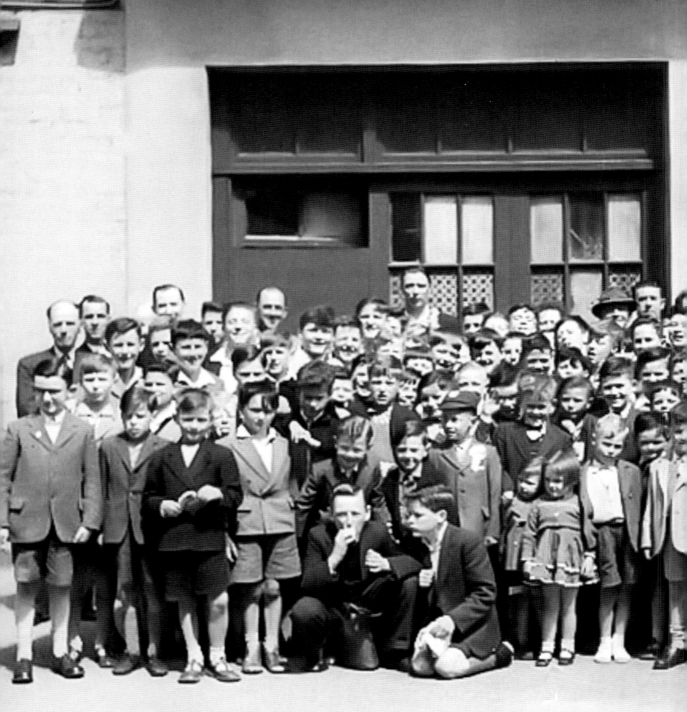

32 St. Nicholas of My

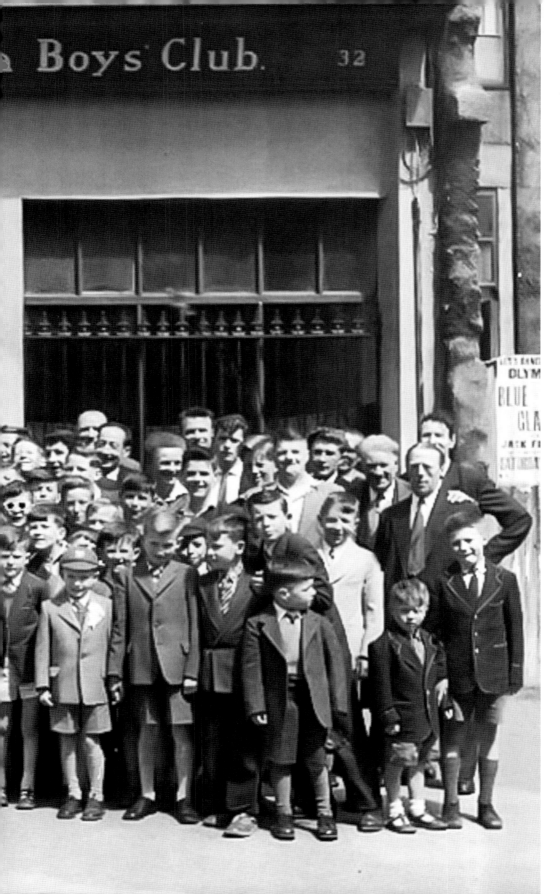

Mr Messit and John Hyland, who helped run the Myra Boys Club, and the faces of the many boys who loved this club dearly. This photo was taken on Kevin Street outside the club.

There were two other similar clubs in the area, St Benedict's and the OLV (Our Lady of Victory), which was run from the Myra Hall on Francis Street by the St Vincent de Paul, before moving to Carmen's Hall. My granny supplied the seven-pound earthenware pots of jam to go on the bread the boys received for their supper when they attended.

Boxing

Boxing was another great pastime for boys in the Francis Street area. The Myra Boxing Club was situated in a small space, two doors down from the Myra Bakery.

Members and officials from the Myra Boxing Club, circa *1958.*

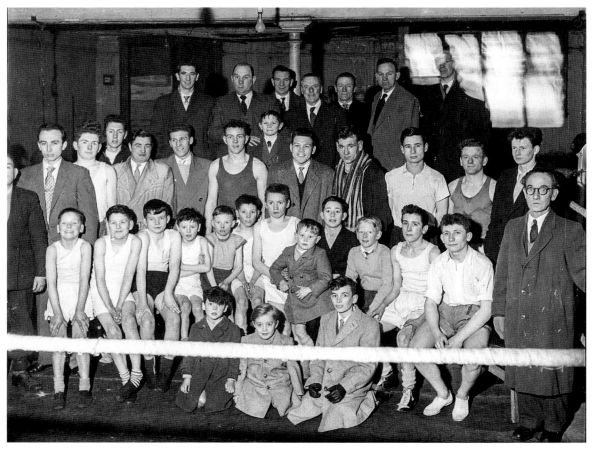

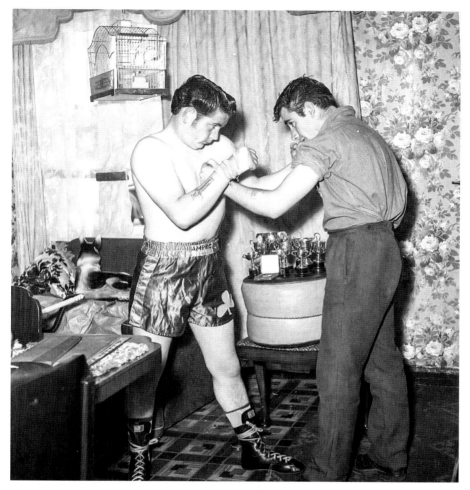

Boxer John Mulvey posing for his photo in his parents' house in Ash Street. The budgie's cage seen hanging from the ceiling was a typical sight in many houses as they made very popular pets.

Girl Guides

The Francis Street Girl Guide company, of which my mam and aunts were members, was a popular group for the girls living in the Liberties to join. As well as working towards merit badges, the guides had an annual Parents Day, which was held in the Iveagh Gardens, when numerous guide troops gathered and demonstrated various drills for their families.

'Our leaders – Captain Malone on the right and Captain Devlin on the left – were wonderful women and taught us many of the skills needed to be a good Girl Guide. One Saturday, I remember our captain brought us to her home in the Tenters area near Francis Street to teach us how to make a stew for our cookery badge. I had many happy days in Francis Street Girl Guides, hiking in the Dublin Mountains or off to the Archbishop Byrne Hall to learn campfire songs and play games. It took me ages to try get my knot correct for inspection, left over right and right over left.' RITA

My mam, Rita (back row, second left) as a brigín at the 1958 Parents Day.

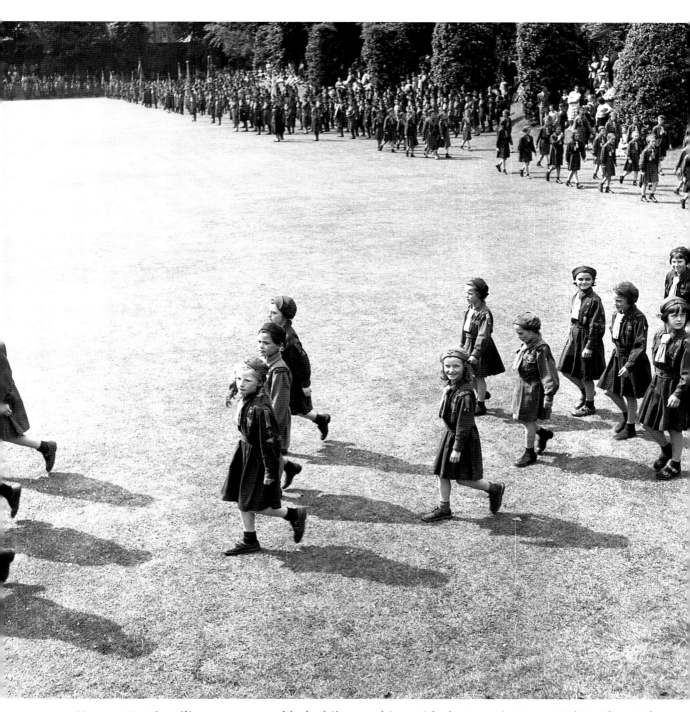

My aunt Patti smiling to my granddad while marching with the Francis Street Girl Guides at the annual event in the Iveagh Grounds.

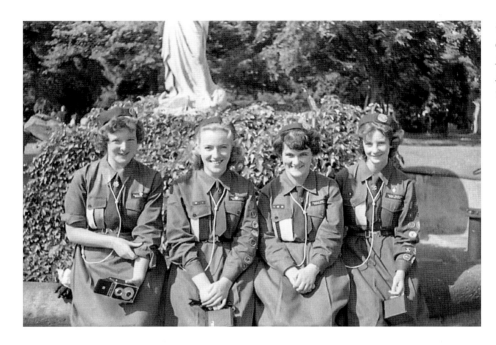

Girl Guides enjoying Parents Day in 1958, Box Brownie cameras in hand.

Drills were performed for the parents by all the different companies. The maypole in the foreground was also a regular feature of the day.

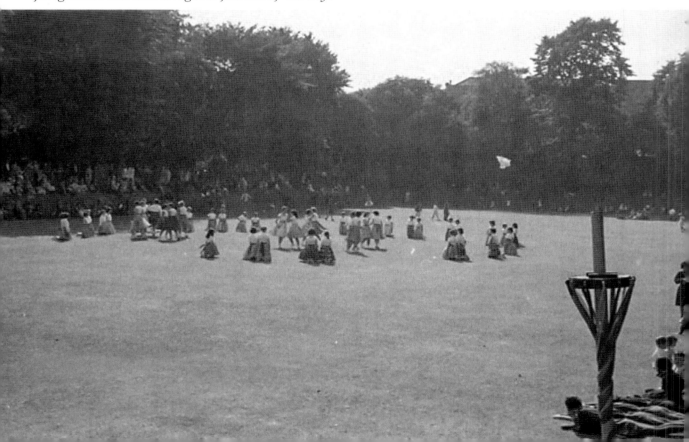

Soccer

Soccer, of course, was another past-time for boys. Apart from the informal matches between different groups of boys from the area, matches were also arranged on a more formal footing, including between altar boys from different churches.

Getting ready for a match between the altar boys from the Parish of High Street, St Audeon's and St Nicholas of Myra.

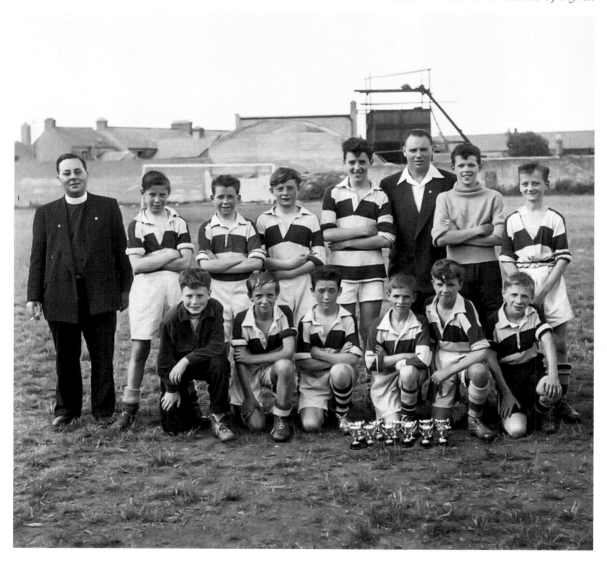

Fr O'Beirne was a curate in the parish of Francis Street, who later returned to the parish as Parish Priest, and spent some time here helping with the soccer matches for the boys of the area.

Footballer Peter Farrell attended some games and awarded the medals to the boys. Peter, surprisingly, loved his pipe, even though he was a footballer. He played inside-forward for Shamrock Rovers, Everton and Tranmere Rovers; he also played internationally for Ireland.

Fr O'Beirne listens as Peter Farrell says a few words before the match, June 1957.

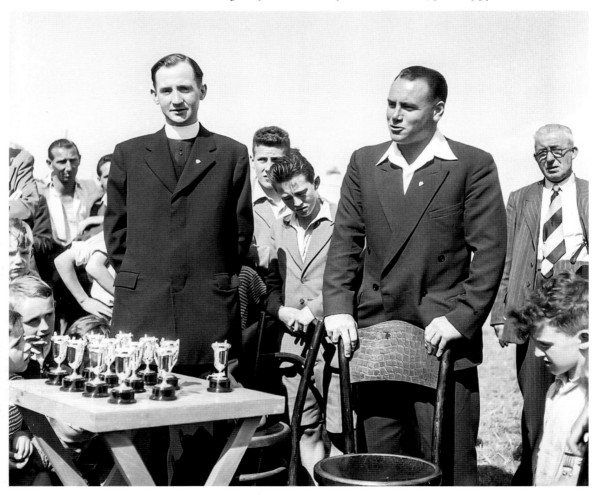

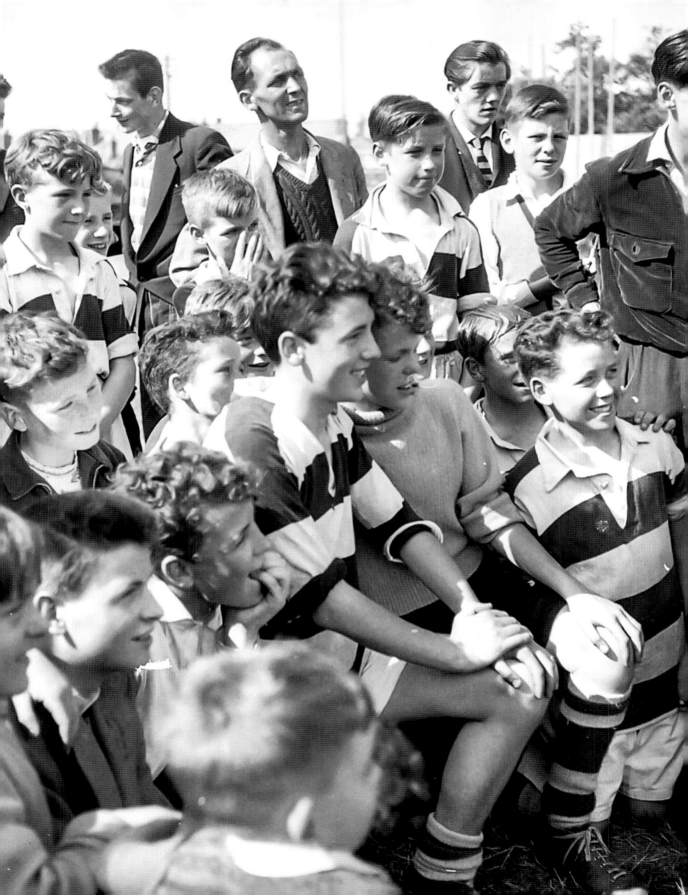

A proud mother with her daughter, Warren Mount School, 1963.

Your big day

Making your Holy Communion or your Confirmation in the fifties and sixties was a big affair. For many kids, it was the only time of the year they would get new clothes or a treat. Going shopping for new clothes was a very special occasion, though some kids had to make do with hand-me-downs. Times were tough for families, and unemployment, poverty and tenement life, along with the struggle to raise a family on one wage or strike pay, meant Holy Communions and Confirmations put a financial strain on parents. Many people turned to money lenders to get their child a nice outfit, while others paid off weekly for months before the big day. Many women who worked in sewing factories hand-made their children's clothes.

If both your parents were unemployed, very often the St Vincent de Paul would help out to ensure every child had an outfit. The pawn shop was the place where many a man's suit

would be taken to get a few bob for a special occasion. My granny Suey would say, 'The three balls of the pawn shop, 2 to 1 it won't come out.'

My granddad took thousands of Holy Communion and Confirmation photographs. It was very popular to have an 'official' photograph of the day and his archive holds precious memories of all the children that passed through the gates of

A young girl having her photo taken in my granddad's studio after making her Communion in Francis Street Church in 1960.

the parish churches in the Liberties – including Francis Street, Meath Street, James Street, Donore Avenue, High Street and Whitefriar Street, as well as many other churches around the suburbs of Dublin.

Holy Communion

Making your communion was a very special day and a very happy time for many children.

Children and their teacher walking to St Stephen's Green to have their photograph taken by my grandfather, circa 1960.

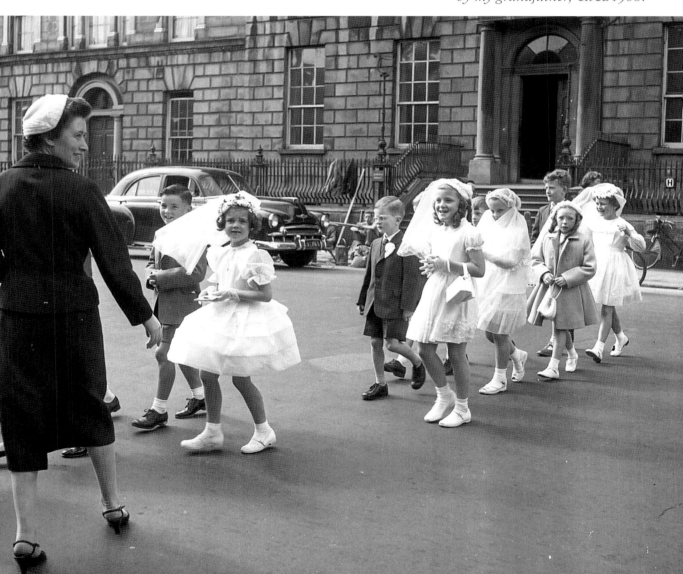

A new suit, a rosette and an overcoat was as important to young boys as the veil and dress was to young girls.

Children did not receive cards, as they do today. Their granny or aunties and uncles bought them rosary beads and a prayer book as gifts. Many children received a penny or a thrupenny bit from relations and neighbours. With no car, you travelled by bus or walked to visit your family.

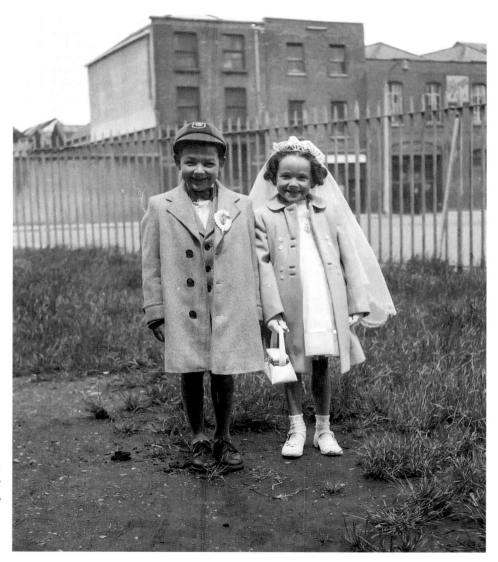

Betty and John Madden posing for their Holy Communion photo in 1958.

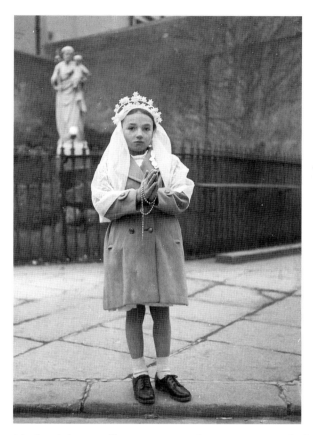 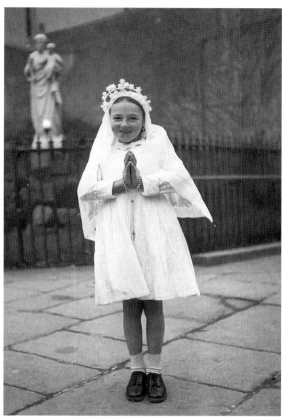

Little girls usually got a coat that went over their dress, often a lovely bright colour. My granddad would take a photo of the girl in her coat and then one to show off her beautiful dress.

May Dowling from Mark's Alley with her niece Dolores Cusack making her Communion in Francis Street Church.

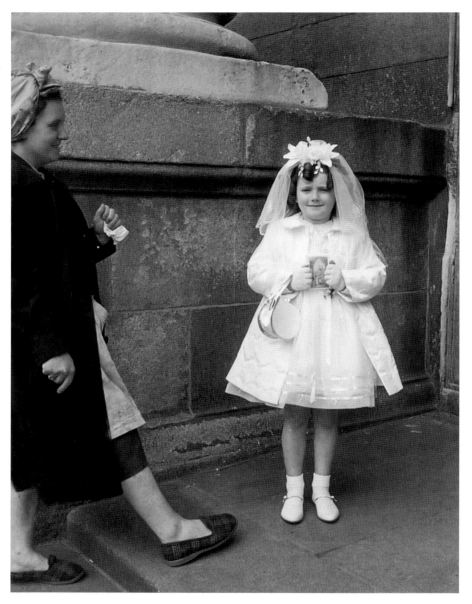

It was tradition that every child had to fast from midnight the night before making their Holy Communion. After the ceremony at the church, it was common practice to have a communion breakfast, usually in a parochial hall or school.

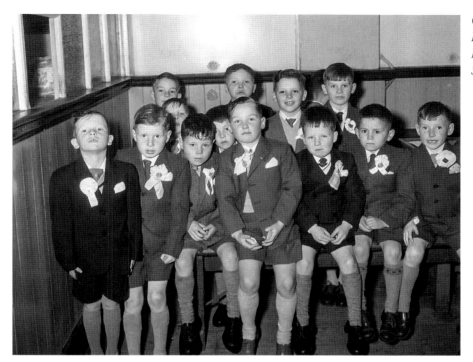

Communion Breakfast at Little Flower Hall, Meath Street in 1960.

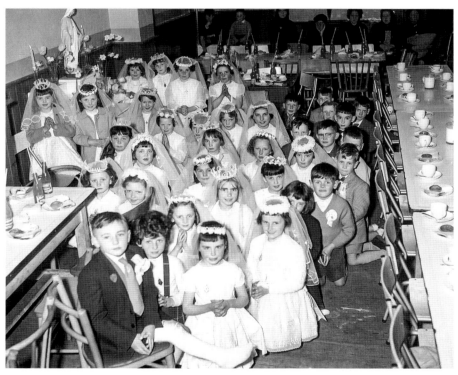

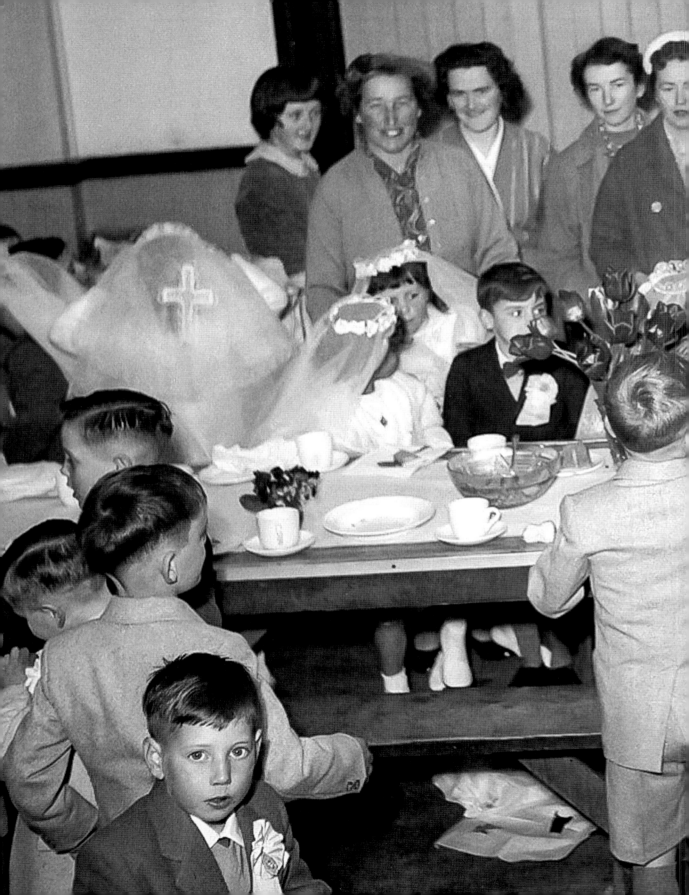

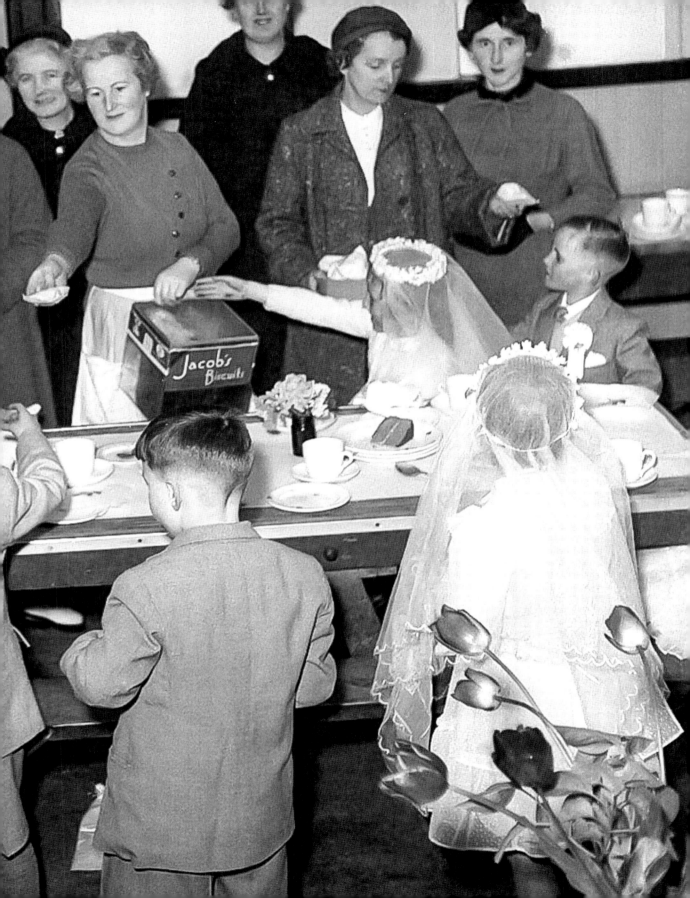

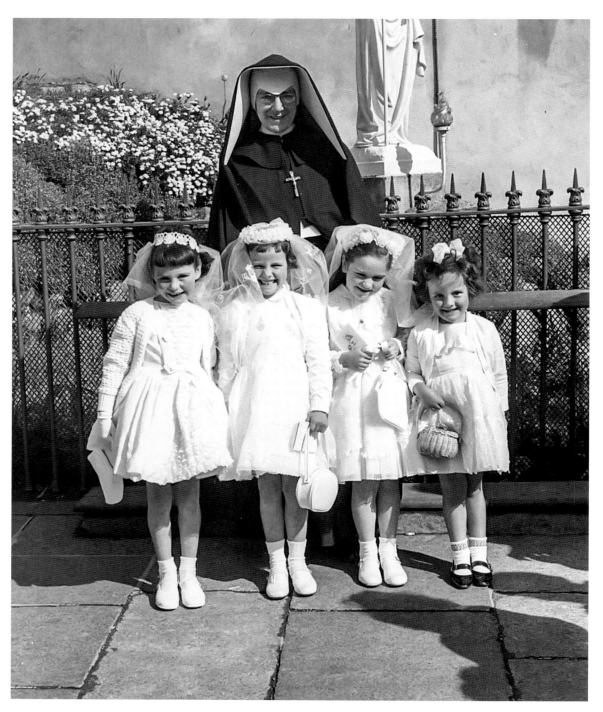

Holy Communion girls with their Holy Faith nun and teacher, Francis Street Church in 1961.

St Patrick's Park adjoins St Patrick's Cathedral and, in the background, is the building of the Bayno, Bull Alley. The Bayno was built in 1913 by Lord Iveagh and through the generosity of the Guinness family. It was the centerpiece of the Iveagh Trust Buildings, where local children played every day after school. The Bayno holds many great memories and nostalgia for the people of the Liberties. It is considered one of the best childhood playgrounds of its time – as the song goes …

'Tiptoe, to the Bayno
where the kids go
For their bun and cocoa
Tiptoe to the Bayno with me.'

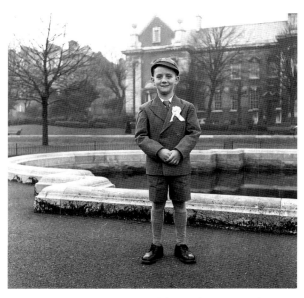

A young boy in St Patrick's Park in 1957 having made his First Holy Communion.

The three Place brothers - Sylvester (George), Noel (John) and Colm in May 1959. Sylvester remembers that they were gathered for the photo after Noel's Communion, after he himself had made his Confirmation the previous March. Sylvester remembers fainting during his Confirmation mass as a result of the required fasting beforehand. The boys went to St Francis CBS and their family lived over their uncle Pat Roche's shop at 59 Francis Street, from the fifties until 1974.

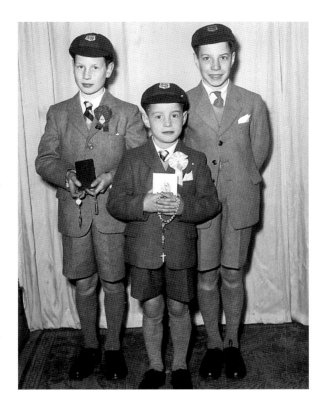

Confirmation

Confirmation was a different situation all together. The fear of God was literally put in you by knowing you may have to face the bishop head on for a series of question that you had to know from your green catechism.

'Who made the world?'

'God made the world.'

The tradition was that children waited for the bishop to arrive at the church – and this wait was one of anxiety and fear. Parents were not allowed into the church, and as soon as those big doors closed, it was show-time! Children hoped the bishop wouldn't pick on them and were warned that they would not be allowed to make their Confirmation if they didn't answer correctly. How could you go out and tell your parents you were not confirmed after they had bought you new clothes? The embarrassment and the shame would have been just too much. I don't think any child was denied the chance to make their Confirmation, but the fear that was induced was enough to make you learn your catechism.

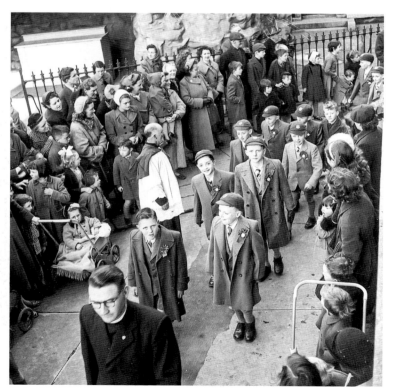

The boys from Francis Street CBS heading to the church for their Confirmation in 1957.

88

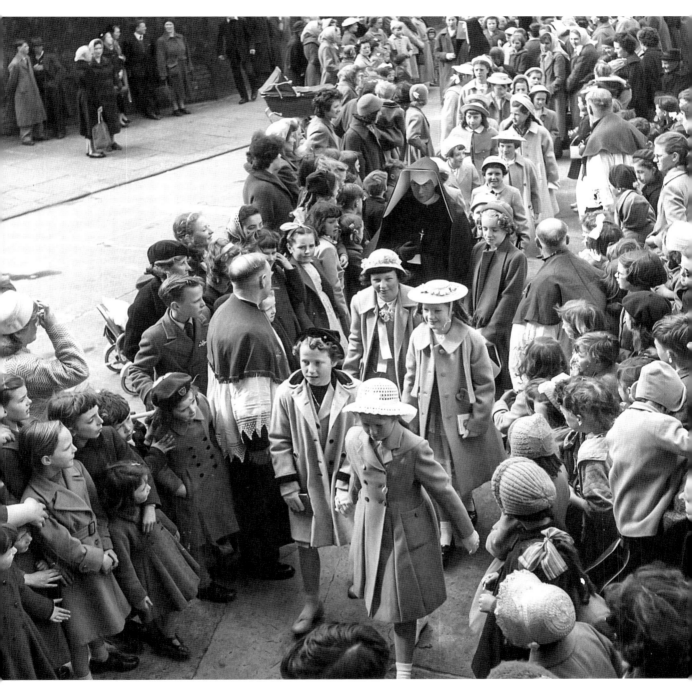

Making that much-anticipated walk into the church, leaving parents and siblings outside while you made your Confirmation, 1960.

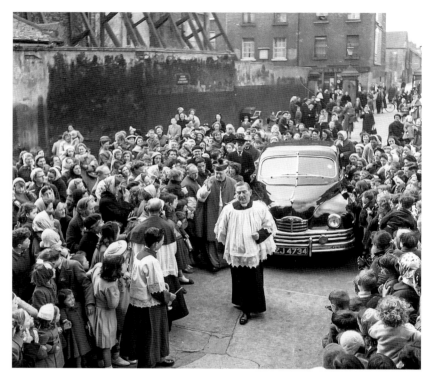

The bishop arriving in his chauffeur-driven car at Francis Street church to confirm the children of the four local schools in 1960.

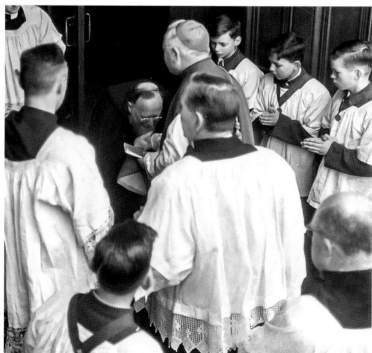

Fr O'Beirne looks on as a priest kisses the ring of the bishop, a symbolic gesture of respect towards the authority the bishop held.

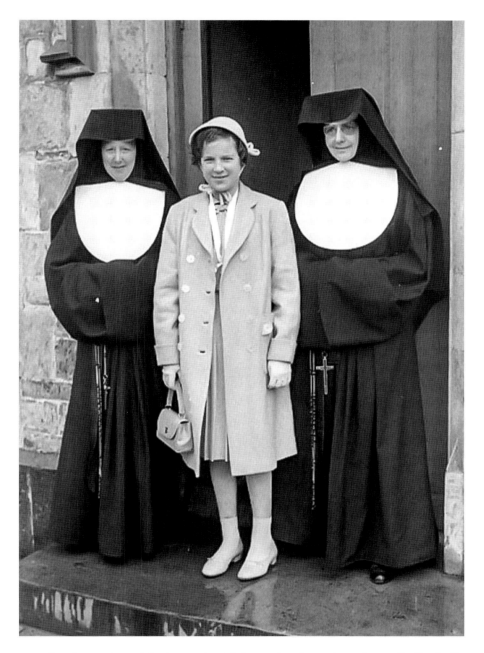

Confirmation girl pictured with her school teachers in 1958. Catholic nuns then wore full habit and were not allowed to show any hair or take their habit off in public. Long wooden rosary beads and a leather belt meant that, in school, children could always hear them coming down the corridor.

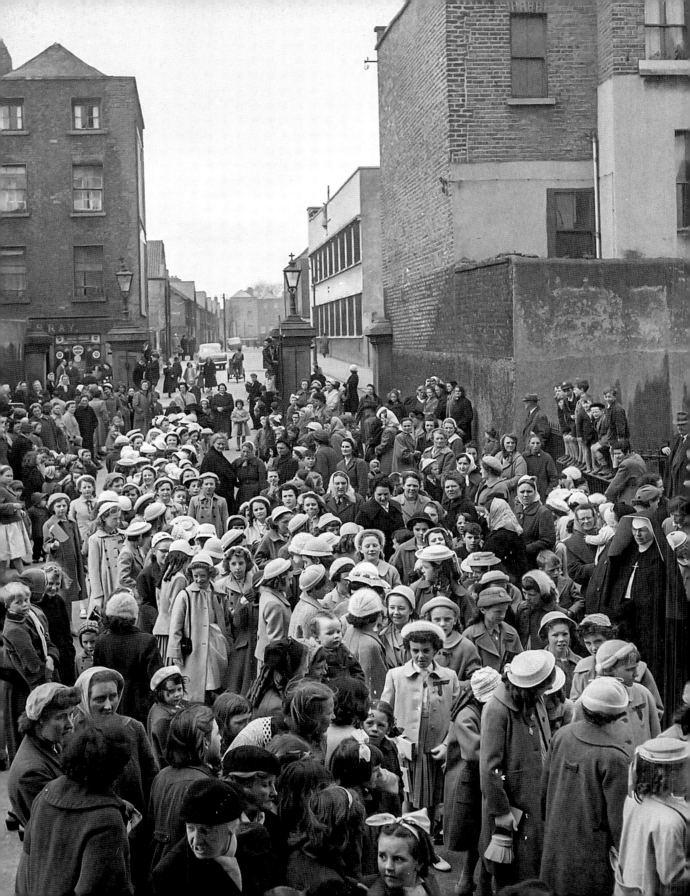

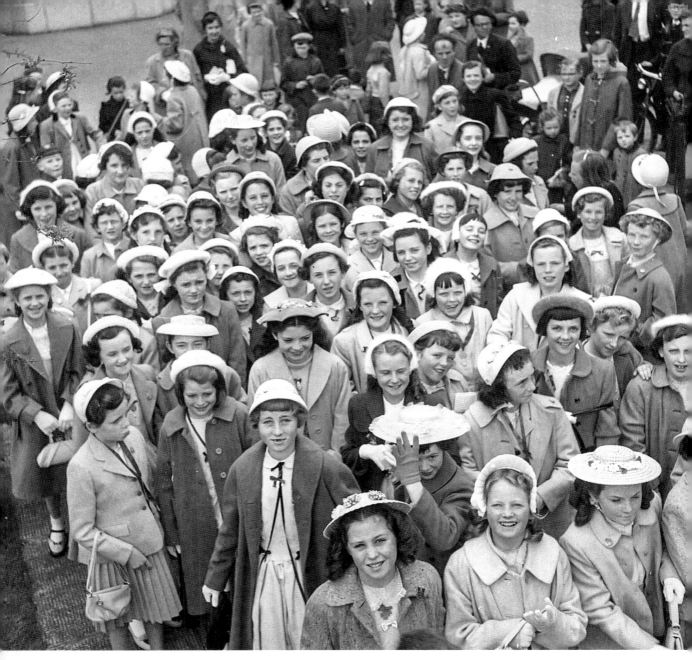

Confirmation at Harold's Cross in 1961. My granddad would always climb to a higher vantage point to get the whole crowd in.

Confirmation Day, Francis Street Church in 1960. Pictured here are children from Francis Street National School, St Brigid's on the Coombe and Warrenmount School. Boys from Francis Street CBS entered separately from the right. Among the crowd is my mam, Rita, waiting to make her Confirmation. The view from the church looks towards Carman's Hall.

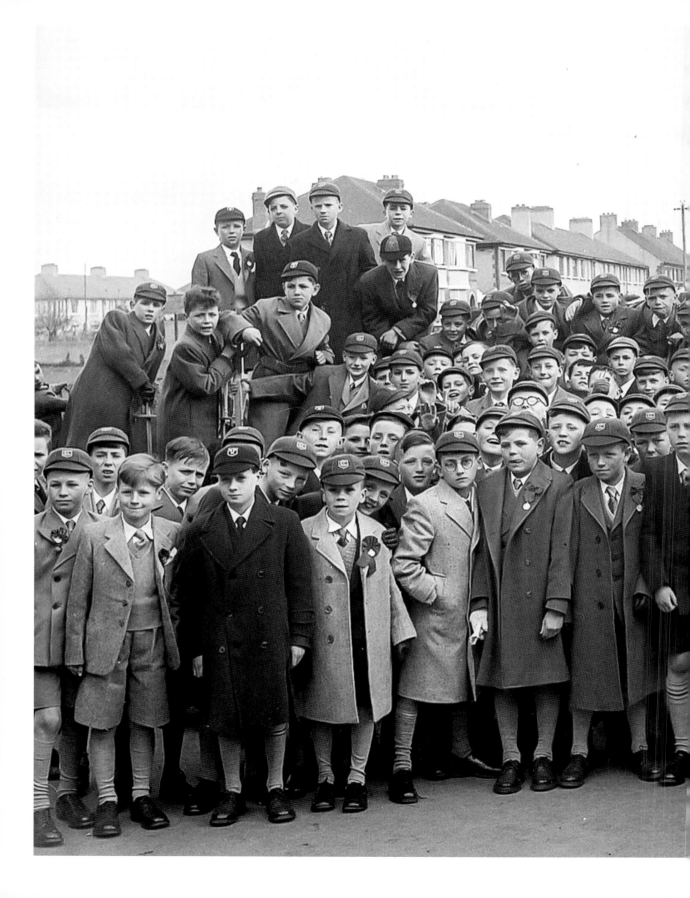

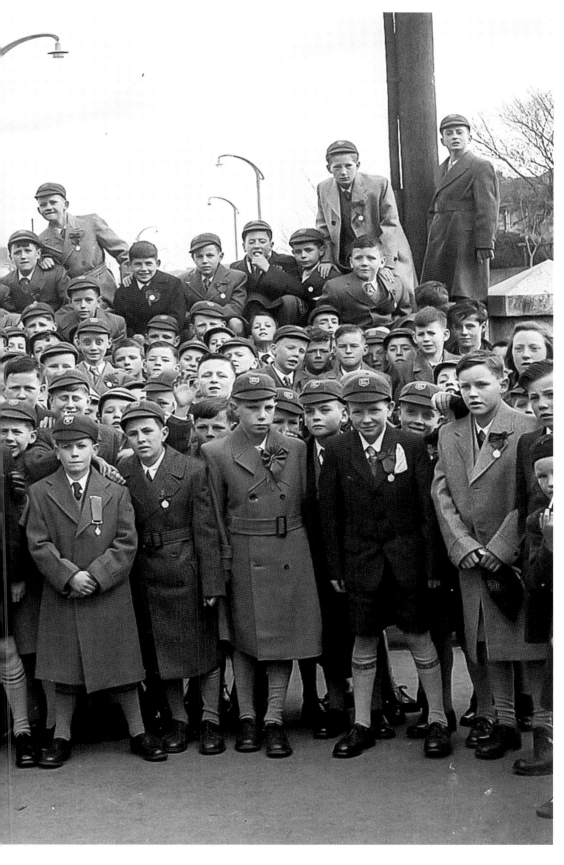

Confirmation at St Agnes's Church in Crumlin in 1957.

'Big smile, now, watch the birdie'

During the fifties and sixties, photographers had to rely on their skills and instinct to ensure they got a photo right. They had no LCD screens to check their image as soon as they'd taken it, and had no option to delete the image and start over. Photographers like my granddad were craftsmen, and black and white photography was an art form to be perfected.

My granddad's studio was nothing like photographic studios today. He had no specially made seating or high-tech lighting and didn't use props or gimmicks. The backdrop was often a curtain or a bed sheet – many times, he just put a blanket or cloth over my granny's Singer sewing machine and sat small children or babies on that. People often just came as they were: some chose to get dressed up for their photographs, others just came in off the street.

The photos in this chapter depict the people and life around the Liberties. I have no names for many of the faces, but each

image is full of character and spirit, and each has a story to tell. Many people passed through the doors of 50 Francis Street, and each had their own reasons for having a photograph taken.

Many people paid for their photographs over a number of weeks, paying a deposit when the picture was taken and the remainder on collection. My granddad developed and processed all of these photographs from his darkroom.

'Dad was happiest when he had a camera in his hand. They say you should choose a job you love and you will never have to work a day in your life, and he was so lucky because that applied to him. He must have said, "Big smile, now, watch the birdie" a million times.' PAULINE

Three generations - mother, daughter and new baby, 1959

The birth of a new baby was an occasion to be recorded and lots of new babies had their first photograph taken by my granddad. Many people couldn't afford cameras, so they came to my granddad's shop to have photographs taken and got extra copies to send to relations overseas.

Over his career as a photographer, my granddad worked for many of the same families across the years. He took photos of babies, then, as the child grew, their Communions, their weddings and even then photographs of their own children. In some families, he had taken photographs of four generations.

My granddad took the first photographs of many babies.

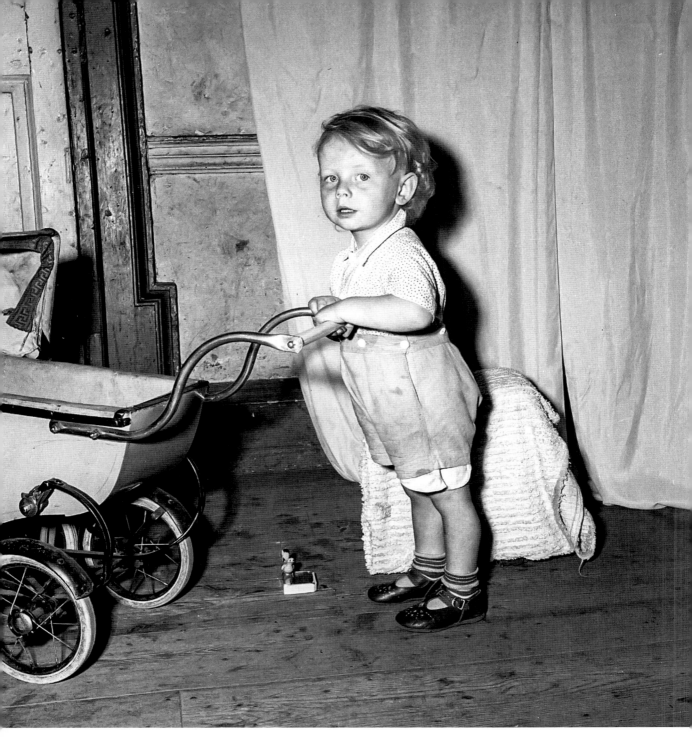

A far cry from the structured baby photo shoots of today, just a natural picture of a toddler as he was. My granddad loved working with children and would blow raspberries and make funny noises to try to get them to look at the camera.

Frances Hogan brings her baby daughter Linda and niece Valarie to have their photo taken.

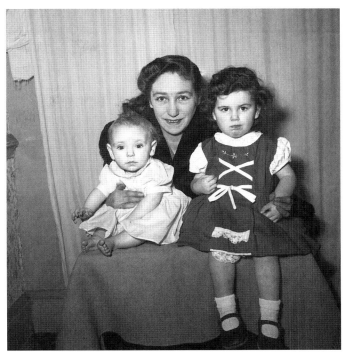

Bridie Johnston from Francis Street with her pal, having their picture taken in 1963.

Paddy O'Connell from Mark's Alley married Theresa Hand from Francis Street and they are pictured here with some of their children, Paddy, Joe, Noel and Mick, in 1957. The family lived in Mark's Alley West, just off Francis Street.

Mr and Mrs Anderson with their sons, Johnny, Shay and Michael, and their daughter, Breda. The family came to have their picture taken every year after a visit to Santa in Dublin and a copy of the photo was sent to the children's grandparents for Christmas.

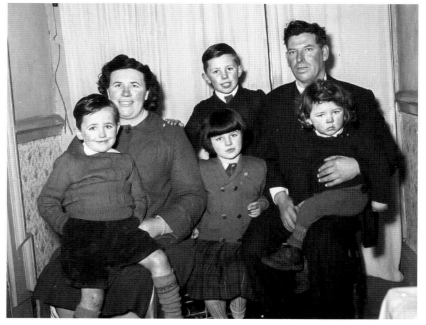

Of course my granddad also took photographs of Suey and his daughters in the studio. He would often return from a photography job like a wedding with a few frames left on the roll and, not wanting to waste his film, he would photograph his family before heading out to the darkroom to develop his work.

My mam, Rita, and Suey in 1959.

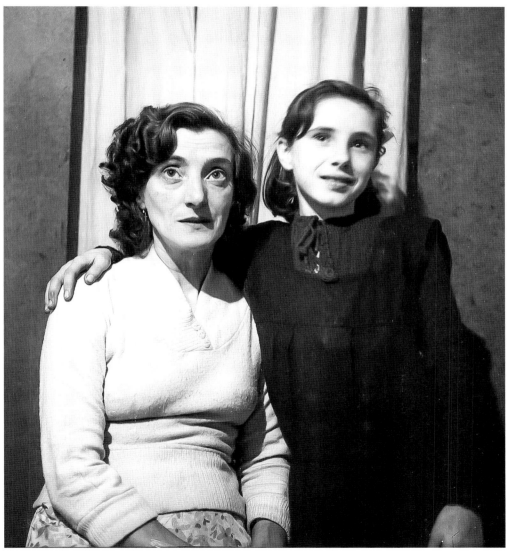

Life, love and laughter
in the Liberties

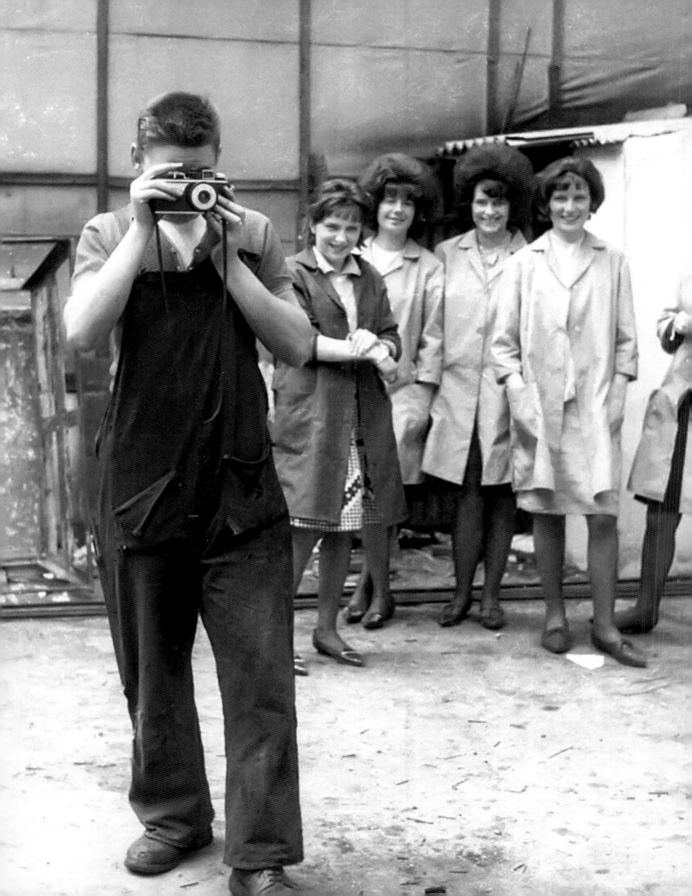

From the classroom to the factory floor

For most people in the fifties and sixties, working life began at the age of fourteen. You left school and went straight to work – either in a factory or, for boys, if they were lucky, in an apprenticeship.

The area around Francis Street was home to many factories, all of which have long since closed. It was customary when you got a job to pay your way and help your parents out. Many young teenagers would hand over their wage packet to their parents in the hope of getting a few bob back to spend at the dance or in the cinema.

Factory work was the main source of income for many teenagers and young people in the Liberties. Sewing factories were popular places to work for women and a friend or a good word could get you in the door. Young girls were mentored and looked after by the older women working on the factory floor

who taught them the tricks of the trade. Songs were sung to pass the time among friends, as on some factory floors talking was not allowed. Money was hard earned and you had to reach your quota of pieces or garments made to get your bonus. The supervisor was feared and jobs were often ranked in order of your starting date or expertise – last in made the tea!

Staff of the T-Clothing factory, which was situated on Francis Street, 1956. This factory was part of the Glen Abbey Group and it made clothing, including vests and underwear.

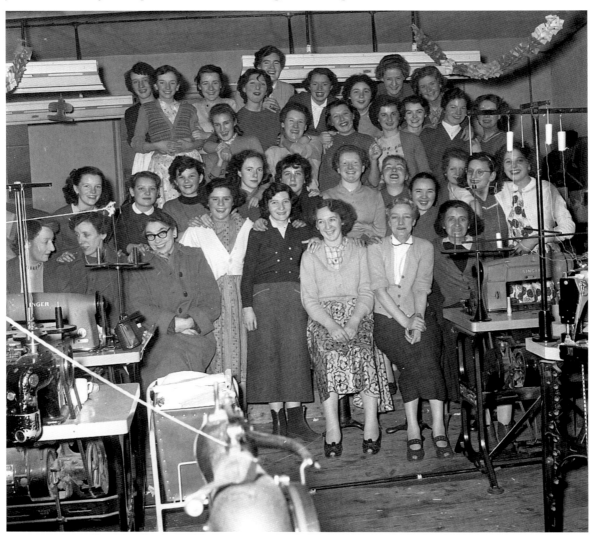

Lena Smith (from Mercer House) having her photo taken with her work pal Anne Keating (from Long's Place) whose younger sister had made her Holy Communion. Lena and Anne worked together in Slumber Sweet Sewing Factory, and Lena remembers that her older sister Chrissie ('Blue Eye') made her dress for her. Lena went on to marry my dad's brother, Billy. Later in life, Lena and Chrissie ran a clothes stall in the Liberty Market for many, many years.

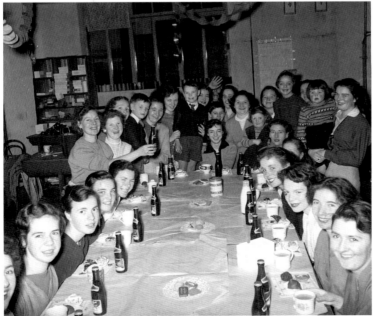

Christmas party for the young workers and their siblings at the T-Clothing factory in 1956. A bottle of pop, teacakes and biscuits were a real treat if you were a kid being brought to your big sister's workplace. Holding the bottle on the left is Mary Ormsby, who was my granny Suey's bridesmaid and who worked at this factory for many years. Mary would keep the scraps of material for the local women to make patchwork bedspreads and bunting for occasions on the street.

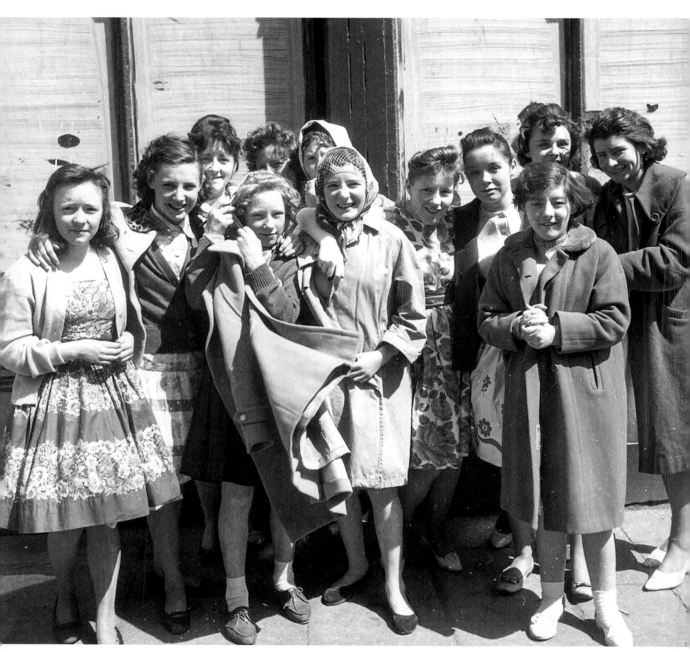

Liberty lasses – Josie Birch and Breda Reilly (from Hanover Lane) and Ann Kelly (from Carman's Hall) among some of the faces in this picture. Schoolfriends became work pals delighted to be getting their picture taken on the corner of Francis Street. The hairnet visible under one young girl's scarf shows that she was employed in a confectioner's or possibly Jacob's Biscuits on Bishop Street. Many of these young girls would have worked in sewing factories.

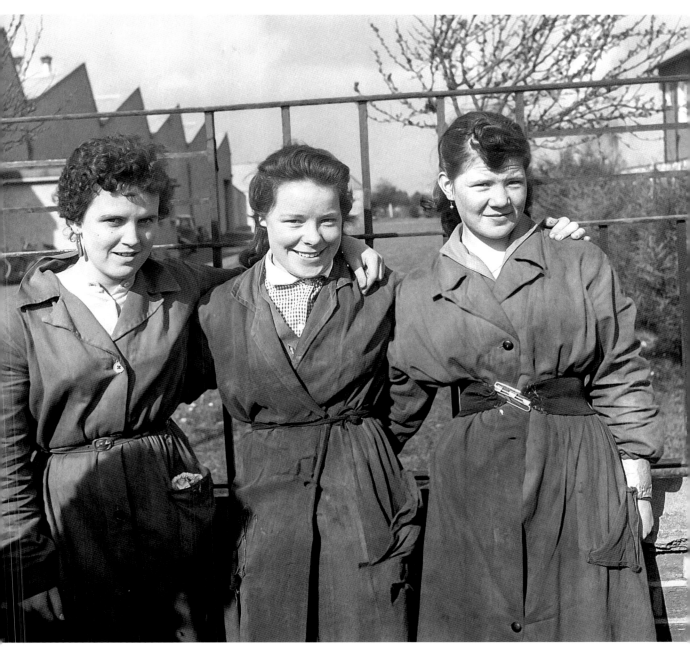

Young girls at break-time outside one of the many factories on the Long Mile Road in 1959. They've used safety pins to hold together their smocks in an effort to pull in their waists and show off their figures – you never know, a factory lad could be chasing you.

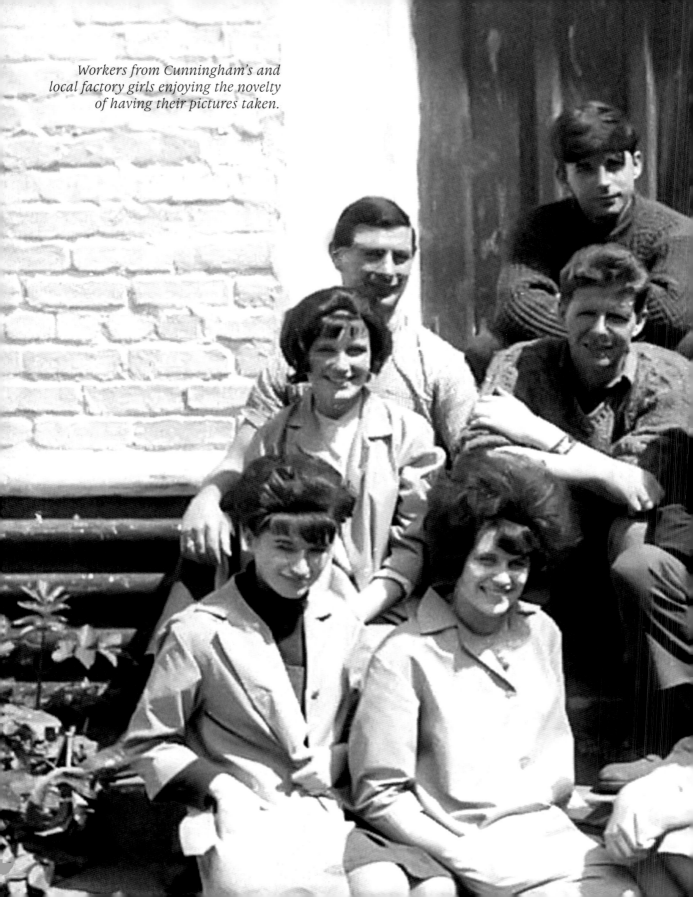

Workers from Cunningham's and local factory girls enjoying the novelty of having their pictures taken.

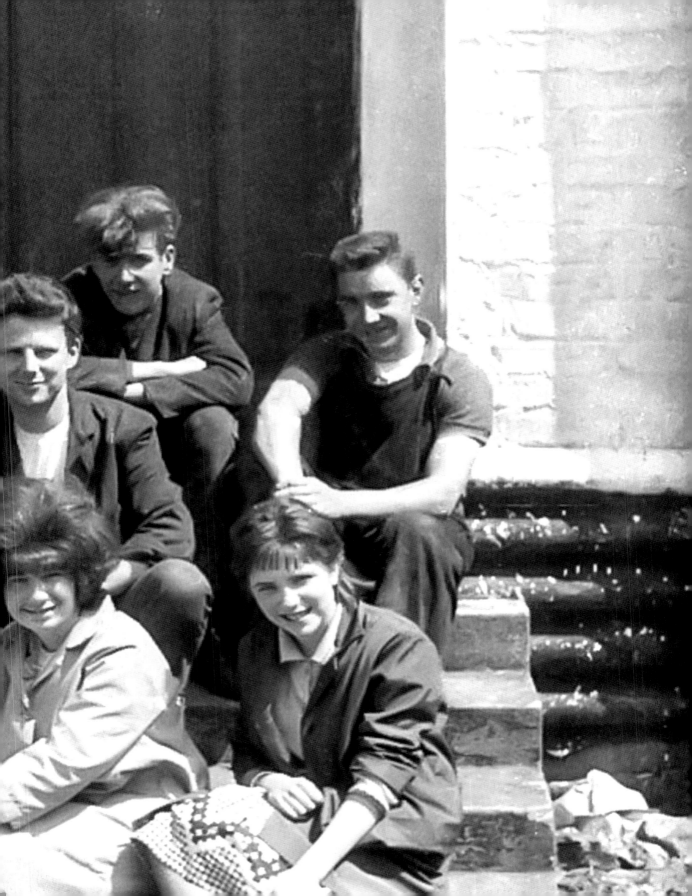

Workers from Cunningham's with Dublin Castle in the background.

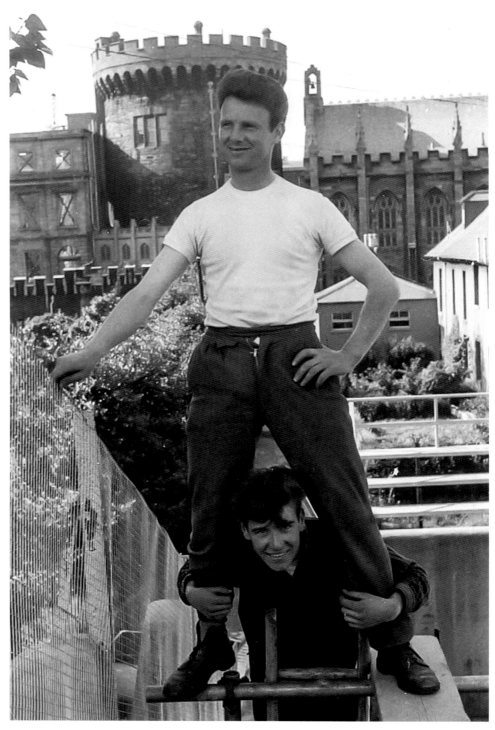

Cunningham's Metal Works situated off Mark's Alley was another employer in the area. My granddad worked there for a while in 1958.

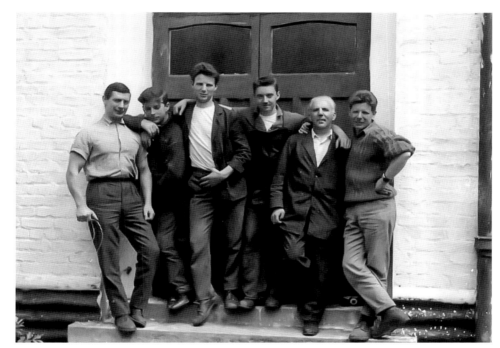

My granddad (second on the right) with the young men from the steelworks.

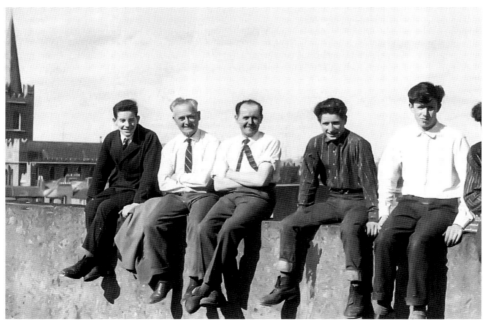

Pals were made for life in some factories and there was great camaraderie on the factory floor. Lunch-time was an opportunity to get outside away from the heat and confinement of the factory and football teams were often set up with leagues between factories and pubs.

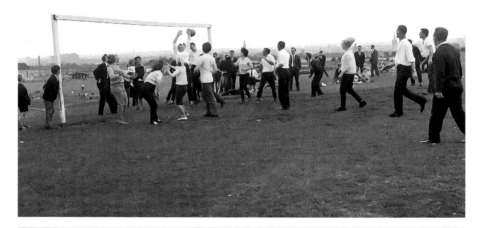

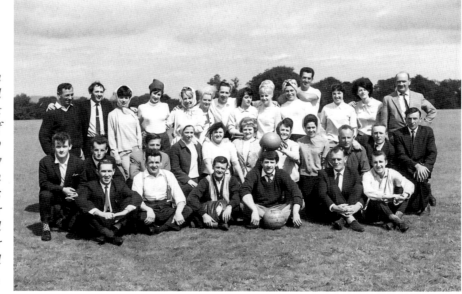

Workers from factories around Francis Street and patrons of McGowan's pub played a friendly soccer match in 1958, the ladies making sure their hairstyles stayed intact with their headscarves and turbans.

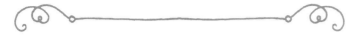

Bakeries

Bakeries were also a common employer around the Liberties. Fresh bread was made on site and the smell of a fresh turnover loaf would waft onto the streets. St Catherine's and Kennedy's were two well-known bakeries, with Kennedy's selling fresh cream cakes that people would walk from far and wide to buy. On Sundays, people would queue for an apple tart from the Myra Bakery on Francis Street after mass.

Bakers making turnovers in 1956.

Sliced pans modernised the baking industry with loaves being mass produced, sliced and wrapped ready for sale on a daily basis.

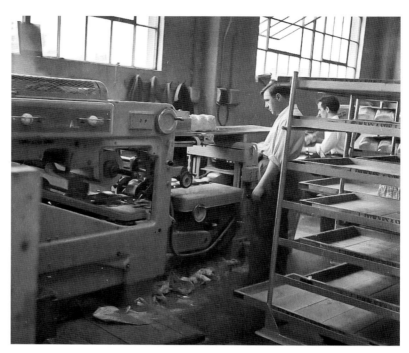

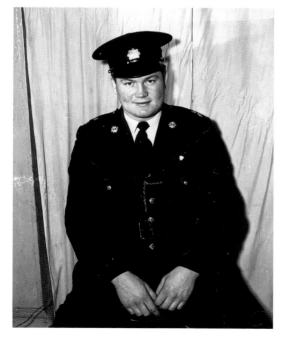

A guard from Kevin Street having his picture taken in my granddad's studio. Guards dropping in for a cuppa and a cigarette was a regular occurrence in the shop, as walking the beat was the way the streets were policed at this time.

Another big employer in the Liberties at this time was Burton's Coat Factory on New Street.

Clocking-on time for the men of Burton's, New Street in 1957.

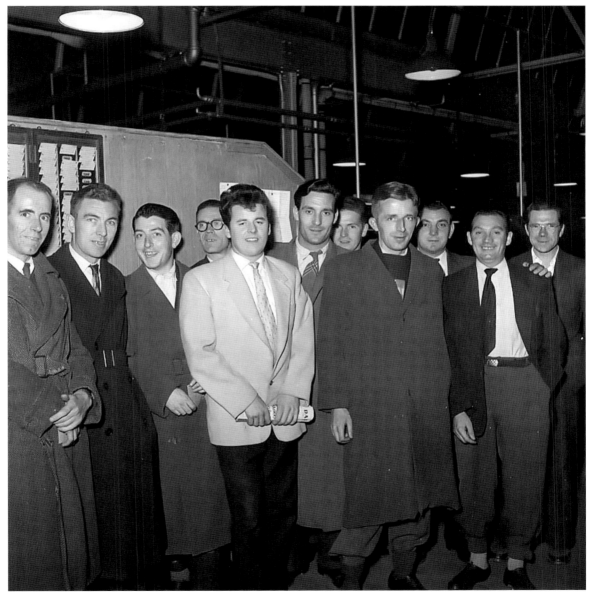

Religion also featured in factory life, with many workplaces holding blessings of their premises and their workers. Prayers and the rosary would be said, but not full mass – it was against Church law to hold mass outside of a church at the time.

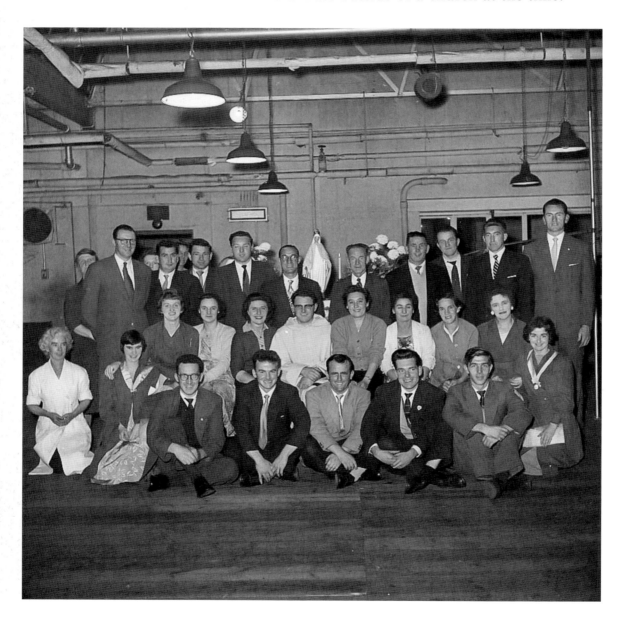

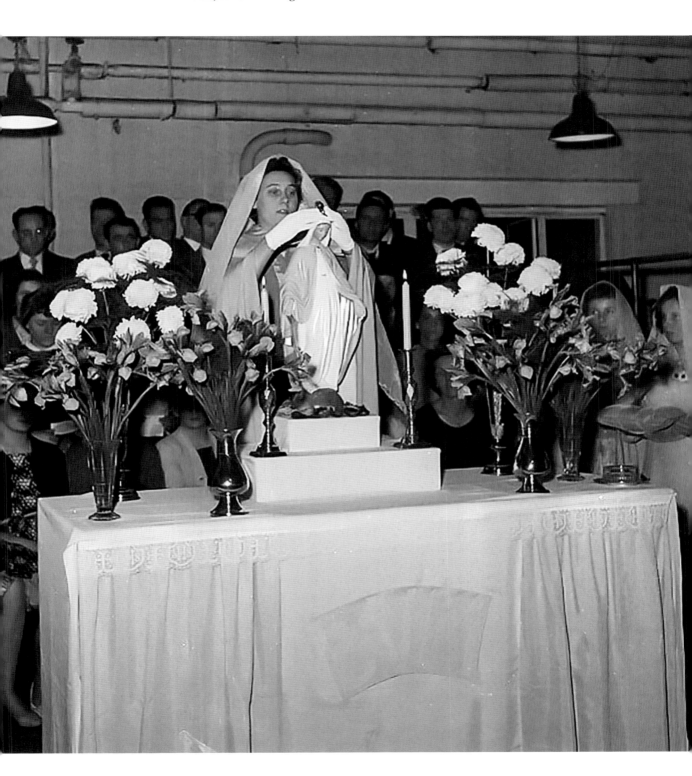

The Children of Mary also participated in the ceremony. Many of these women could also have been factory workers.

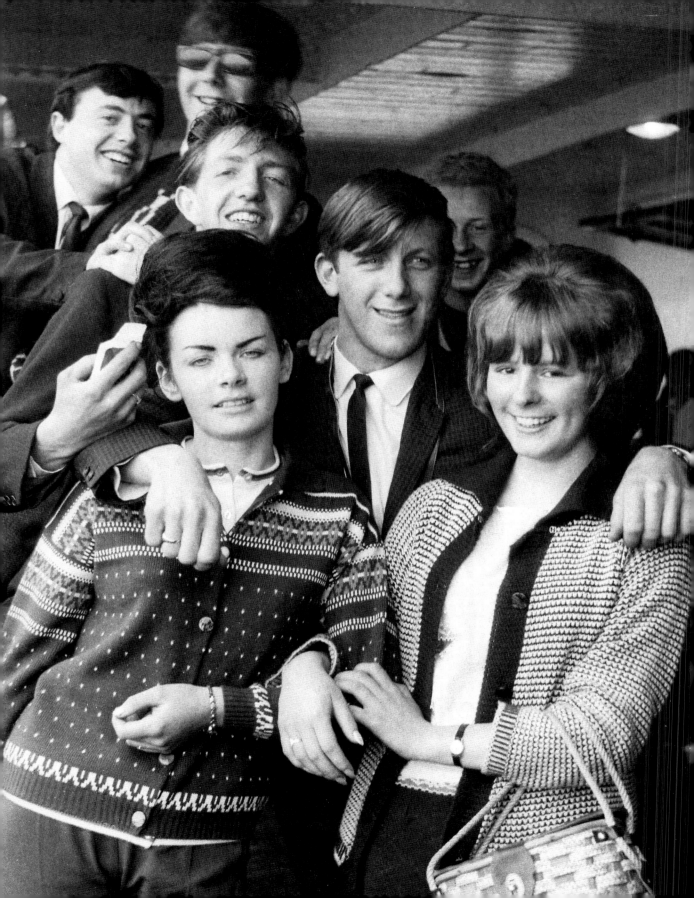

Teenage life

The dance halls, the ice-cream parlour and 'The Hop' were all part of teenage life in the Liberties during the fifties and sixties. Growing up in this era, you were still very much under the watchful eye of your parents and religious influence remained strong – the moral rule of no sex before marriage was a part of life that you didn't question. There was a certain innocence in the teenagers of this era.

Most teenagers took the pledge at their Confirmation and many wore their Pioneer Pins, which were the symbol of their decision to abstain from alcohol and tobacco, the idea being that others would not offer you either of these things when they saw the pin.

At the top of Francis Street, just across from the Tivoli Theatre, there was a dance hall called Johnny Rae's, which was run by an Italian named Luigi Rae. During the week, it was

an ice-cream parlour but changed into a dance hall on weekend evenings. Many a fella found his 'mot' in the dance hall, and thousands of marriages were born out of these nights out.

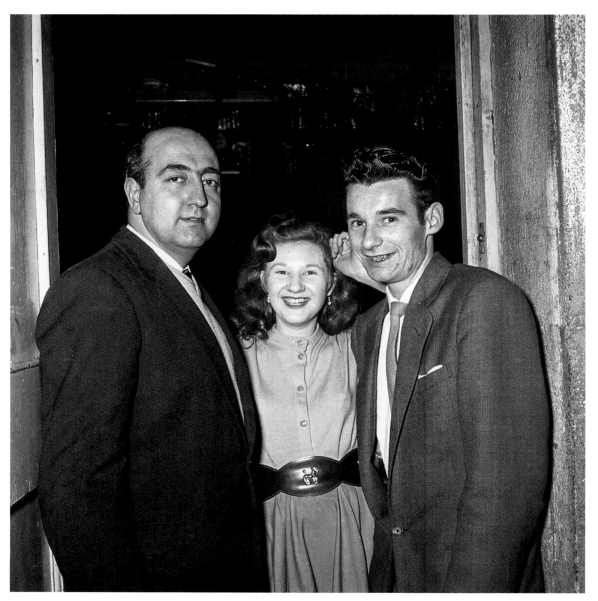

Luigi Rae talking to two of his patrons.

Johnny Rae's in 1958.

In the sixties, dating rituals were a little different than they are today. *Dating*, *courting* and *going steady* were all terms used to describe the 'current situation' with your new fella or mot. Dating was a group affair, and you always had your pal with you if you wanted to meet or get to know a member of the opposite sex. Double dates and blind dates were the norm, and your aim as a girl was to find a polite fella that your ma and da would be happy to see you go out with.

'If you went to Father Brown's Hall and you danced too close, you were told to move apart. Slow dances were called "the lurch". At the dance in the Boxing Club in Ranelagh, a man stood on a crate to ensure no close contact occurred. If you went to the rink on Aungier Street, you skated for an hour in the hope that you didn't fall and rip your nylons, as you'd have only bought them on the way home from work on the Friday and they cost half a crown.' RITA

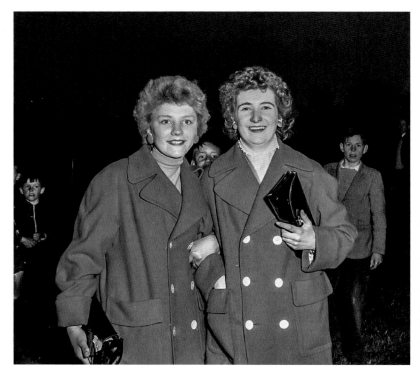

Young women attending a football match in 1960. They may well have had their eye on fellas on the football pitch or in the crowd. There was no Facebook or Snapchat to make connections – you and your best friend would 'go chasing'.

Dance bands

Dance bands and showbands were coming to the forefront of the music scene and they had only one job to do – keep everyone dancing. These bands were very popular because they could play songs that were popular or in the charts as well as the old numbers. They entertained audiences of mixed generations and dancing to the hits was very popular for a night out.

Dance bands entertaining the old and young on a night out. Everyone enjoyed the music and dancing was a must. Rock 'n' roll, jiving and the Hucklebuck were all the rage.

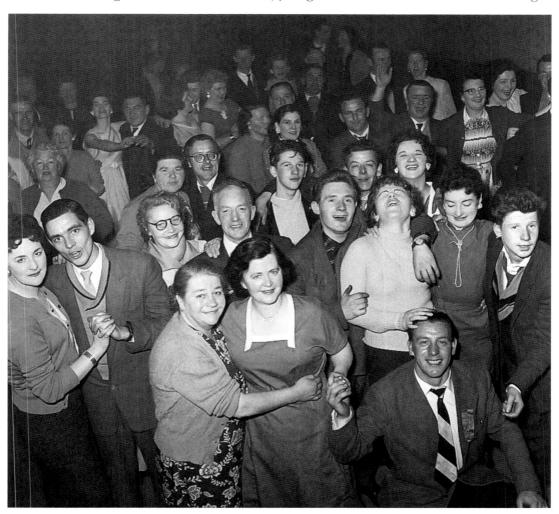

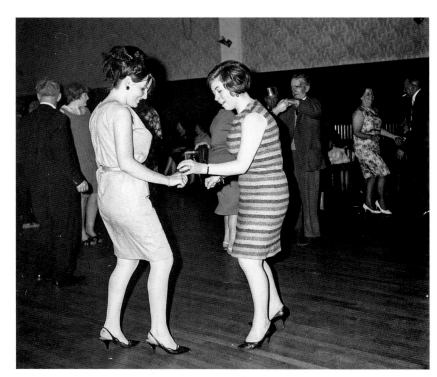

In the sixties, when women became more empowered and pop music emerged on the scene, girls would dance together and no longer had to wait to be asked up to dance by a fella.

Willie and Annie Byrne from St Teresa's Gardens, dancing to the Hucklebuck, a hugely popular hit in the dancehalls by Brendan Bowyer and the Royal showband in 1965.

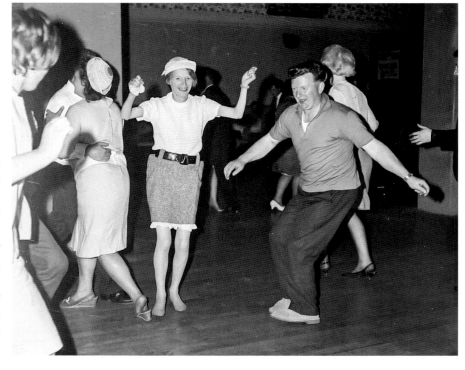

Well-known and established showbands played the larger venues, like the National Ballroom and the Olympia Ballroom, while newer dance bands played at community or parochial halls. Many of these bands were very young as they started to make their way into the world of showbusiness.

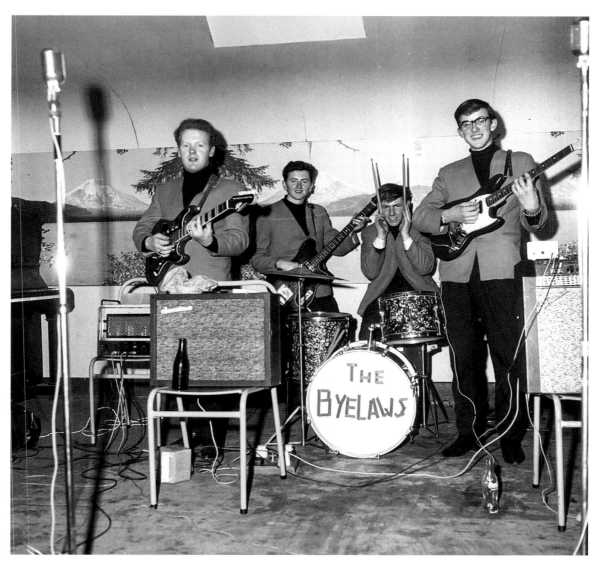

The Byelaws were formed in 1967 and hailed from Ballyfermot. Pictured here are members Jimmy Conway, Paul Holohan, Willie O'Reilly and Terry Young.

Fashion

Growing up in this era, along with the music came the fashion and style of the fifties and early sixties. Girls were a lot more modest in their style of dress. Below-the-knee skirts were in fashion and girls didn't show a lot of skin – the swinging sixties and the mini skirt had not yet arrived. Chiffon scarves and Teddy Boy haircuts, along with Brylcreem and winkle-picker shoes, were all the fashion at the time.

In the Liberties, you may have gone to McDonald's clothes shop or Frawley's on Thomas Street for your fashions. If it was a special occasion, you went to Pim's, a beautiful department store on George's Street, or Harper's on the corner of George's Street and Wicklow Street.

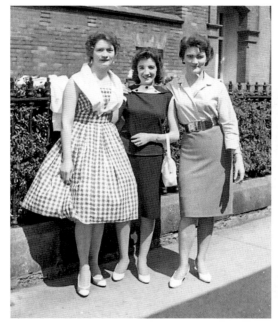

Ladies' fashion was modest but accentuated the figure and femininity. These fabulously stylish ladies in the early sixties are Molly and Rose Kelly, with Rose Doyle in the centre.

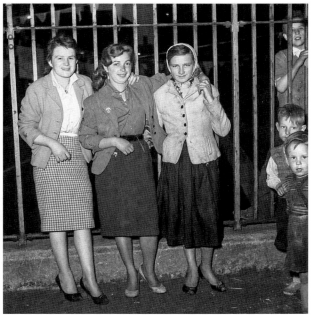

Angela Farrell from Ash Street (centre) with her pals, outside the Oliver Bond flats in 1963.

'We won the money in the bingo at the Tivoli and we bought knee-high leather boots to match our coats. My granny Guy killed me and told me they were "whore boots" and said I would go to hell if I wore them. I used to sneak them out and myself and Teresa would put them on down the road. We thought we were gorgeous.' RITA

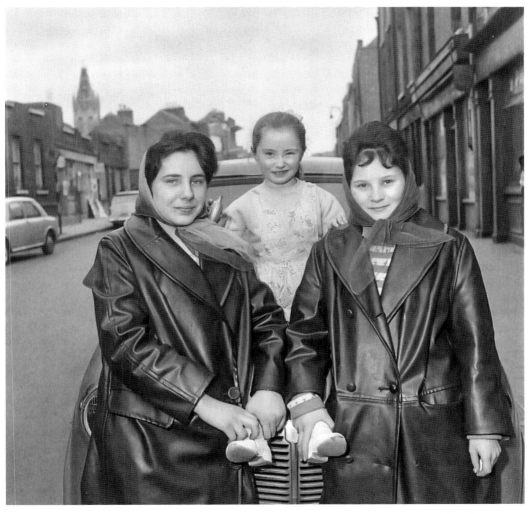

My mam, Rita, and Teresa Johnston wearing their chiffon scarves and leather coats bought from Shirley's on Aungier Street. Sitting on my granddad's Austin car is my aunt Pauline.

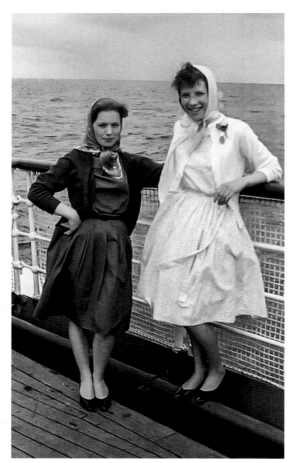

Keeping your hair in one piece was a hard task on the sailing to the Isle of Man, which was often a very rough crossing and the boat could be packed.

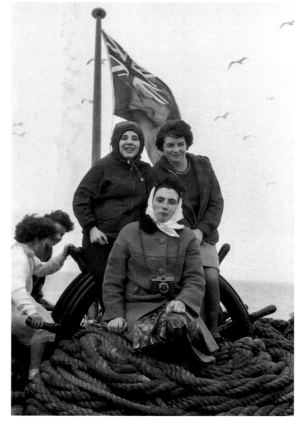

My mam, Rita, my aunt Maureen and Kathleen Dolan from Mark's Alley heading off to the Isle of Man as a sixteenth-birthday treat in 1964. My granddad made sure the girls had cameras to take photos along the way, though he would have been there working as a photographer on an organised trip.

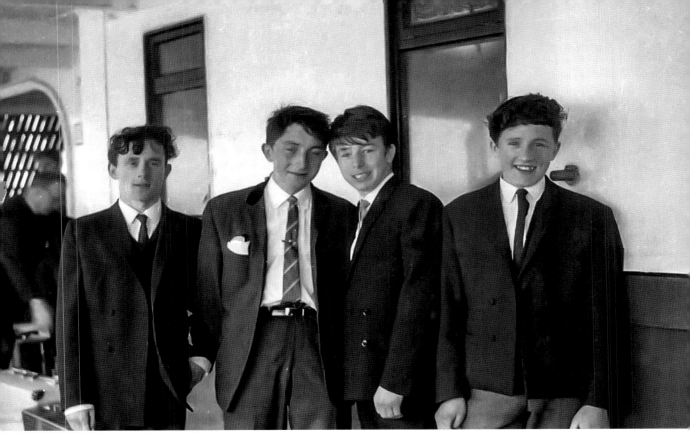

In 1964, back-combed hairstyles and hair that was sprayed within an inch of its life to keep it in one place were all the rage for girls, while the Beatles had a huge influence on how teenage boys styled themselves.

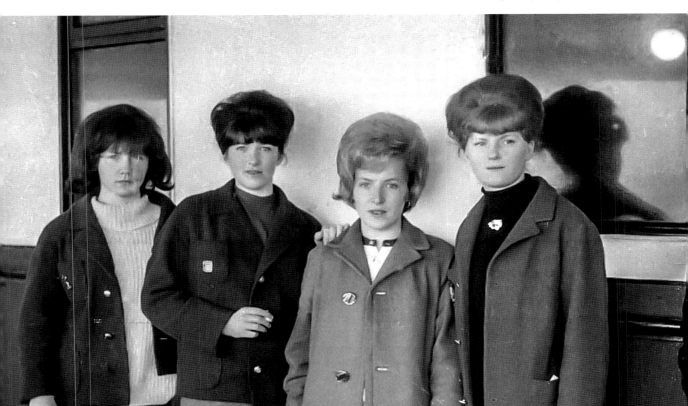

'Your hairstyle was very important. Many girls would wear their rollers to work under their scarves so they would be ready to go out that night.' RITA

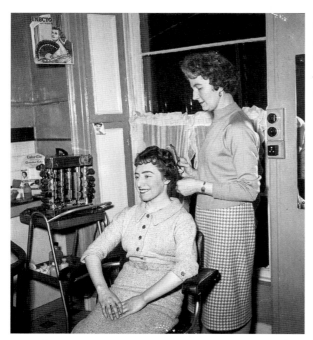

In the sixties, heated rollers became very fashionable and revolutionised hair salons. If you couldn't afford to go the hairdresser, you got yourself a home perm kit and hoped for the best.

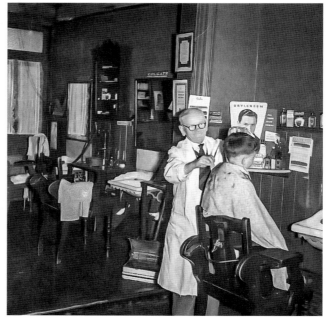

Joe McDonald had his barber shop at 43 Francis Street. Brylcreem and hair oil were the old reliables, and lads were clean cut as beards were not very fashionable. Teddy Boys always had a comb in their back pockets, an essential piece of kit for making the quiff.

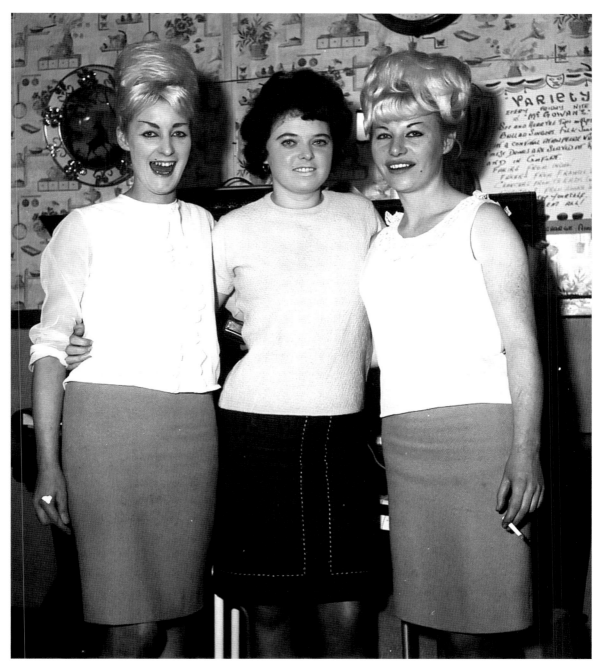

During the sixties, skirts got shorter and shorter and started to be worn above the knee.
Beehives and hairpieces, along with manicured eyebrows, were very fashionable.

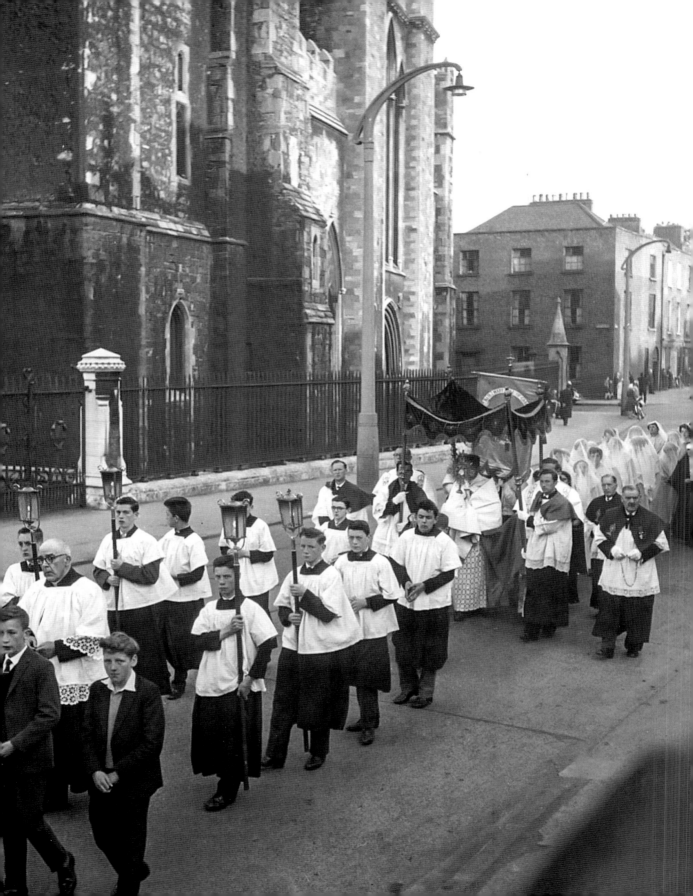

Religious events and parades

Religion and the celebration of feast days played a very important part in the lives of Irish people during the fifties and sixties, including their working lives, their family lives and their social lives.

The majority of people lived by the law of the Catholic Church, and lived in fear of the stigma or shame of not abiding by the words of the priests and bishops. They were taught that if you did not obey God, He would punish you, and this left many with a literal fear of God.

There are seven sacraments within the Church that required specific celebration and ritual – Baptism, Confession, Communion, Confirmation, Holy Orders, Matrimony and Anointing of the Sick – but people also attended church for other reasons, including mass, benediction, sodality, forty hours' adoration and the Stations of the Cross.

When a new baby was born, relatives and friends would

pin holy medals or a cross on the pram to protect the baby. Baptisms usually took place within a week or two of birth, though many new mothers could not take their child to be baptised because they, themselves, needed to attend the church for a ceremony called Churching, which 'cleansed' them after childbirth. They had to perform this ritual before they were allowed to attend a religious ceremony. Very often, it was a nurse from the maternity hospital or the child's grandmother who took the baby to be baptised – and if your granny didn't like the name that had been chosen for you, she could easily change it during the christening to one she did like.

The church of St Nicholas of Myra (Without).

Holy days and feast days were revered. Ash Wednesday, Holy Thursday and Good Friday were all days when people did their duty and obeyed the customs the Church had laid down. I remember my granddad telling me about having his throat blessed on St Blaize's feast day.

The focus of religious life of many in the Liberties was the Church of St Nicholas of Myra (Without) on Francis Street. In penal times, it had been the city's Roman Catholic Pro-Cathedral – and a five-minute walk in either direction brings you to the Protestant cathedrals of St Patrick's and Christ Church.

The building commenced in 1829 and the church opened in 1834, with its dedication to St Nicholas following a year later. The 'without' refers to the parish outside the old city walls – there is also a parish named St Nicholas (Within). St Nicholas was

the patron saint of mariners and sailors and also inspired the character of Santa Claus. He enjoyed giving gifts in secret and was well known for putting coins in people's shoes if they left them out. According to Irish folklore, St Nicholas is buried in County Kilkenny.

The Legion of Mary

The Myra Hall on Francis Street was situated opposite the family shop, and my granddad became a caretaker and key holder of the hall. It was a very significant building and community amenity for the area, and it was here, in September 1921, that the Legion of Mary held its first meeting.

The Legion of Mary was founded by Dubliner Frank Duff to promote the Catholic faith and to lead the campaign to close down the notorious red-light district of 'Monto' in Dublin. Monto was short for Montgomery Street, an area

A Legion of Mary meeting in the Myra Hall in 1963. Founder Frank Duff is in the front centre.

on Dublin's northside that was notorious with prostitution and ill repute in those days.

My granddad remembered Frank telling him about the first meeting, at which fifteen people (thirteen women and two men) were present – but from then on it only grew. Duff's aim was to help laypeople advance the teaching of the Catholic Church. There were strong links between the Legion and the St Vincent de Paul.

A Legion of Mary meeting at the Myra Hall in 1960.

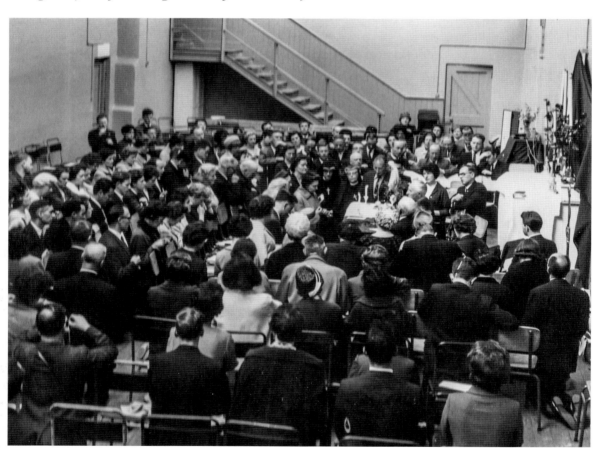

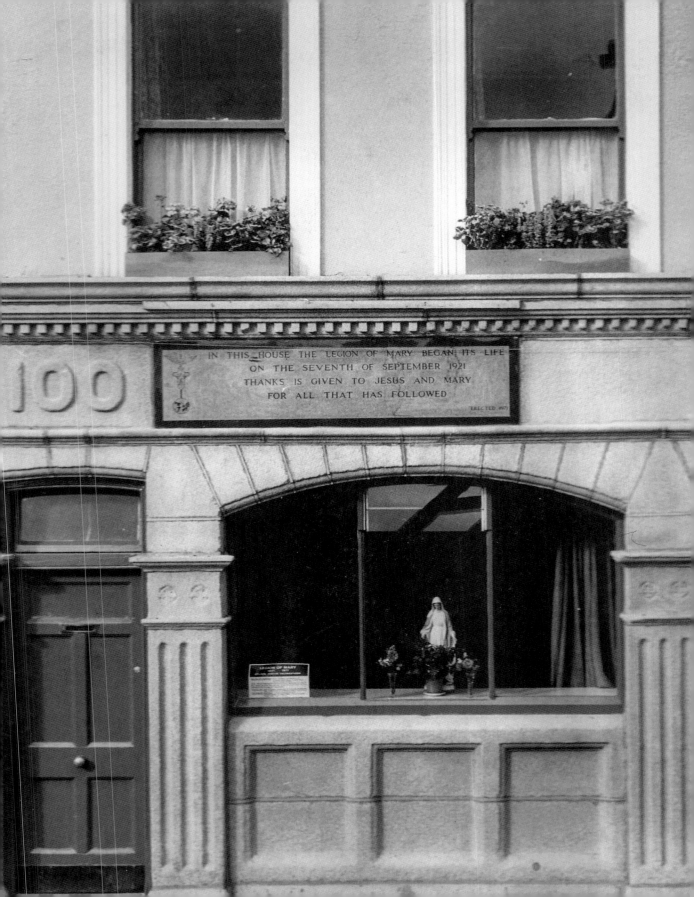

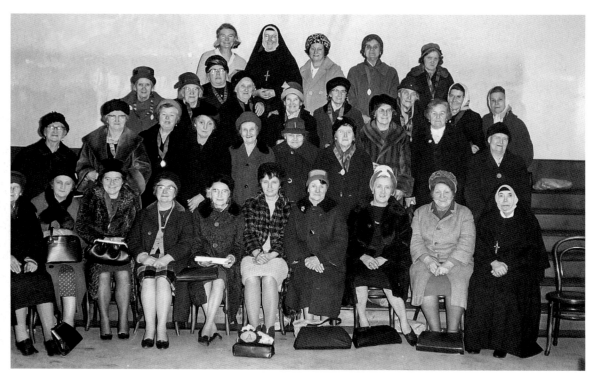

The Catholic Mothers' Club (Mothers' Union) ran out of our Lady's Hospice in Harold's Cross and was attended by many of the older women from the Liberties area. It was a social group run by the Sisters of Charity, where women could get a cup of tea, a chat and prayers.

May Processions

There were many ceremonies that took place on the streets around the Liberties, including the May Procession and the Corpus Christi Procession, and that involved the whole community.

People's social lives often centred around church activities, and they gave people an opportunity to meet and talk to neighbours. My granddad took many photographs of these ceremonial events and they encapsulate just how devout the ordinary working-class people of Dublin were.

Children were taught from a young age about the religious feasts and holy days – it was a normal part of growing up that you took part in these processions with your parents or school.

Children dressed for the May Procession at Oliver Bond House, circa *1960*

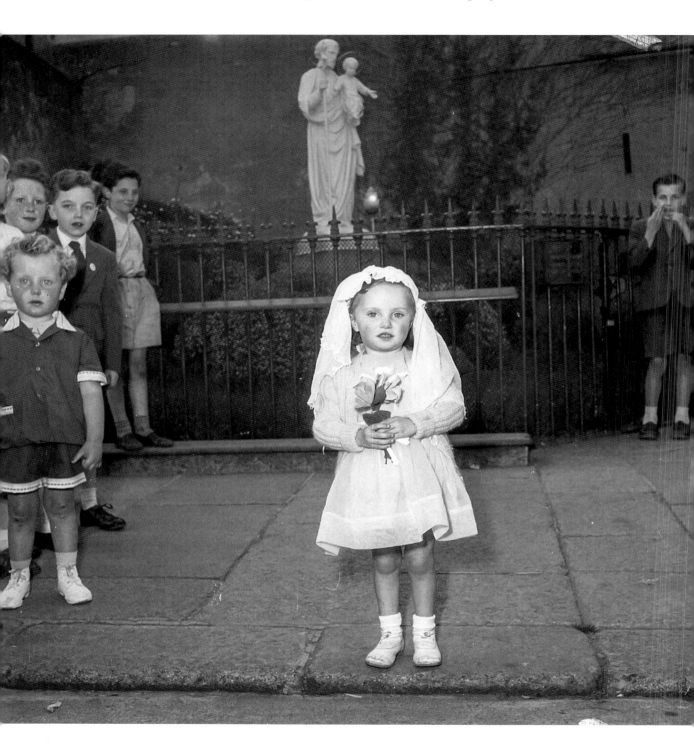

The Children of Mary was founded in 1830, after St Catherine Labouré told of a revelation she had received from the Blessed Virgin Mary, stating it was Our Lady's wish that a confraternity be founded for young women and that many graces and blessings would be bestowed upon them if they carried out her wish.

This organisation for women grew in the fifties and sixties and there was a strong group active in the Liberties. Before being accepted into the Children of Mary, young women went through a period of probation for six months. When you had been accepted as a fully fledged Child of Mary, you had the right to wear the distinctive blue cape of the organisation. When a Child of Mary got married, she was embraced on arrival at the church by other Children of Mary, who removed the blue cape from over her wedding gown.

'I recall the nuns in the Holy Faith encouraging us and telling us to join the Children of Mary when we were leaving school. We didn't want to, we wanted to go dancing.' RITA

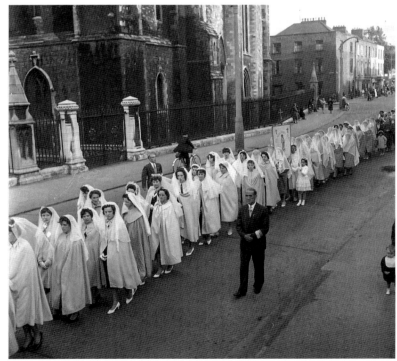

The young women of the Children of Mary Confraternity walking down Patrick Street in May 1958.

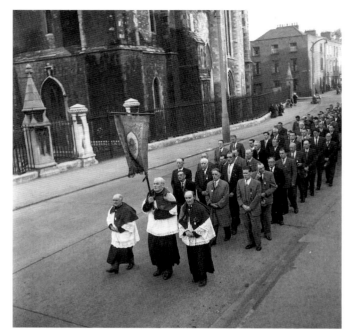

Men's sodality guilds from the local parishes also walked in these processions.

Men's sodality guilds recruited men from all walks of life – working men or the unemployed. Local men canvassed other men to join, and those who had strayed from the Church were encouraged and helped to go to confession and receive Holy Communion again. Football pitches, pubs and workplaces were all canvassed to recruit men to get back into the way of God.

Sodality was a social outlet for men to meet and talk, and its ideals were based on the teachings of the Catholic Church, with confession once a month for all members.

Members of the Women's Sodality Group walking in the May Procession on Patrick Street in 1958. St Patrick's Cathedral is in the background. Members of this confraternity group were identified by the holy medals worn around their necks. My granny Suey and her mother were members of the Francis Street Women's Sodality Group, along with many of their neighbours. The women would go to benediction once a month in the church.

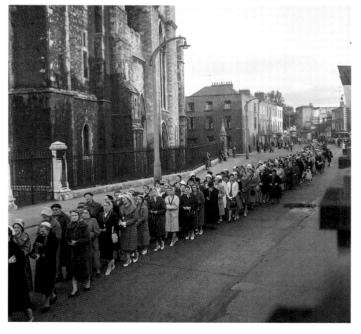

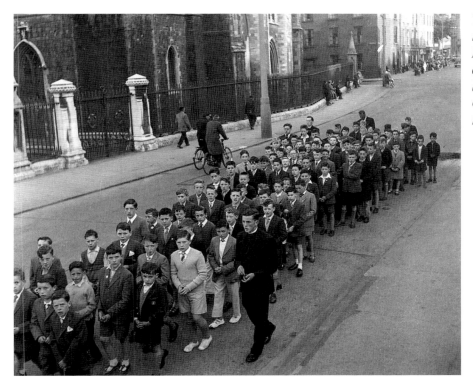

Young boys from the Christian Brothers School on Francis Street being led by their Christian Brother teacher.

Corpus Christi Procession

During the feast of Corpus Christi, the Blessed Sacrament was brought through the streets to remind everyone that Christ had once been a man and had walked among us. There was a lot of ceremony attached to this celebration.

The ritual of the Corpus Christi Procession began in the church and brought a great sense of community to the streets in the Liberties. It was a reminder to the parishioners of the relevance of the divinity of Jesus Christ, and they honoured their belief that He was a man and the Son of God. This procession brought the body of Christ to the people, some of whom would not have been able to attend mass; the elderly or the sick were brought out onto the street by neighbours to be blessed during the parade.

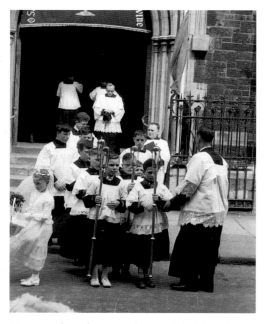

Young altar boys wait outside Meath Street Church for the priest and the congregation to emerge to start the procession.

The priest would bless everyone in the church before taking the monstrance, a large, ornate holder, and walking out of the church to start the procession through the streets to share the body of Christ in the community.

Small altars would be set up at designated locations along the route and the parade would walk to each station where prayers would be said.

The priest would cover his hands with the humeral veil as he was deemed not worthy of holding the Blessed Sacrament. Incense was placed in the thurible and was used to honour Jesus. The congregation would often sing the hymn 'O Salutaris Hostia', a Eucharistic hymn written by St Thomas Aquinas in the thirteenth century.

The priest would then place the Eucharist into the monstrance, which was then placed on the temporary altar. Hymns were sung and a decade of the rosary was said.

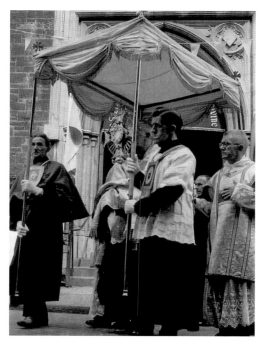

The priest, his hands covered, carries an ornate monstrance containing the Blessed Sacrament from Meath Street Church ready to begin the procession along the streets.

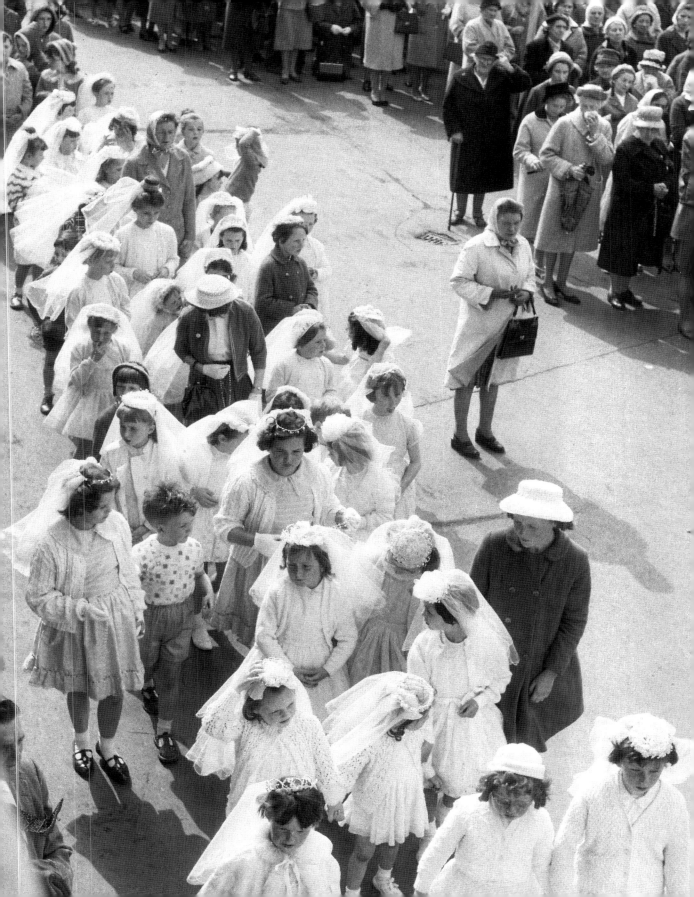

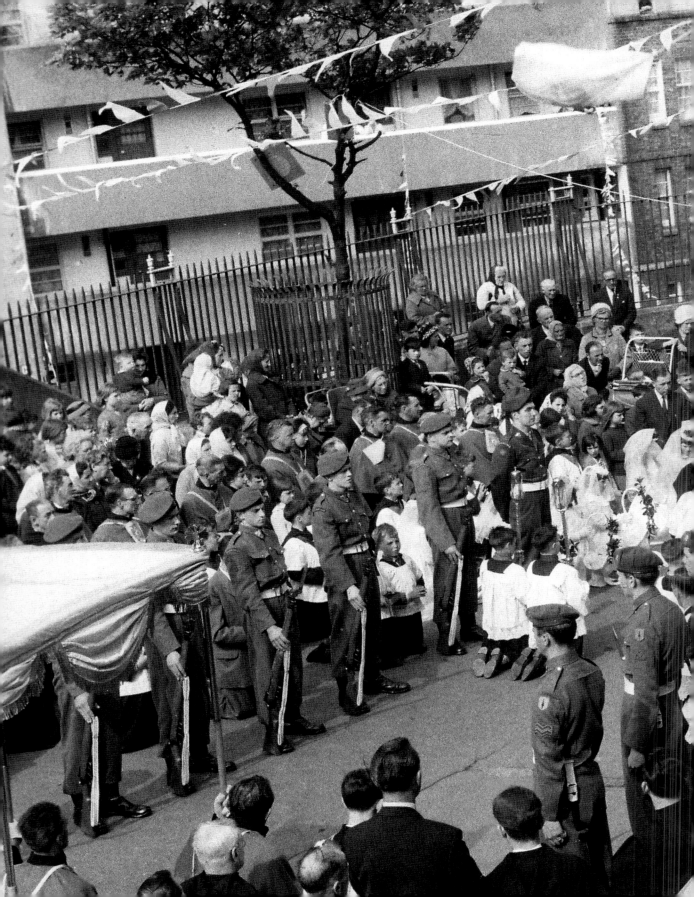

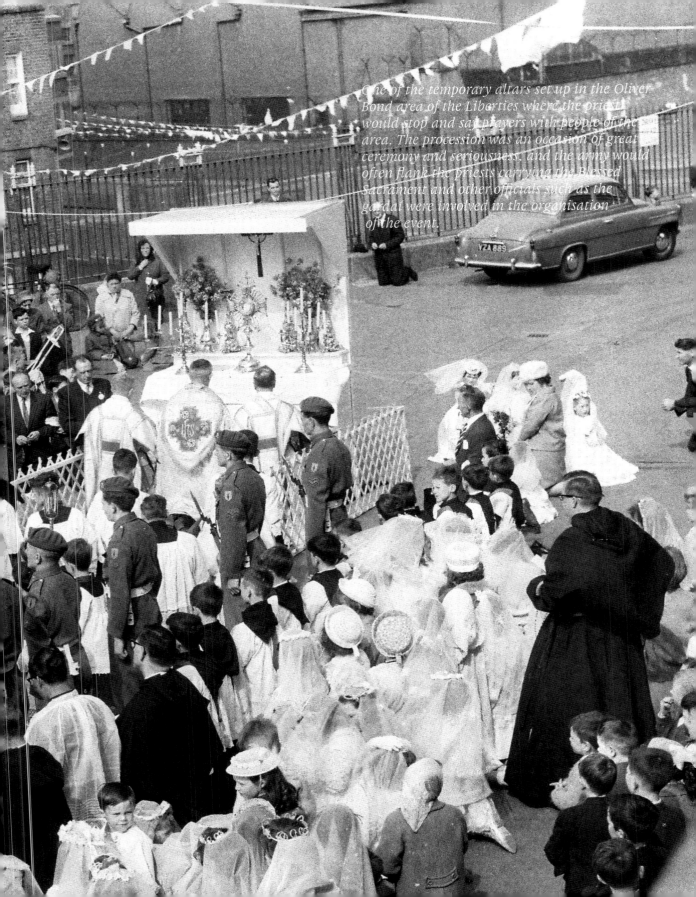

One of the temporary altars set up in the Oliver Bond area of the Liberties where the priest would stop and say prayers with people of the area. The procession was an occasion of great ceremony and seriousness, and the army would often flank the priests carrying the Blessed Sacrament and other officials such as the gardaí were involved in the organisation of the event.

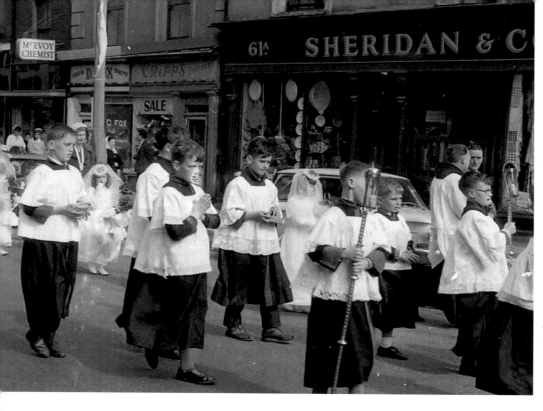

Corpus Christi Procession passing through Thomas Street, which has been decorated with bunting and flags for the occasion.

People kneel on the paths awaiting the Blessed Sacrament to pass by Harrington's on Thomas Street, now known as the 'Clock Pub'. The Thomas Street fire station is on the left – it is now the National College of Art and Design. Next to the fire station was John Power's Distillery Company.

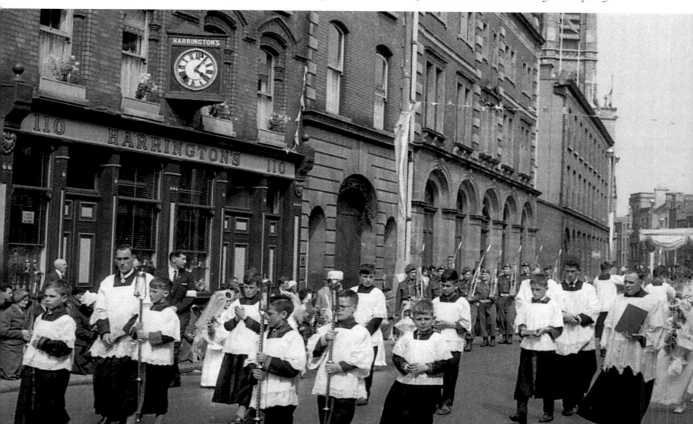

When the parade had passed through the streets, the Blessed Sacrament would return to the church and the hymn 'Tantum Ergo' was sung from the altar as the priest once again blessed the congregation with incense. After that, the crowd would slowly drift from the church, to the background noise of 'Adoremus' – 'Let us adore' – being sung by the priest or choir.

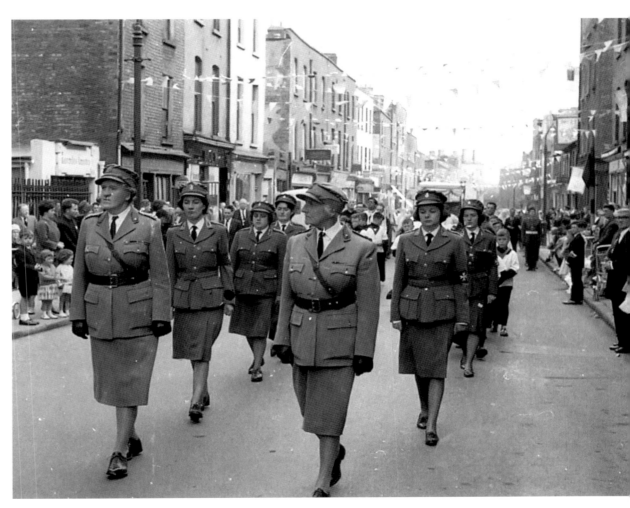

The Knights of Malta walking down Meath Street in the Corpus Christi Procession. The official name of this Catholic organisation was The Sovereign and Military Order of St John of Jerusalem, of Rhodes and of Malta. The distinctive insignia of the order was worn on the sleeve of the uniform. They were eagerly sought after to walk in church processions.

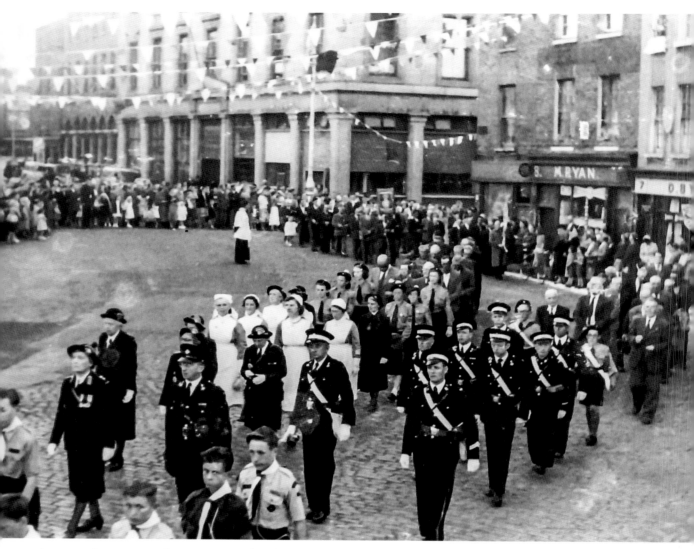

A procession moves along Cornmarket leading to High Street in 1956. Many organisations took part in the processions, like the St John's Ambulance and the Civil Defence.

During these feast days, Liberties people and shopkeepers decorated their homes and shopfronts with pictures, relics and holy statues. Shopfronts were cleaned and windows were spotless. Steps to premises were polished and scrubbed in the days leading up to the celebration.

My granny Suey's altar outside 50 Francis Street to honour the feast day of Corpus Christi. It was made from red crêpe paper and the pictures were taken from the walls in the house to add to the display.

Mrs Kelly (left) and Mrs Byrne (right) from Oliver Bond House stand beside the picture and lamp in honour of the Sacred Heart. Pictures such as this adorned many balconies at religious times of the year.

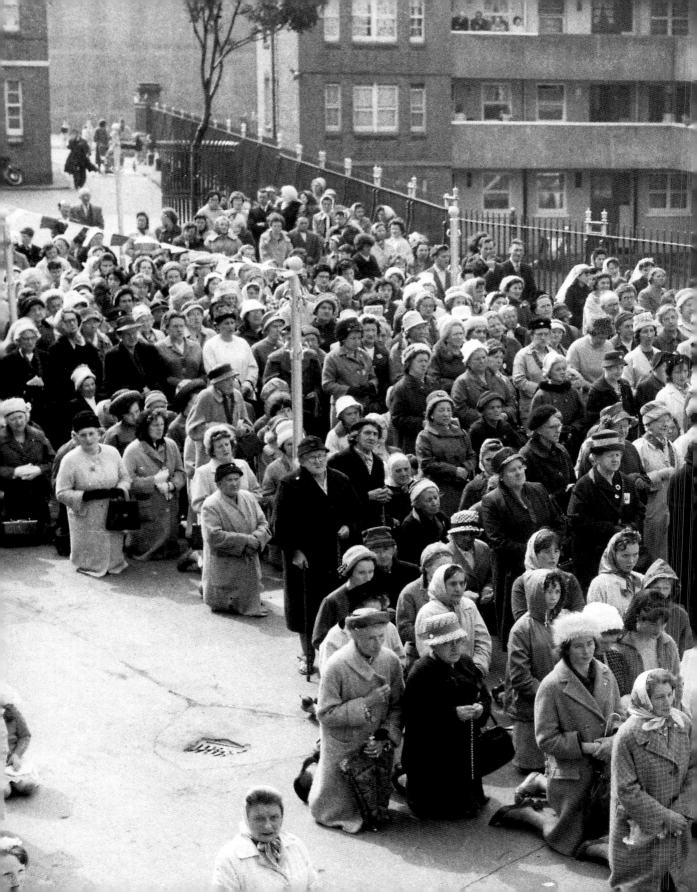

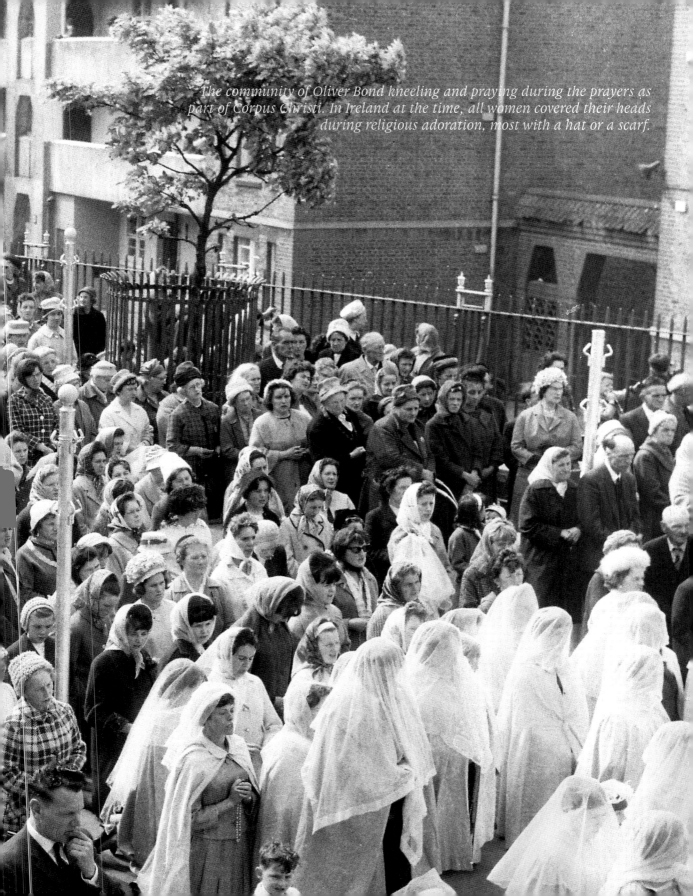

The community of Oliver Bond kneeling and praying during the prayers as part of Corpus Christi. In Ireland at the time, all women covered their heads during religious adoration, most with a hat or a scarf.

Along with the decorating and adorning of the roads and shops, young children dressed for these religious occasions. Girls wore white dresses – if you were old enough to have made your Communion, you wore your Communion dress – and carried baskets of flowers for the May Procession, while young boys wore surplices and short white trousers.

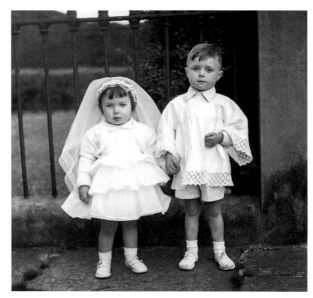

Very young children in the grounds of St Nicholas of Myra church dressed for the May Procession in 1958. The boy is wearing his surplice, a white tunic made of cotton or linen fabric. The young girl is dressed all in white for purity and innocence.

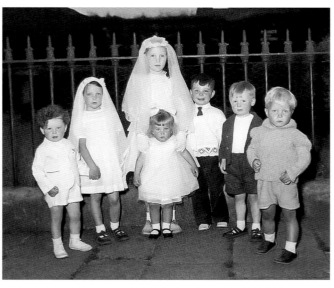

Religious life

Another religious sway on family life in this era was having a priest or nun in the family. It was the height of respectability and a mark of decency that you had raised the 'perfect' child who had chosen to devote their life to God. Some devout parents would pray that one of their children would enter the priesthood or the convent.

The reality, however, did not always match this. Some men became priests because their friends were entering the seminary and they just went along to see what it was like, while others did it to keep their parents happy – though there is no doubt that some entered because of their own genuine devotion to God.

It was common for young women in Ireland to become nuns at this time and it was seen as a vocation or calling. To become a nun, women went through a process of 'discernment', which meant spending time with an order or with other nuns and praying. This usually lasted one to two years, depending on the order. After applying to her chosen order, the woman would undergo an aspirancy, whereby she spent time with the order and the other nuns would determine if she was a good candidate and would 'fit' in their convent. If the nuns of her order determined she was a good fit, she would be accepted into a postulancy. After several months of proving her devotion and ability to fit in, the young woman entered the convent as a novitiate. It was during this time that she was assigned a new name and became a novice nun. After some time, she would take her vows and then, after a few years, take her final vows to finish the procedure, making her a member of the 'consecrated religious', unlike a priest who was ordained

Clonliffe College was the setting for the ordination for most priests in the Dublin Diocese. The tradition was for ordinations to take place on a Saturday, when the priest would give his First Blessing, normally to his mother, followed by his father, and siblings. The following day, the Sunday, the newly ordained priest would say his first mass and then enjoy an ordination meal with family and friends.

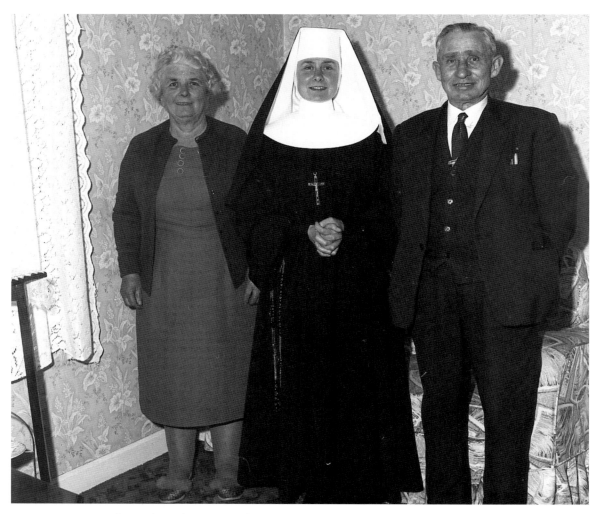

A young woman from the Liberties and her proud parents after she has taken her vows of 'poverty, chastity and obedience' and joined the religious order as a nun in 1963.

Bestowing his first blessing after his ordination on his mother. This would have been a very special and momentous occasion for family and the newly ordained priest.

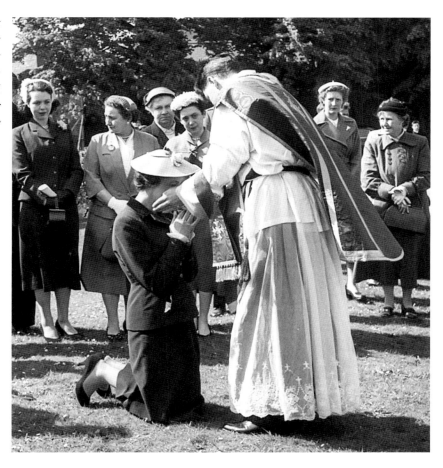

His father, siblings and other family members are next in line to receive a blessing.

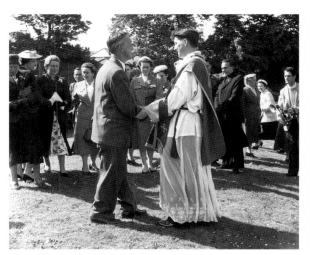 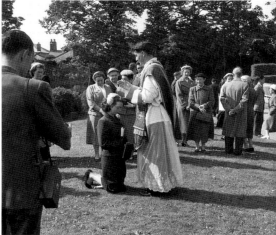

Being an altar boy

l remember my time as an altar boy in the late fifties. Training began at seven or eight years of age, and took place on a Saturday. The first thing to do was to learn a new language – Latin – to be able make the responses at mass, starting with 'Ad Deum qui laetificat juventutem meam' and a lot more. The final linguistic challenge was Psalm 29, 'De Profundis', which was said at the end of mass. It was all very daunting when you were a kid.

Next, we were ready to learn the rubrics of serving mass, such as how to take the priest's biretta from him, when to change the missal from the Epistle (right-hand) side of the altar to the Gospel (left-hand) side. The altar boy needs to know the difference between a simple bow and a profound bow by the priest while also knowing when to ring the bell – at the Sanctus, then at the Oblation. It was often hard to see when his hands were on the chalice as that was your cue and was followed by the two sets of ringing for the Consecrations.

Another facet of religion for many young boys was to become an altar boy.

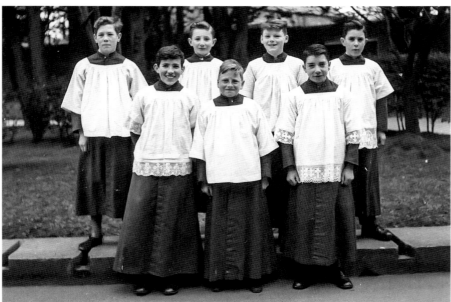

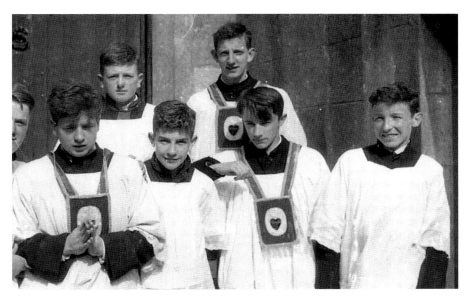

But there was also serving Benediction – being an acolyte, who carries the candles, the thurifer, who carries the thurible, which has the red-hot charcoals, and the boat carrier, who carries the boat which contains the grains of incense. You must also be able to put the humeral veil on the priest before he gives the Benediction – all with the added pressure of also looking angelic.

The altar boy also attended other occasions, such as baptisms, marriages, funerals, miraculous medal devotions, sodalities and renewing the candles.

And then we cannot forget the altar boys' annual excursion, a day's outing provided by the parish to say thank you to the lads – there were no girls allowed then – who had served the church over the previous year, being available to serve mass from 7 a.m. every day and evening devotions.

Finally, when we eventually became senior altar boys, the circle was completed, and we had to begin to teach 'Ad Deum qui laetificat juventutem meam' to any new recruits.' DONAL

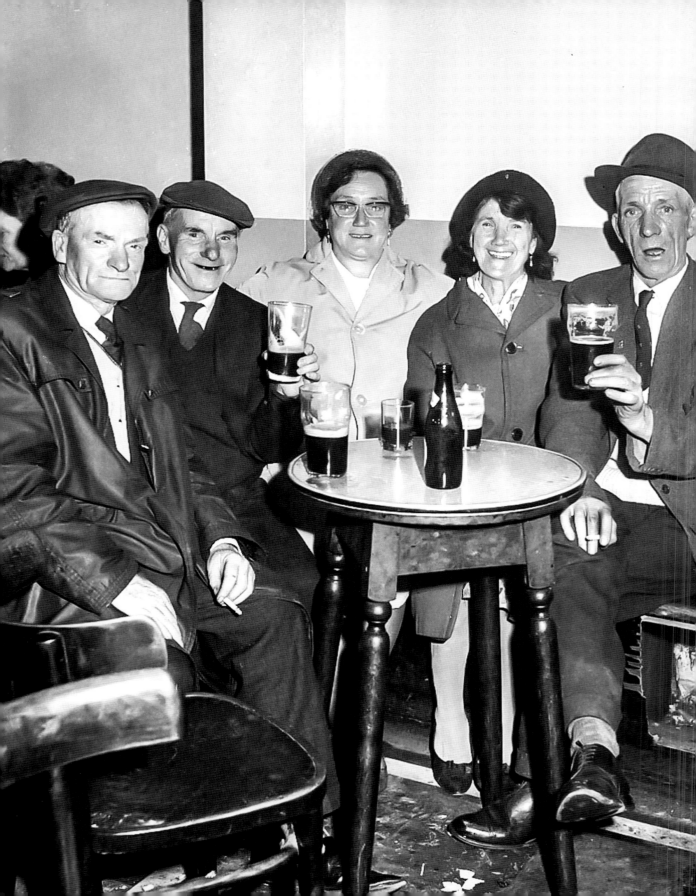

Pubs and their patrons

Dublin pub can be a very special place. Many were more than just a place to get a drink and enjoy the company of your neighbours: they were a place where wheeling and dealing took place, and where friendships and romances were made and lost.

In Francis Street, there were several pubs to choose from – The Barley Mow run by Mr McGowan and his family, Clarke's run by Micheál Clarke, along with O'Connor's, Doyle's and Lambert's, which faced the Tivoli Theatre. It was normal for Dublin's streets to have several pubs on them and they were usually small and family run, with the family living above the premises, which was the case for the pubs on Francis Street. Many pubs had a snug, an area where the women could sit and have a quiet drink away from the talk of racing and the darts.

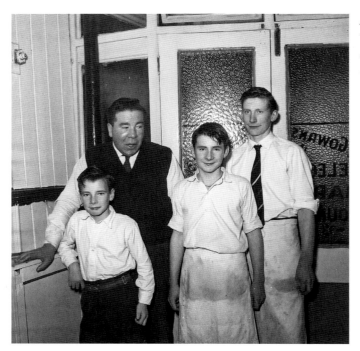

Mr McGowan from The Barley Mow with two of his young sons, Danny and Tony, who worked in the family business.

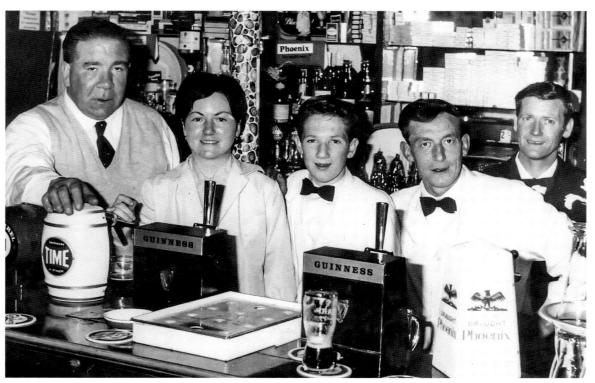

Competitions and singalongs

During the fifties and sixties, competitions became regular occurrences in the pubs around the Liberties. Men had singing leagues and darts competitions, and pubs competed against each other with leagues running all year.

Singing competitions in pubs were a form of entertainment for the men. Men got up one at a time to sing their song for the final of the contest.

Sing-songs also happened naturally when people's vocal chords had been well-lubricated and old songs and laments could be

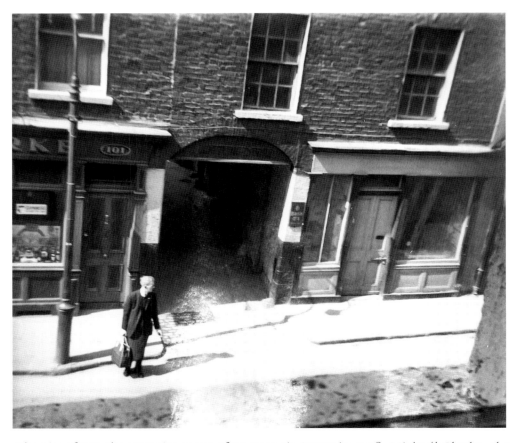

The view from the upstairs room of 50 Francis Street in 1958. Micheál Clarke, the pub landlord, is walking across to the Myra Dairy to visit my granny Suey and get his groceries. Michael and Suey were great pals.

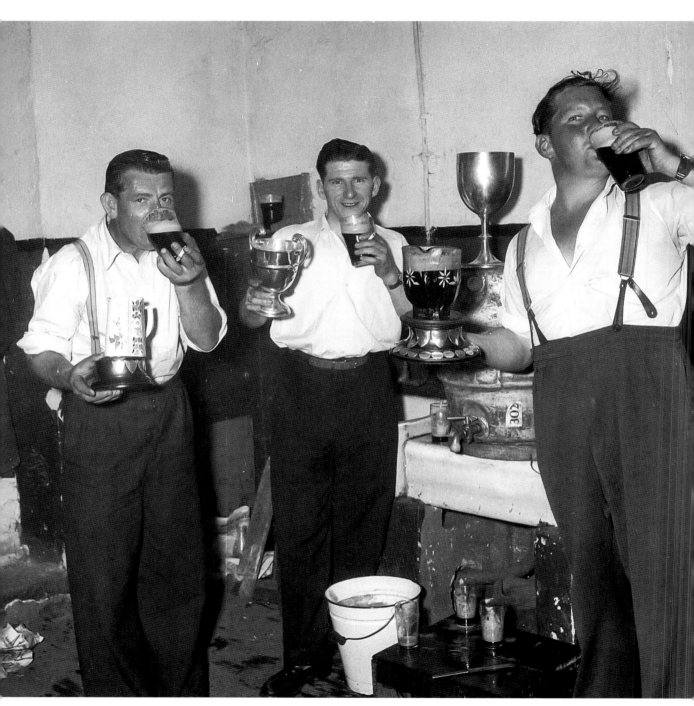

A Mr Courtney and his two friends with their trophies.

heard when you walked by the doors. There were no phones or televisions in pubs to distract people, and everyone loved a singalong and a sentimental tune or ballad would set the mood of the evening.

Guinness or Phoenix ale were the popular drinks of the time, and my great-granny Walsh had a fancy for a large bottle of stout.

An awards evening in McGowan's pub (The Barley Mow) circa 1960: Joe Wade, holding the trophy, Tommy Flynn and Mick Glynn, Barney Clancy and John Garrigan. At this time, it was customary for men to always wear a suit to the pub.

171

The patrons of Clarke's pub, including Thomas Riley and Gem Murphy, celebrating winning a darts tournament in 1958.

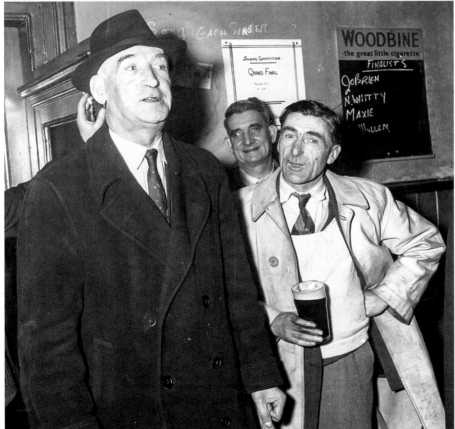

The men from Doyle's Pub take part in the grand final of a singing competition in 1960, with the winner chosen by applause.

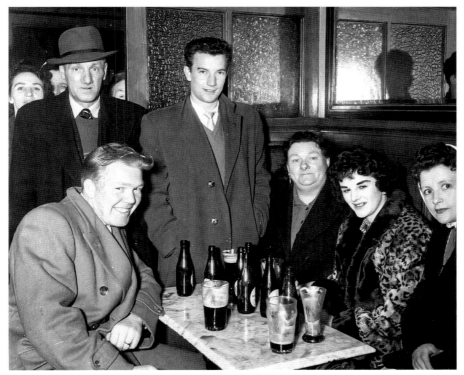

Jitters McGee with his trilby hat having a drink in Clarke's. He was another well-known Liberties man.

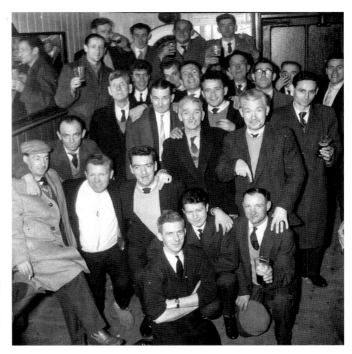

Micheál Clarke and his faithful patrons, including the Long brothers, Francie Mooney and Thomas Riley, in the back bar of Clarke's.

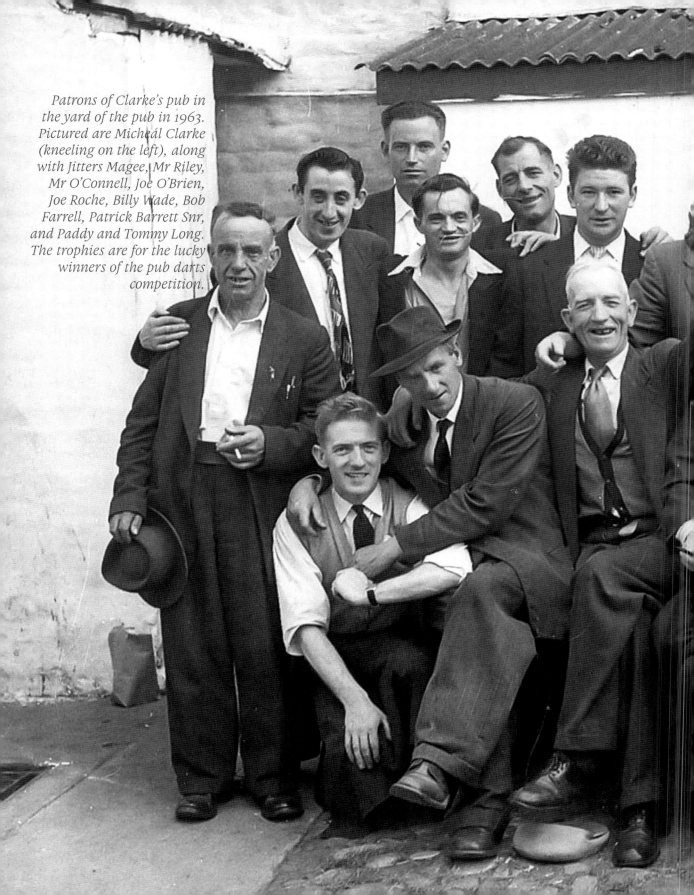

Patrons of Clarke's pub in the yard of the pub in 1963. Pictured are Micheál Clarke (kneeling on the left), along with Jitters Magee, Mr Riley, Mr O'Connell, Joe O'Brien, Joe Roche, Billy Wade, Bob Farrell, Patrick Barrett Snr, and Paddy and Tommy Long. The trophies are for the lucky winners of the pub darts competition.

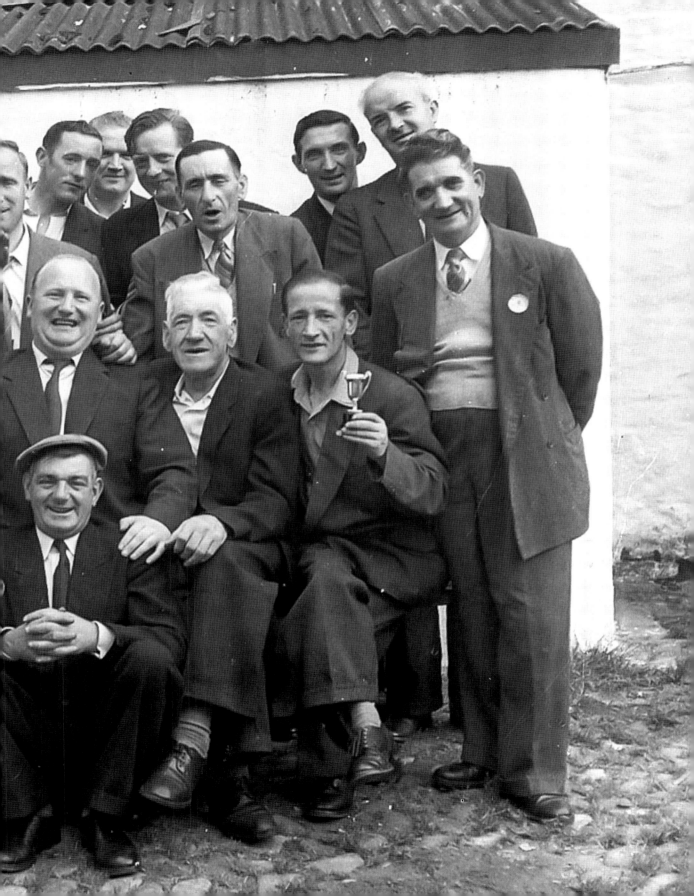

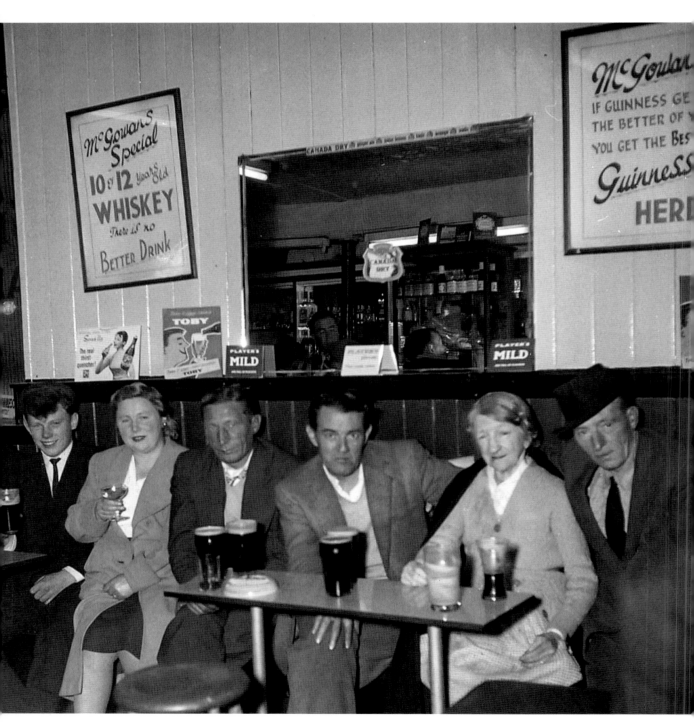

Members of the Connell Family from Mark's Alley and Francis Street enjoying a drink in McGowan's. Johnny Browne is sporting his trilby hat.

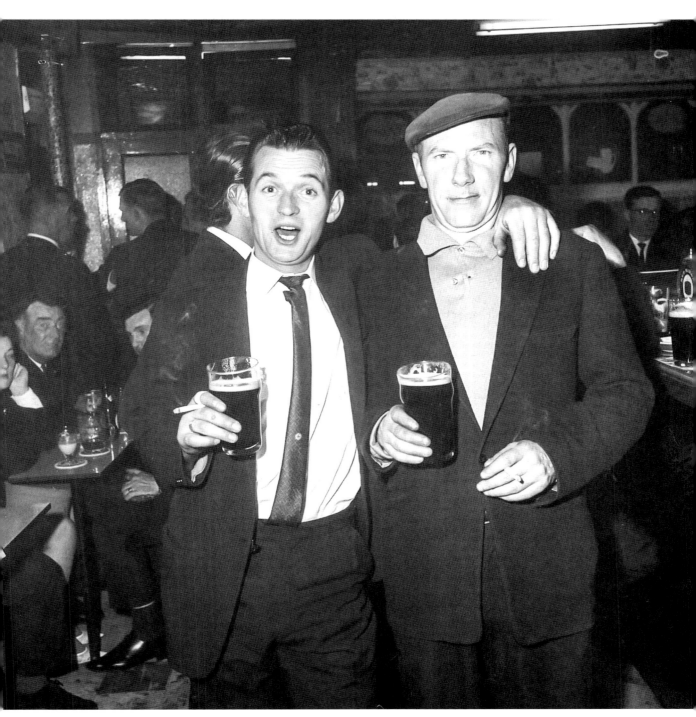

Christy Dillon and Christy Coughlin enjoying their pints of porter in McGowan's circa *1960.*

A famous visitor to Clarke's pub

Francis Street was well known for its connection to boxing. There was a boxing club on the street and boxing promoters lived in the area. Billy Conn was an Irish American boxer and World Light Heavyweight Champion. In the ring, he was known as the 'Pittsburgh Kid'. In 1972, he joined locals in Clarke's for a few pints of porter and, despite his size and stature, left a little worse for wear.

Having become the World Light Heavyweight Champion he tried to become the first person to win the World Heavyweight title without increasing his weight. In the title fight in June 1941 against Joe Louis, Conn lost to a knockout having been in the lead on points. After the fight, he told reporters, 'I lost my head and a million bucks.'

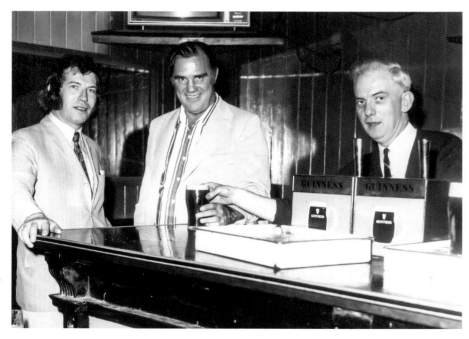

Billy Conn (centre) being served a pint of the black stuff by owner Micheál Clarke (right).

Local entertainer and singer Silver Ryder plays the piano for the crooner on the mic in McGowan's, circa *1960.*

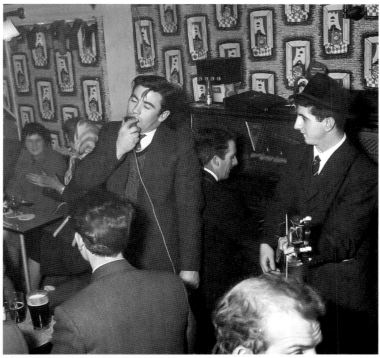

Looking dapper with their dicky-bows, entertaining patrons of The Barley Mow in 1961, are Tommy Scott on the mic and Jimmy Kinsella on the right.

Singing in McGowan's on a Friday night in 1960.

Leo O'Brien and band setting up for a night's entertainment in the Drake Inn in 1963.

Flood's was another popular pub that my granddad would often take photos in. He had spent some time living on Slane Road in Crumlin, and would often drink there with his mother and brother, Gerard. Flood's was situated on the corner of Sundrive Road and is now known as the Four Roads.

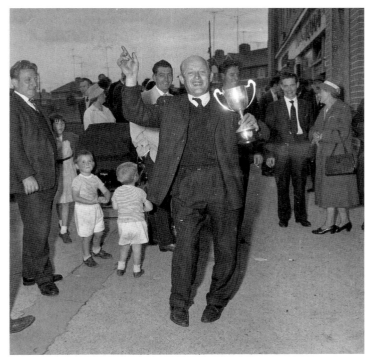

Charlie Fitzsimons holding the football cup outside Flood's in 1961.

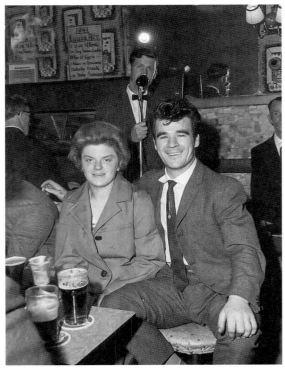

Nellie Brannigan and Mattie Murray from the Oliver Bond flats, enjoying a drink in The Barley Mow in 1961. Jimmy Kinsella is on the mic, entertaining the patrons.

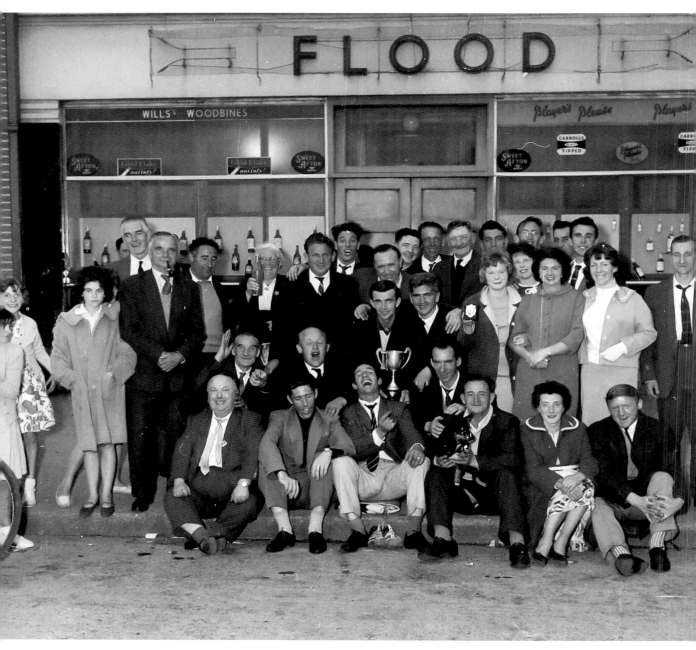

Patrons of Flood's, including my granddad's brother Gerard, who is holding the cup, and my granny, who is sat on the front right. Great-granny Guy, John Keating and Gerard's wife, Kathleen, are also in the photograph.

Fr Michael Cleary

Fr Michael Cleary is featured in many of my granddad's photos in the late fifties and early sixties. Apart from his role as a priest in the Dublin Diocese, he was also a very keen footballer and played many matches around the Crumlin, Inchicore and Liberties areas.

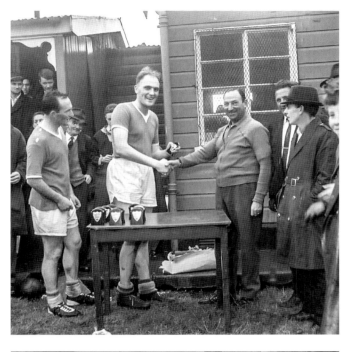

He played charity matches as part of a team in the Saints and Sinners annual tournament. Fr Cleary became a well-known personality and went on to host his own television show and produce two albums of songs, which is how he became known as the 'singing priest'. Fr Cleary often had a pint in Flood's in Crumlin after a match and my granddad took several photos of the teams and tournaments.

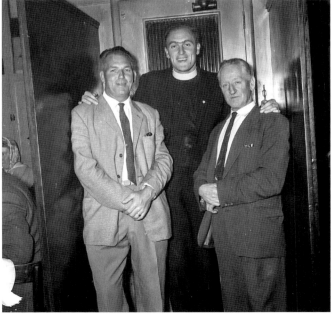

Flood's was a popular spot with well-known priest, Fr Michael Cleary, who worked nearby in St Bernadette's Church and also played football locally.

Fr Cleary collecting a trophy in St. Pat's football ground in Inchicore.

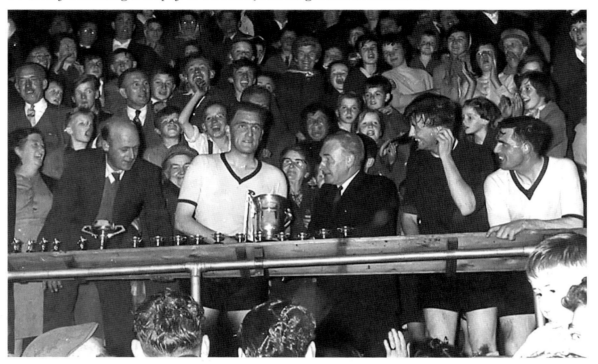

The Transport Club Football Pitches in Crumlin in the early sixties. Fr Cleary is front centre and at the back left is the grandfather of Irish football hero Robbie Keane.

Pub trips

There was a tradition in Dublin pubs in the fifties and sixties to head off on an annual bus trip. My granddad would often go on these trips to take photos of the day's events. Accordions and other musical instruments would be brought along to entertain each other on the journey and, of course, have a sing-song.

A short walk from Francis Street is the area of Pimlico, where the smell of the hops from Guinness's permeated the air.

Patrons of the Pimlico Tavern getting ready to head off on an excursion to Drogheda. Patrons include Michael Mulhall of Gray Street, Chrissie and John Hendrick, Bernard McCluskey (kneeling front), Robert Conway, Eddie and Lily Cramer of Vicar Street, and Willie and Bridie Fitzroy.

Ladies from the Pimlico Tavern, ready for their day out to Drogheda, including Patty Hayes, Carmel Whyte, Lizzy Bell and Chrissie Walsh.

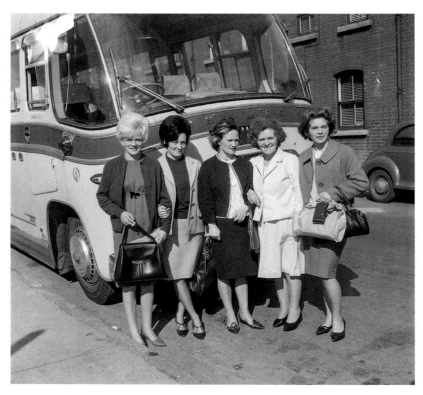

Patrons from The Barley Mow heading off on their annual excursion in 1959.

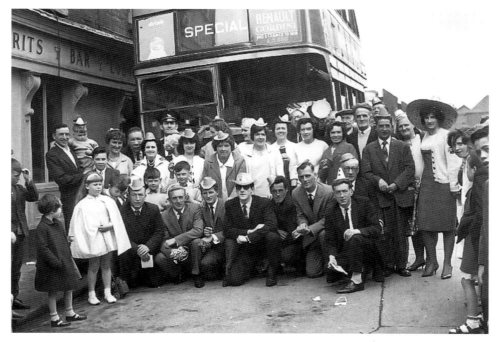

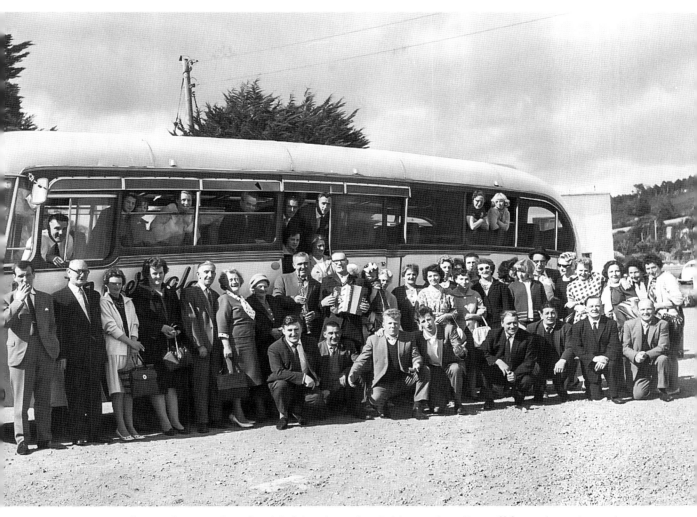

Patrons from O'Connor's pub with friends and neighbours heading off for a day trip to the races at Fairyhouse in 1958.

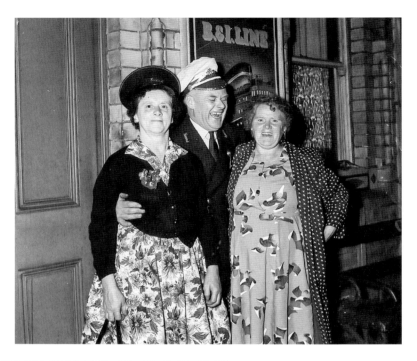

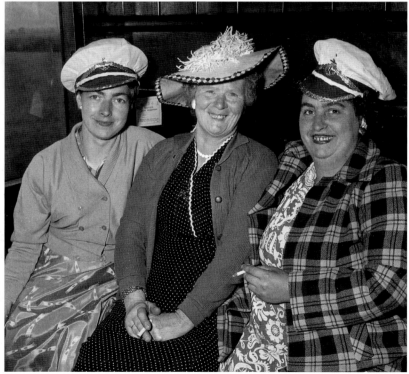

Heading off on the boat or the train for the day was a popular choice for an excursion in the fifties and sixties. Great planning and saving for these trips would take place beforehand, with people saving by the week and paying off what they could as they had it. For many hardworking men and women, this was a day away from the hardship of day-to-day life.

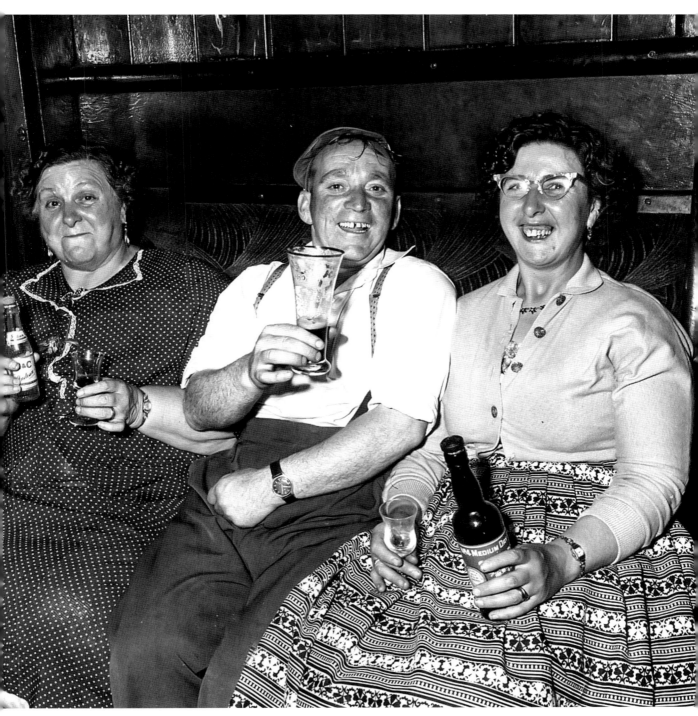

Enjoying a much needed drink on the train on a day out in 1958.

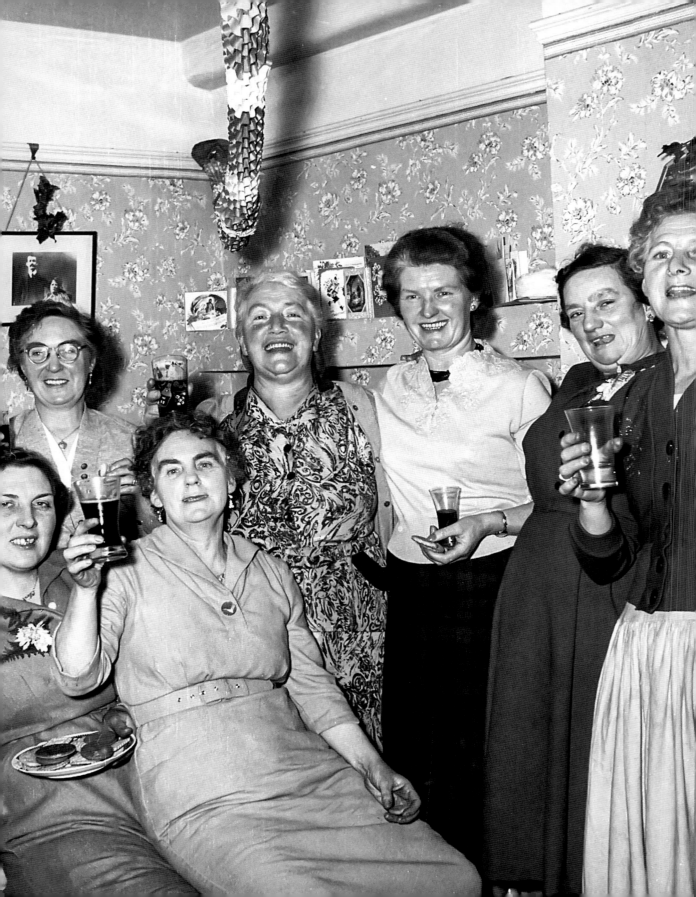

The hooley in the parlour

A decent hooley was an integral part of family tradition in Ireland. For Dublin families, the parlour or front room was known as the 'good' room, and for families that had moved from tenement buildings, having this extra space was a luxury.

It was perfectly acceptable for your granny, aunts, uncles, neighbours and friends to pile into the parlour for an evening during which each person would answer the 'noble call'. This was your time to do your party piece, from playing the spoons to a tune on the squeeze box to belting out a Ruby Murray hit. No one was left out – young and old participated – and a hooley wasn't a hooley until someone sang 'Danny Boy'.

The tradition of waking a body at home often could see families gathering over a period of days with a hooley an integral part of celebrating your loved one's passing. Hooleys brought families and friends together.

The 'iron lung' (a barrel of stout) was carefully brought into the house and set up so that pints of porter could flow freely. Babycham, snowballs or a glass of sherry were produced for the posh auntie. A good hooley could last well into the night and a round of sandwiches, crubeens (pigs' feet) and ribs would be produced to soak up the alcohol.

Some members of the Killeen family from Garden Terrace, with Christy Faulkner on the banjo, at a house party with neighbours and friends.

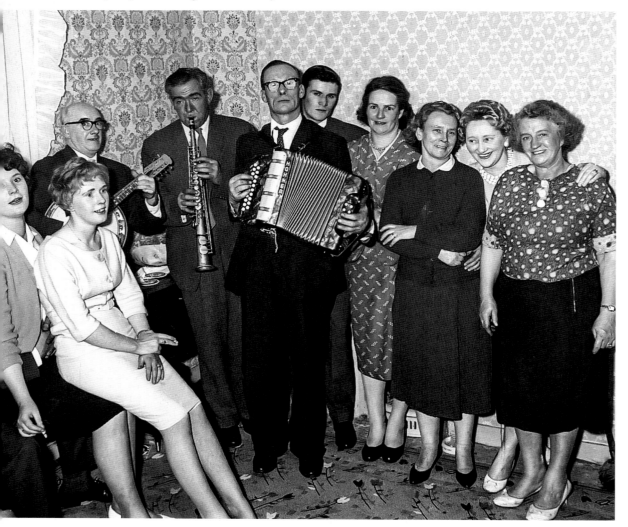

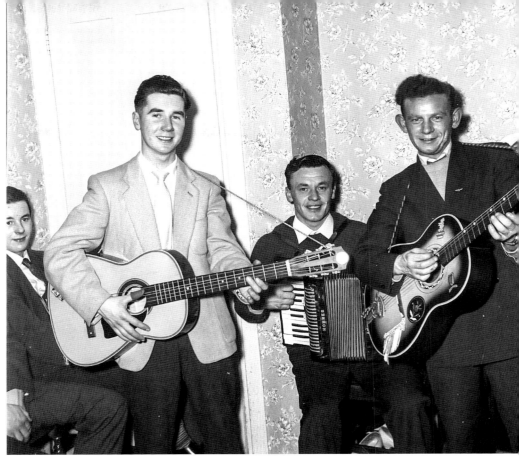

Anyone in the family who had a talent for playing a musical instrument would be central to the celebrations.

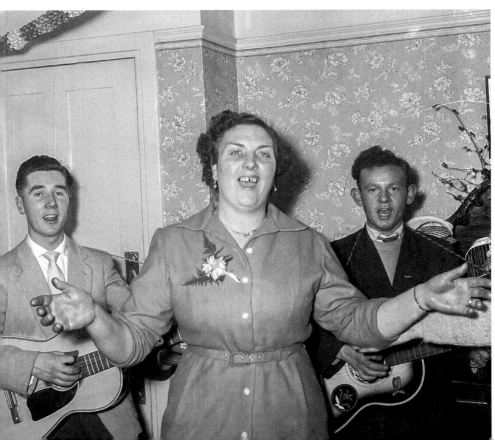

Answering the 'noble call' and taking your turn to sing.

The Sacred Heart and the Blessed Virgin bore witness to many a hooley with pictures of these religious figures hung in almost every home.

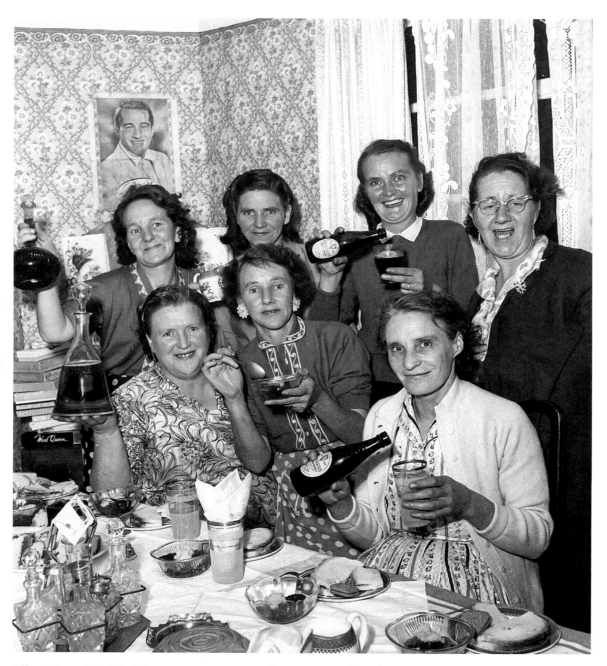

Ellen Finn, Mariah Winters, Mary McGrath, Mrs Carroll and Mary Russell from St Teresa's Gardens, enjoying a drop or two with their idol Perry Como looking on.

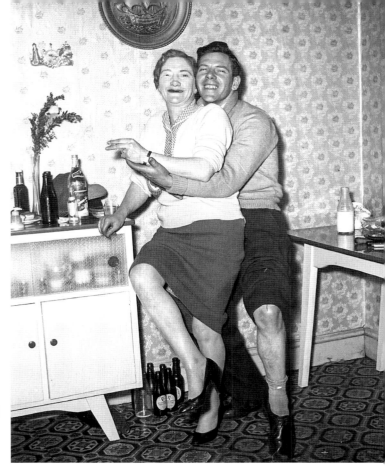

Shenanigans and high jinks were all part and parcel of a hooley.

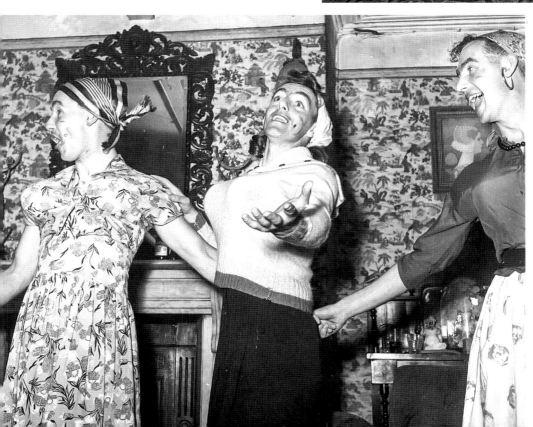

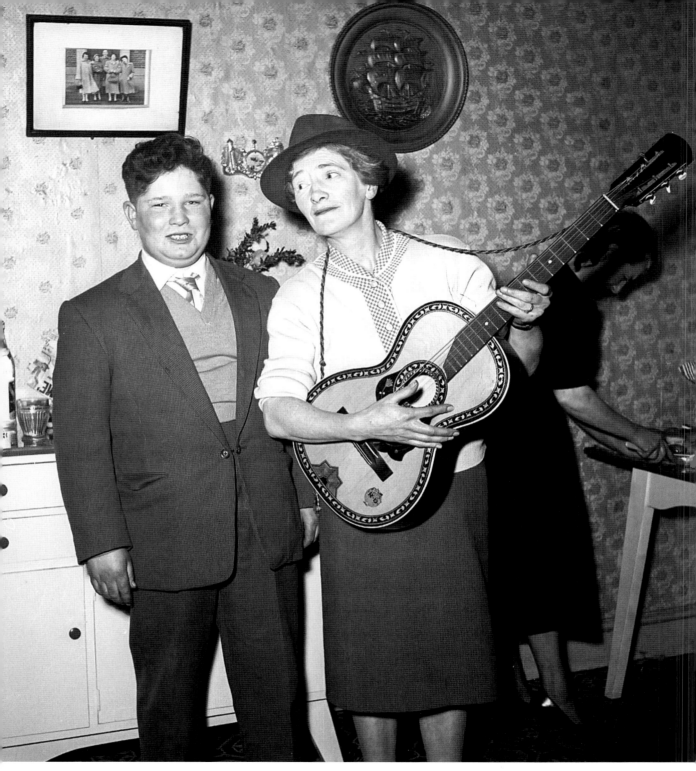

Michael Reilly and his mother, Mariah Connell, performing together at a family hooley in 1958.

Young musicians played for relatives and friends, with many musical skills being passed down from generation to generation. You always had your party piece ready for when you were called.

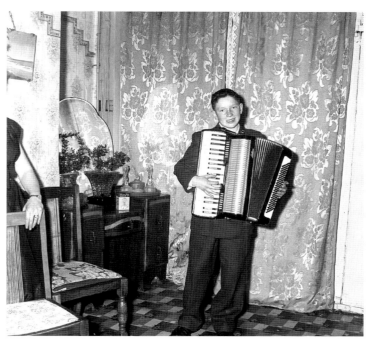

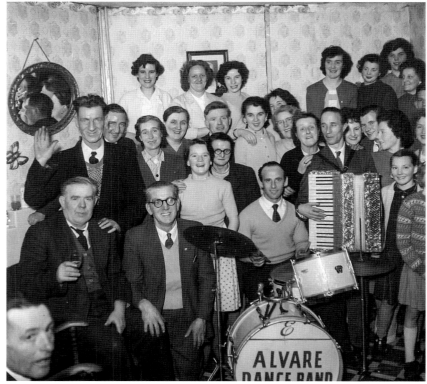

How many people can fit in the parlour? Quite a few plus a dance band!

Chairs and tables could be moved aside to make room for a dance, and young and old were part of the celebrations.

A fleeting moment in time captured on film. Memories of times gone by.

Weddings and parties

Many families in Dublin, especially in working-class areas like the Liberties, celebrated family events, such as birthday parties or anniversaries, at home rather than hiring a venue. The best cups and saucers were taken out from the china cabinet and every household either had a 'fancy' tablecloth or had a neighbour they could borrow one from.

A big spread of home-made sandwiches, cakes, buns and a trifle was laid on and everyone sat down together with a cup of tea. Family, friends and workmates would attend and, when the tea was over, the singing and dancing began.

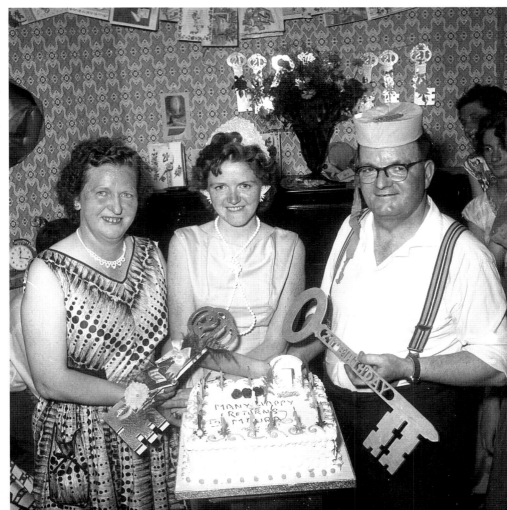

Edith and John Duff celebrating their daughter Maura's twenty-first birthday. The key of the door was a symbol of turning twenty-one and a mark of reaching adulthood.

The 'iron lung' is visible in the background set up and ready to meet the demand for a pint of stout.

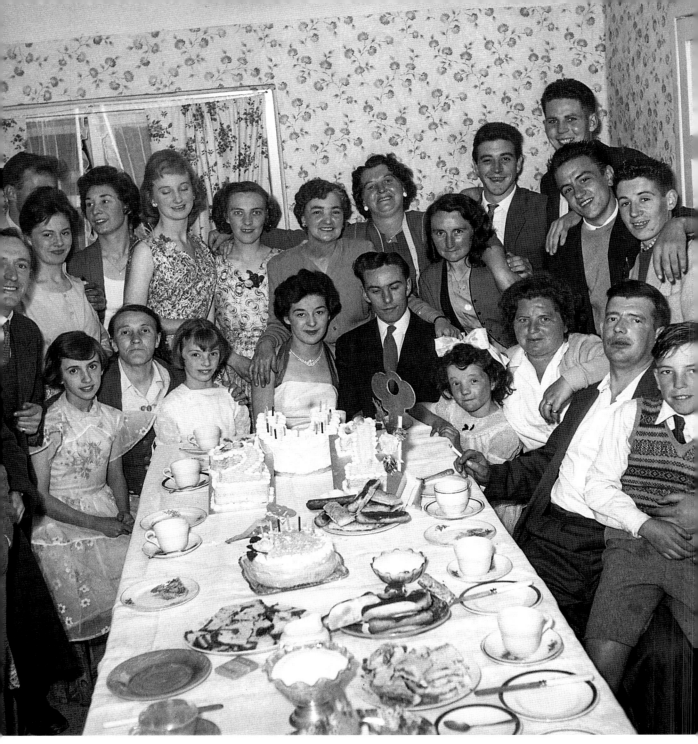

Along with celebrating their twenty-firsts, many young couples used this occasion to announce their engagement to be married.

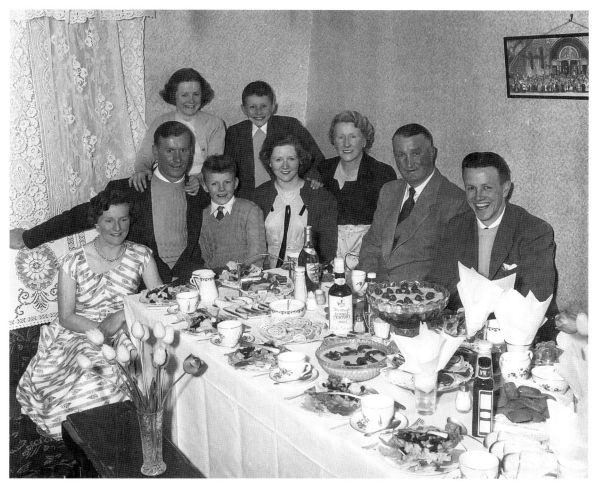

Singer Eileen Reid and her parents and family celebrating with delicious home-made desserts and trifles.

House weddings were also very common as lots of families could not afford the cost of going to a hotel. Everyone would help to prepare the food – boiled hams, sandwiches, a simple salad and, of course, some booze. Everything was home-made and neighbours would help to get the house ready.

Wedding cakes often had three or four tiers, and the top tier was kept to be the christening cake for the first baby.

Weddings ended early, with the bride and groom, if they could afford it, heading off on a honeymoon to popular places like the Isle of Man or Galway. The guests left behind would stay on and continue the celebrations. Many Irish people living and working in England returned home to attend weddings of their relatives and the hooleys could last for several days.

My granddad was always busy for wedding pictures before April, as everyone tried to get married before the end of the tax year so you could get all your tax back – the bride might be referred to as a 'beat-the-tax bride'.

Members of the Dominican family celebrating the wedding of Rosie and Neddy, who had just been married in Meath Street Church on St Stephen's Day, 1957.

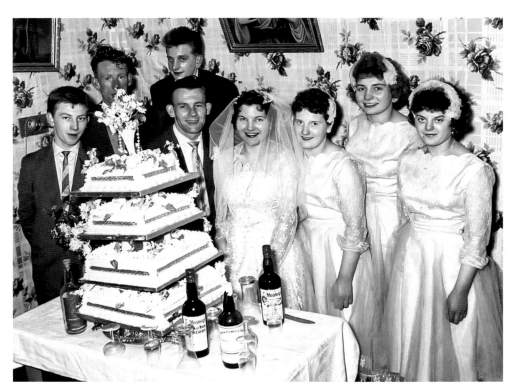

Mr and Mrs Foley of Durrow Road in Crumlin, celebrating their fiftieth wedding anniversary.

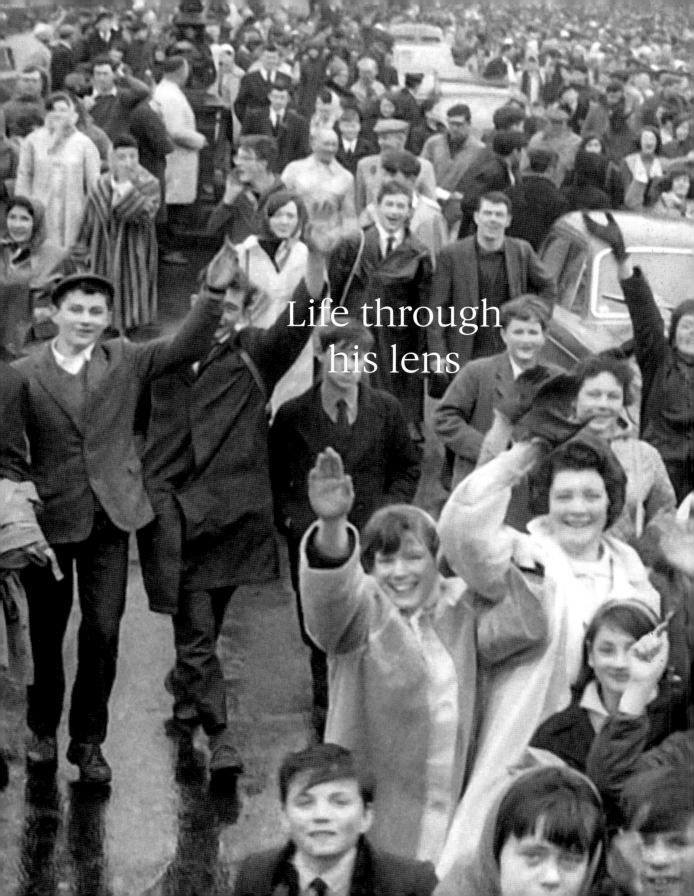

Life through
his lens

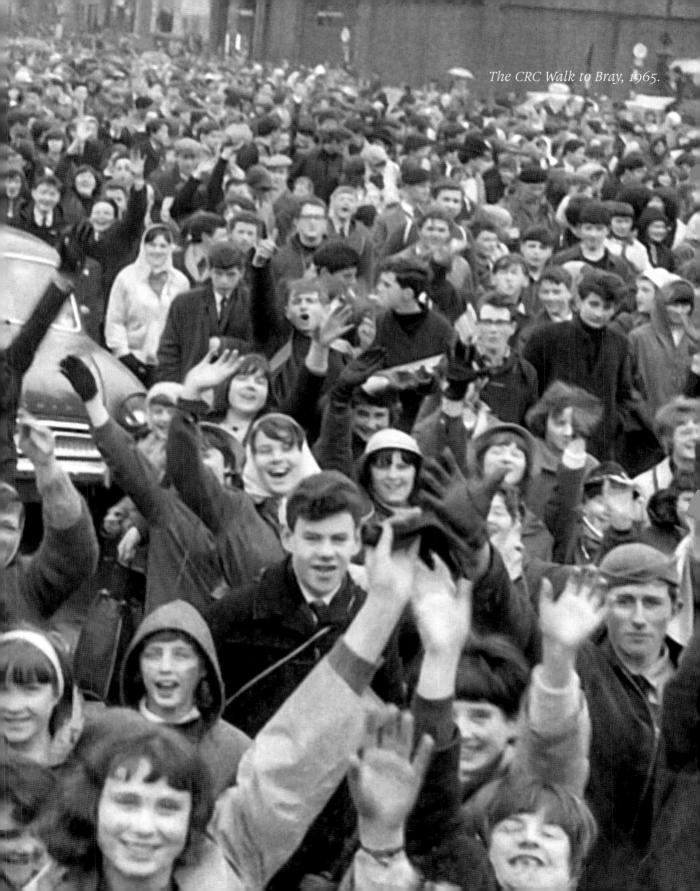

The CRC Walk to Bray, 1965.

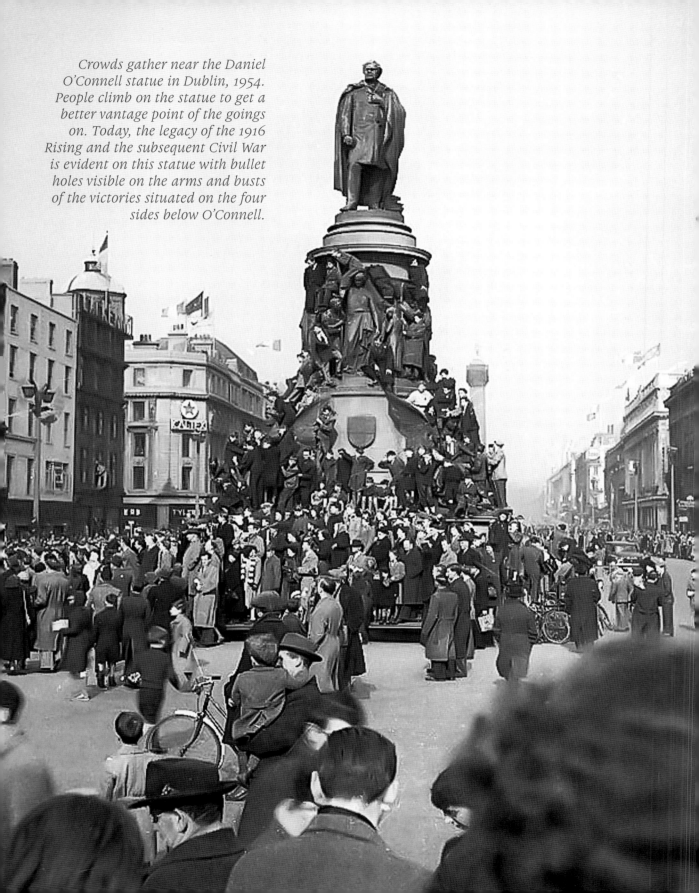

Crowds gather near the Daniel O'Connell statue in Dublin, 1954. People climb on the statue to get a better vantage point of the goings on. Today, the legacy of the 1916 Rising and the subsequent Civil War is evident on this statue with bullet holes visible on the arms and busts of the victories situated on the four sides below O'Connell.

A portrait of Dublin

My granddad was always the type who had to see what was around the next bend on the road or see what was over the next hill. If there was something happening, he was there.

While working on restoring and cataloguing his archive, I have come across many photos of Dublin and its people, as well as those he took on his travels around the country with his friends on his BSA motorbike.

But, as much as he loved heading off cycling in the country or off on his motorbike to the seaside, Dublin was my granddad's town and the city was his walking ground for taking photographs. If he knew something was going on or heard a rumour of an event, he would head to where the action was going to be. It's not surprising that in all of these boxes of negatives, I found some old photos depicting the events and people in Dublin. He always got himself to a good vantage point by climbing a wall or lamp post or by moving people out

of his way. He had a great sense of adventure and wasn't afraid to stick his neck out to get a good shot.

The everyday people and events of Dublin he captured in his photos could be classed as 'street photography' today. There are few celebrities here: most of the photos are of regular Dubliners going about their lives. These photos were a lovely surprise to find in his archive, and not only have I gained a new insight into the life and times of the people in the photos, but I also learned a little bit more about the photographer my granddad was.

Dublin landmarks

Dublin's Mansion House in the evening, 1956. Looking at this photo, I wonder if he took it for the beauty of the Mansion House or to capture the Ilford van outside. Ilford were suppliers of photographic film and photographers' supplies which my granddad would use for his work.

St Patrick's Cathedral in 1959.

St Patrick's Cathedral is a stone's throw from my granddad's home and shop. The park attached to this cathedral was a favorite place of mine to visit with my aunt Maureen. For many years my granddad would take local children's communion or confirmation pictures in this park.

My granddad often told me the story of *Gulliver's Travels* and how it related to this building. Jonathan Swift, the author of this book, was the Dean of Saint Patrick's Cathedral from 1713 until his death in 1745. A gifted writer, Swift suffered greatly with humming noises in his ear and many thought he was mentally ill or insane in his later life. Ninety years after

his death, Sir William Wilde, a physician and father of Oscar Wilde, exhumed his body to discover that Swift had had a loose bone in his ear, which had been the cause of the noises and his ear trouble.

When Swift died and his will was read, he had left his money to fund a new hospital to help those affected by mental illness. Perhaps the stigma he felt at being labelled 'mad' spurred him on to do this. This hospital still exists today, just a mile away from the cathedral. At first it was known as Dr Swift's, but today we know it as Saint Patrick's Hospital.

Dublin Zoo

Sarah the famous elephant at Dublin Zoo in 1954, in cramped conditions for this majestic creature. Back then it was perfectly acceptable to take a ride on the elephant. Sarah and her keeper Jimmy Kenny were household names in Dublin.

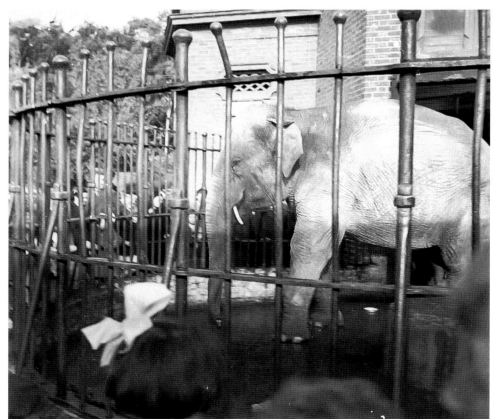

The original thatched entrance to Dublin Zoo, in the Phoenix Park, 1954.

A summer's day at the bandstand in 'The Hollow' in the Phoenix Park, Dublin, 1954.

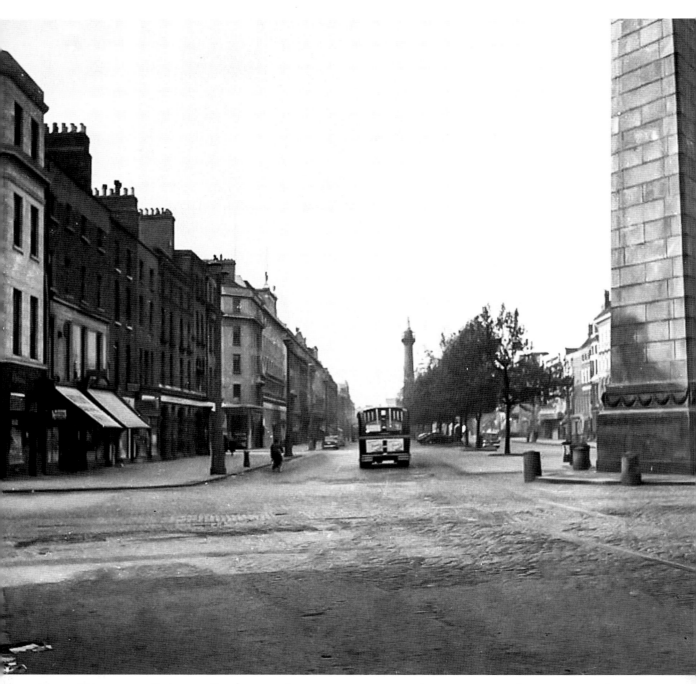

The cobblestones of O'Connell Street, early morning in 1954. What goes around comes around. The tram tracks visible on the right have long since disappeared, with tracks now appearing again on the street in the present day for the new Luas tram lines.

St Michael's Close in 1956. This street leads to Cook Street near Christ Church Cathedral. The poverty and poor living conditions in these tenement buildings tell the tale of what life was like for many Dubliners at this time. Coady's shop was well known for selling broken biscuits wrapped up in a newspaper cone, a real treat for kids. My great-granny Guy was born on Cook Street.

McBirney's on Aston Quay lit up for the 1954 An Tóstal Festival, which was held in Ireland as a celebration of Irish life and culture. The hope was that the festival and parades would draw tourists into the country during the Easter season. Many towns started a clean-up campaign for this festival and this led on to the beginnings of the Tidy Towns competition, as we know it today.

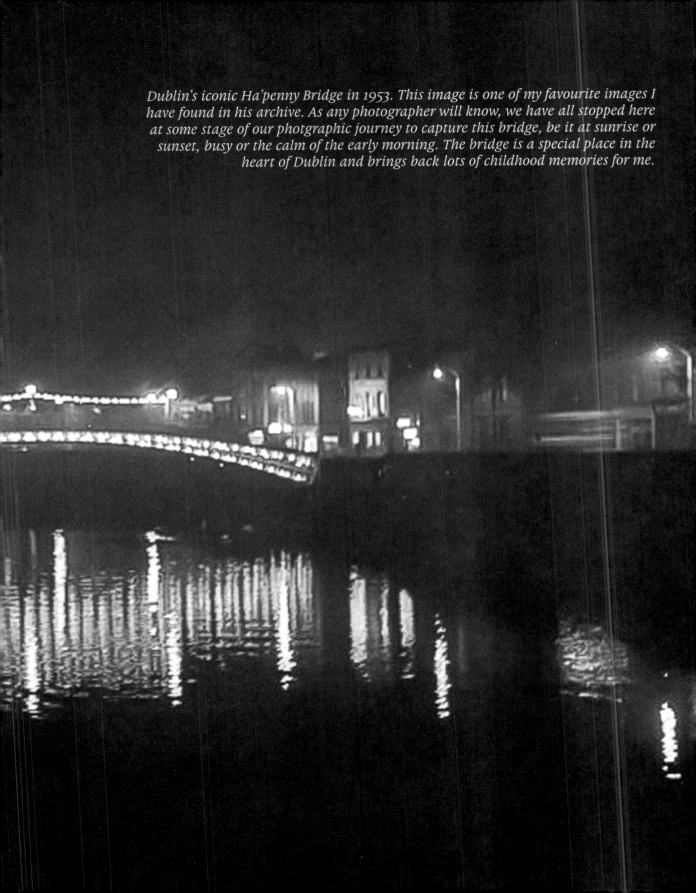

Dublin's iconic Ha'penny Bridge in 1953. This image is one of my favourite images I have found in his archive. As any photographer will know, we have all stopped here at some stage of our photgraphic journey to capture this bridge, be it at sunrise or sunset, busy or the calm of the early morning. The bridge is a special place in the heart of Dublin and brings back lots of childhood memories for me.

Moore Street

Dublin's Moore Street is steeped in history and has been the home of a long line of Dublin merchants and street traders. It is most well known for its fresh fruit and veg stalls, though fish and flowers are sold too.

Moore Street has a deep connection to Irish independence, as a row of its terraced house were once occupied by Irish volunteers during the Easter Rising, including Michael Collins. Numbers 20 and 21 Moore Street were where the surrender order was accepted by the Volunteers, after consultation with three of the leaders of the Rising, Thomas Clarke, Joseph Plunkett and Seán Mac Diarmada.

Lord Mayor of Dublin James O'Keeffe cutting the ribbon on a stall on Moore Street and chatting with shoppers.

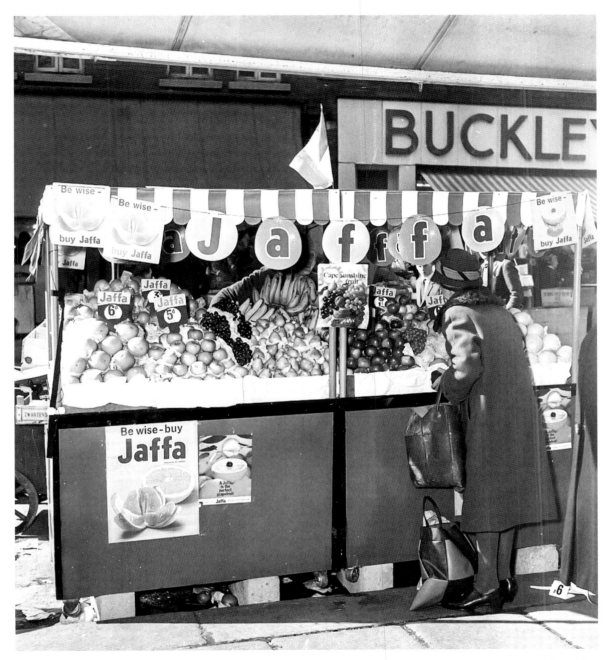

Moore Street in 1963.

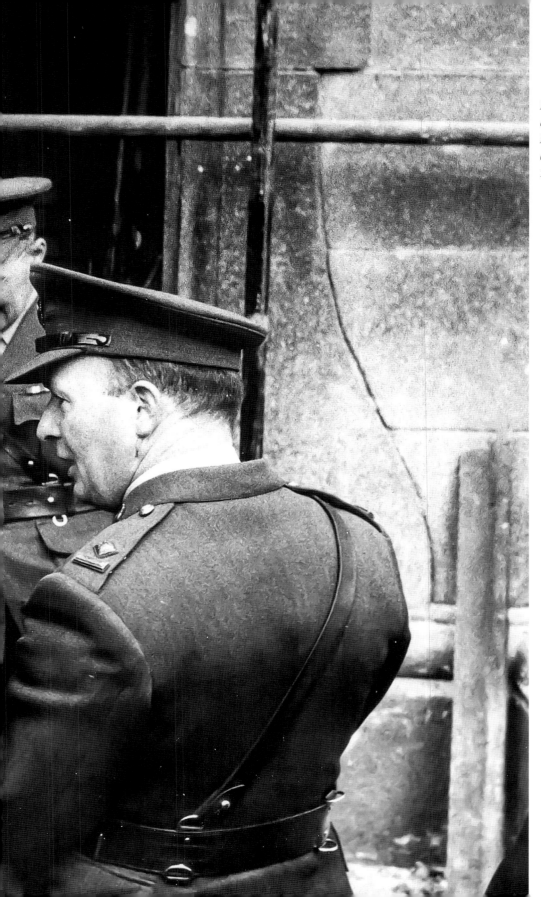

Irish army officers after Nelson's Pillar was destroyed, March 1966.

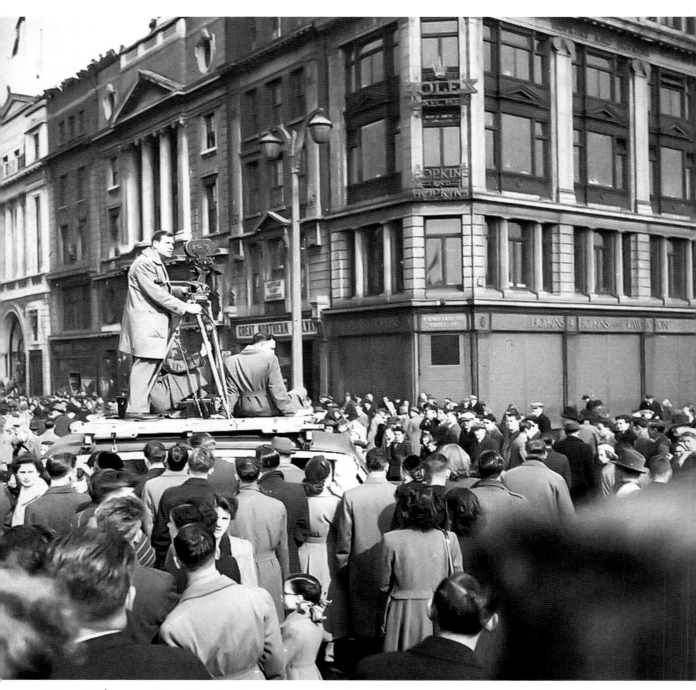

Before RTÉ started broadcasting in 1961, news and events were often documented by British Pathé News. In this 1958 photograph on Dublin's O'Connell Bridge, you can see the reel-to-reel camera recording the events of the time.

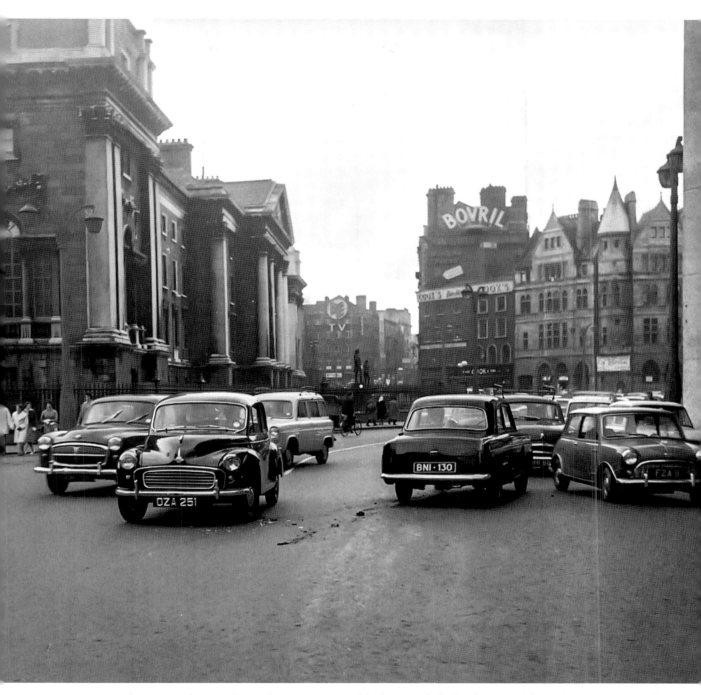

Always ready to take a photo, my granddad never left the house without his camera and captured the most everyday incidents, like this car accident on Dublin's Westmoreland Street in 1961, with Trinity College in the background.

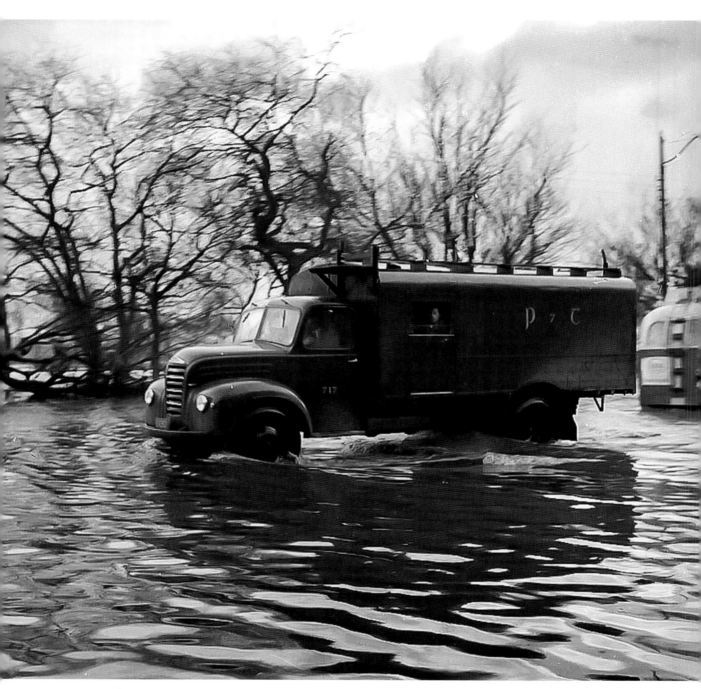

A Post & Telegraph van driving through the flood in Fairview in 1954.

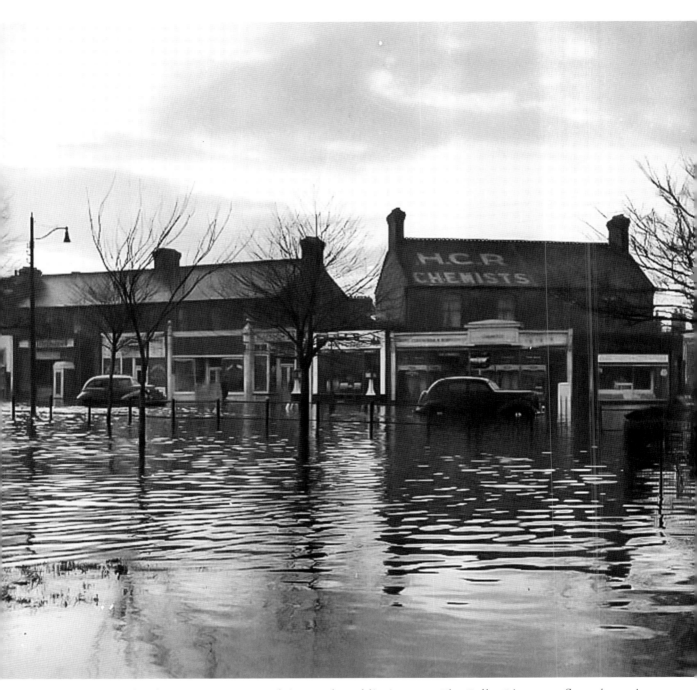

Flooding at Fairview Park in north Dublin in 1954. The Tolka River overflowed causing damage to the park and surrounding roads.

Workers from the Dublin Port and Docks in 1954.

US naval ships on Sir John Rogerson's Quay in the early fifties. People were allowed to board these ships to look at the guns and layout of the deck, which was a huge thrill for children at the time.

A train leaves Dublin in 1961 with shopkeepers and fuel merchants to head to visit the Bord Na Móna Briquette Factory in Derrinlough, County Offaly. My granddad was asked to go on this trip to document the day.

President Eamon de Valera flanked by two Irish army officers.

The opening of the Garden of Remembrance

The Garden of Remembrance was built on the site where the Irish Volunteers had been founded in 1913, which is also the site where several of the leaders of the Rising were held overnight before being taken to Kilmainham Gaol. It was opened in 1966 by President of Ireland Eamon de Valera, who was a commander during the Rising, to commemorate the fiftieth anniversary of the 1916 Rising.

The garden is dedicated to the memory of 'all those who gave their lives in the cause of Irish freedom' and is located at the former Rotunda Gardens in Parnell Square at the northern end of O'Connell Street.

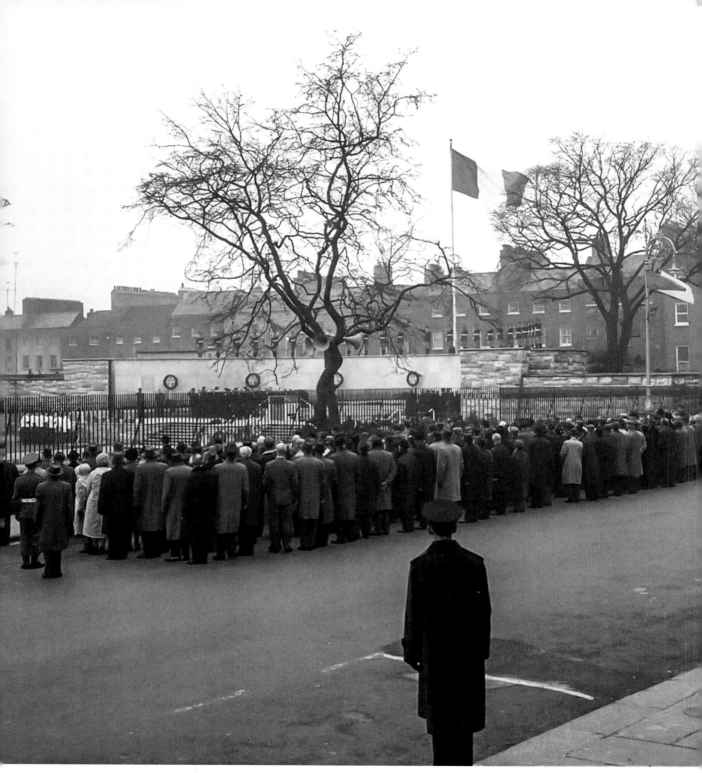

Veterans of the Rising and dedicated Irishmen line up outside the gates of the new garden to view the ceremony and pay their respects to their deceased comrades. On the high wall of the park, in the distance, there are soldiers lined up to give a rifle salute.

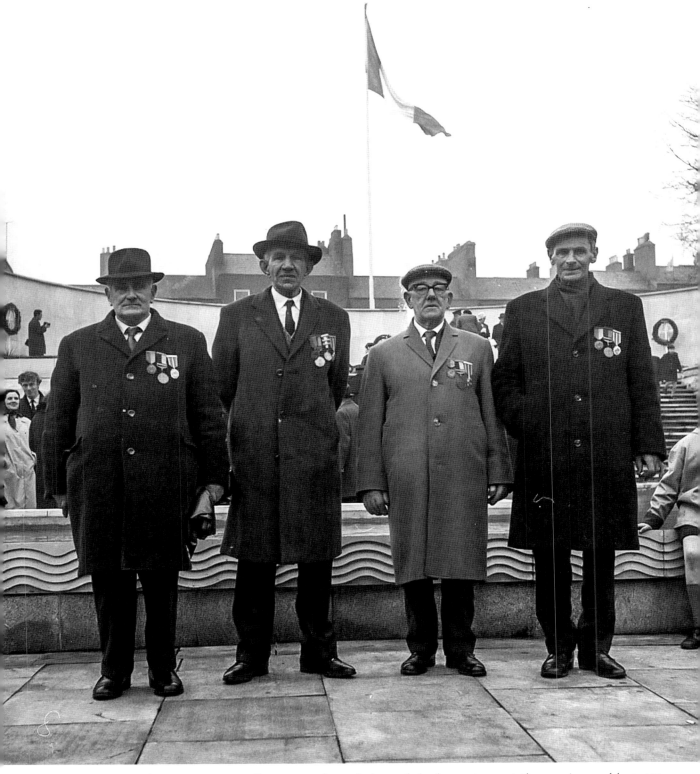

Retired army men proudly pose to show their medals that represent the service and bravery they have shown for Ireland. Many of these men would have been involved in the Rising.

The laying of wreaths to commemorate those who gave their lives for Ireland and to celebrate Ireland's Rising. The Dublin insignia is depicted on one wreath.

Two generations of soldiers have their picture taken. Behind, a lady walks by wearing her own or her husband's medals. Women played a big part in the 1916 Rising.

The 1965 CRC walk to Bray

In 1965, the Central Remedial Clinic started a charity walk from Dublin to Bray, and thousands of people, including many teenagers, came out to join this walk to raise money. Among those thousands were my mam and her older sister, Maureen, and my granddad, of course, was there with his camera to record it. The weather that day was typical of a summer in Dublin – there was a downpour. My aunt Maureen recalls her mother making her put brown paper under her coat to 'stop the damp' getting on her chest. My granny Suey waited in Rathfarnham to give the girls dry socks along the way. When they arrived at Bray, everyone was given a ticket to get a sandwich and a cup of tea before taking the train back to Dublin.

This event continued for many years, increasing in popularity with the influence of celebrities getting involved with the fundraising.

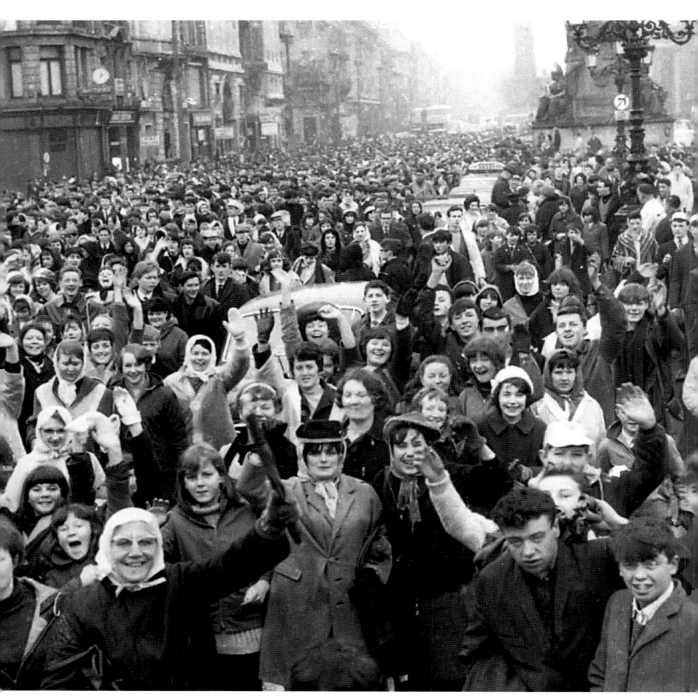

Dublin's O'Connell Street when thousands turned out to walk for charity, 1965. My granny Suey is on the right-hand side in her striped fur coat. My mam, Rita, and her pal Ann are in the front of the crowd.

The 1960 Phoenix Ale Pram Push

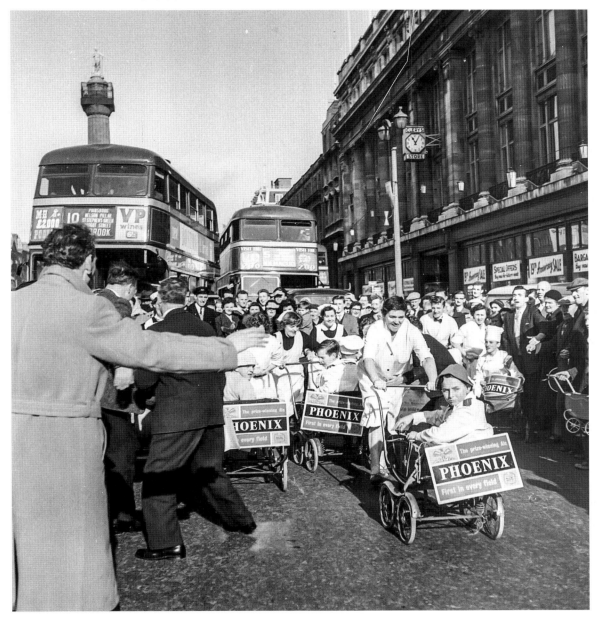

Racing the prams down O'Connell Street.

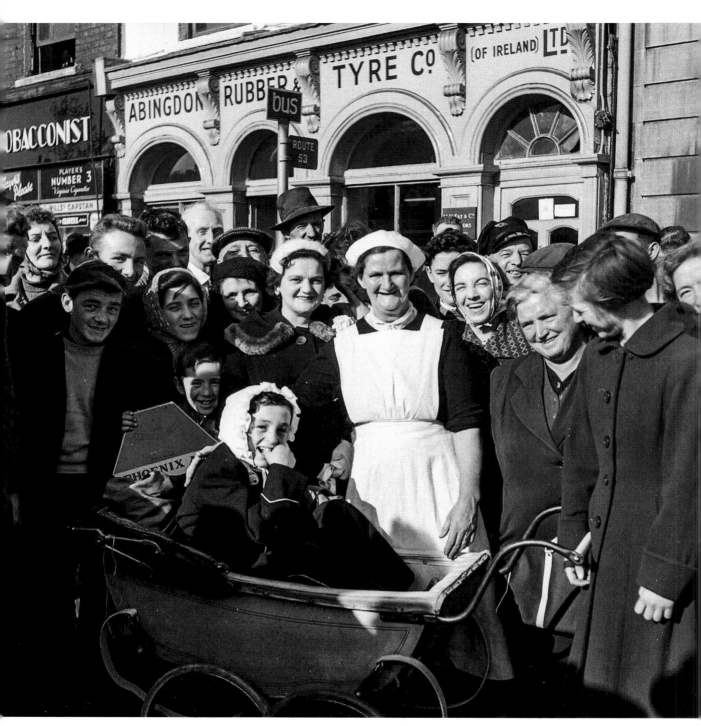

Biddy Holmes dressed up with her apron.

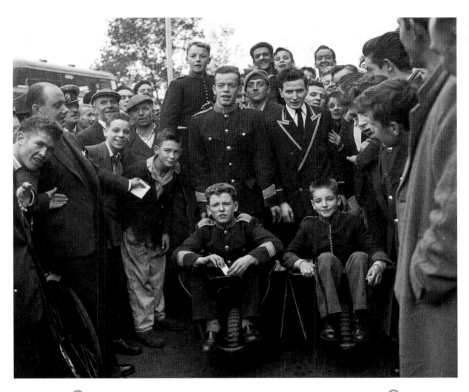

Hotel porters and doormen from surrounding Dublin hotels also took part in this event.

Faces about town

Alfie Byrne was elected Lord Mayor for the last time in 1954 and he considered the people of Dublin his second family. Every day, people called to his political offices or to the Mansion House without appointment. Byrne made sure he met them all and came to be known as the 'Shaking Hand of Dublin'. In 1937, he challenged the courts when they sentenced young boys to an industrial school for stealing apples from an orchard because they were hungry. Byrne told the judge 'that the home of the child is better than any institution'. After his final term as Lord Mayor, Trinity College awarded him an Honorary Doctorate of Law for his service to the people of Dublin. He was described as 'a champion of the poor and a friend to all men'.

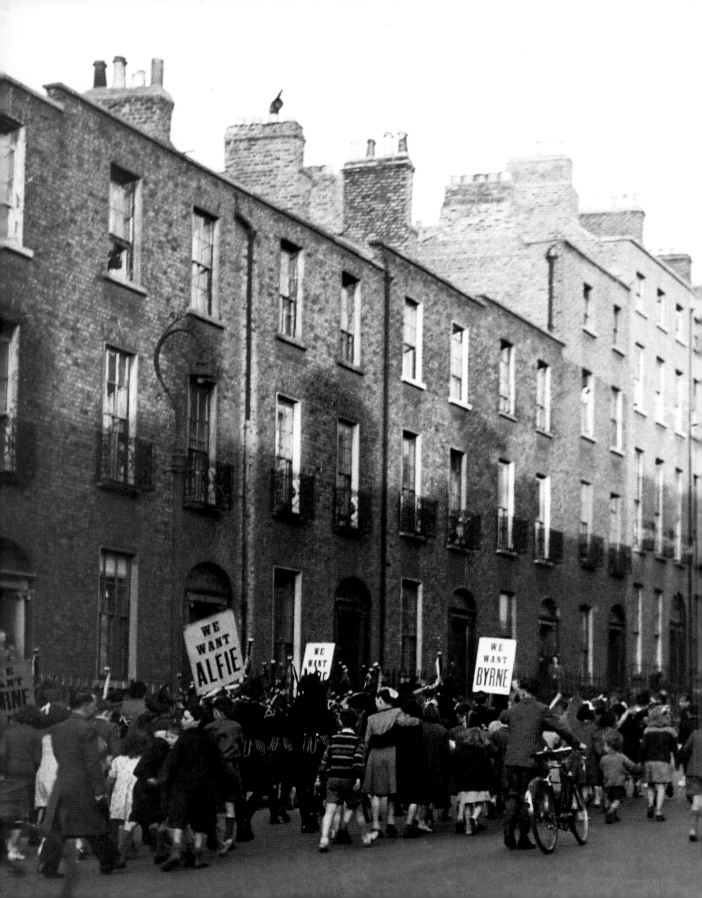

Alfie Byrne was a well-known Irish politician and is the only person to have been elected Lord Mayor of Dublin ten times. He was well loved by the people of the city and in this picture we can see people holding placards with 'We want Alfie'.

Victor Bewley of Bewley's Café

Victor Bewley was born in 1912 and grew up on the family farm in Rathgar. His family were Quakers and, at the age of seventeen, he entered his father's business – the Bewley's cafés, a bakery, a farm, and a coffee-and tea-importing business. Victor Bewley became the chairman of The Bewley Company in the thirties.

While at a public meeting in the Mansion House during the Second World War when children were dying in poverty in the Dublin slums, a public plea went out for a loan of premises to help distribute free meals to starving families. Victor Bewley was the first to offer his Westmoreland Street premises for use after the café had closed. For four years, families were fed from the premises after hours.

However, he was most noted for his treatment of members of the Traveller community. In the sixties, Victor Bewley did an enormous amount of work to raise the issue of Travellers' rights and their needs. He was the founding member of the Dublin Committee for Travelling People, and was secretary of the National Council for Travelling People, and later its chairman. The school for Travellers on a halting site in Cherry Orchard in 1965 got free milk and buns from Victor Bewley.

In 1972, he decided to transfer Bewley's ownership to his workforce, a move that was looked upon as madness by the government. It lasted for nine years before a private company bought it.

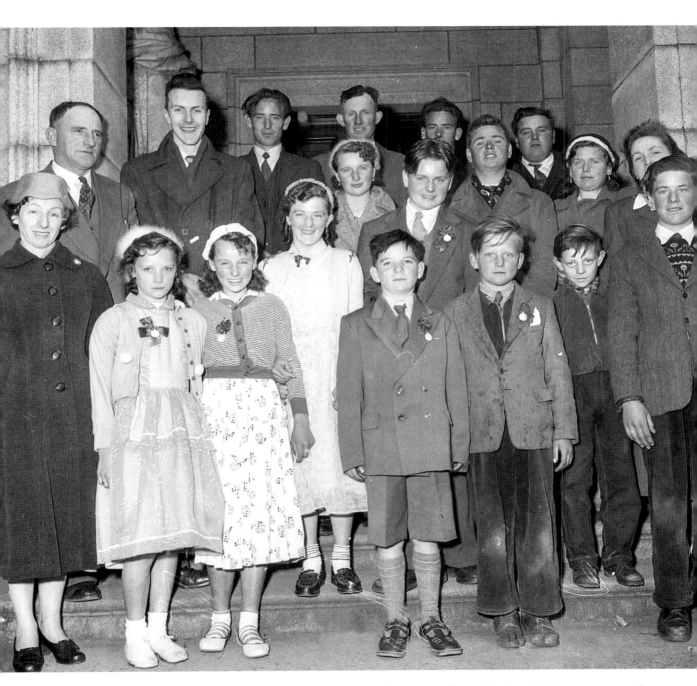

Victor Bewley (second row, first left) pictured at a confirmation in which some young boys from the Travelling community (front right) were confirmed.

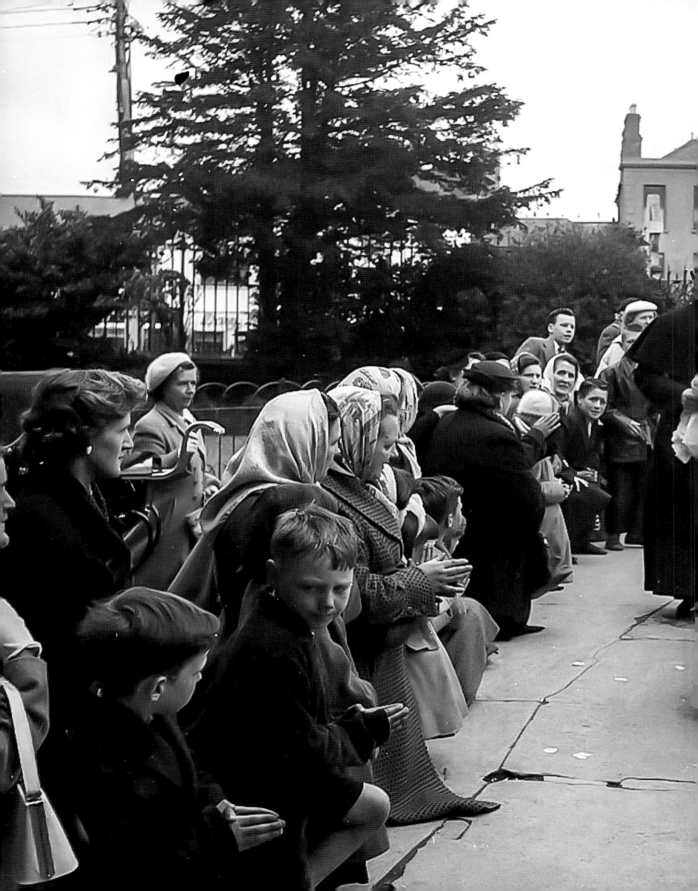

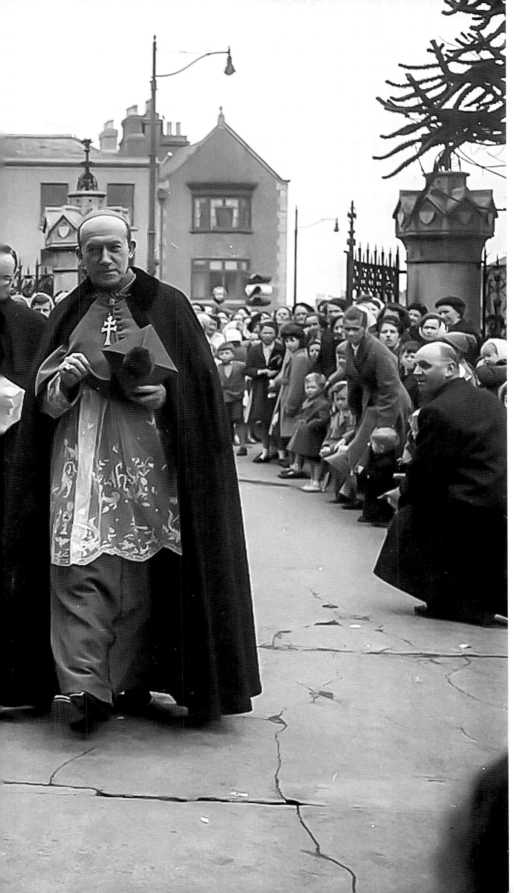

John Charles McQuaid, the Catholic Primate of Ireland and the Archbishop of Dublin (1940-1972). Many people feared him and his power and influence in Irish politics, as well as his turbulent relationship with Eamon de Valera. His episcopal motto was taken from John 18:37: 'Testimonium Perhibere Veritati' ('to bear witness to the truth').

Visitors to Dublin

Entourage of Cardinal Agagianian, Papal Legate, driving up Aston Quay in 1961.

Taoiseach Seán Lemass and Cardinal Agagianian.

Cardinal Agagianian, a papal legate for Pope John XXIII, visited Dublin in 1961. On his arrival, he was welcomed by Taoiseach Seán Lemass and the Lord Mayor of Dublin, Maurice E. Dockrell, who, to the fanfare of trumpets, presented a message of welcome in illuminated manuscript. Cardinal Agagianian then went on to Áras an Uachtaráin, the Irish presidential residence, to meet with President Eamon de Valera. Over 100,000 people lined the streets of Dublin to see the cardinal pass by during his visit to Dublin. Also notable in the picture is that the traffic now flows the opposite way on this street.

In June 1963, John F. Kennedy became the first serving president of America to make a visit to Ireland. The Irish lined the streets to welcome the president. This picture of JFK with his wife, Jackie, in their escorted cavalcade passing by the Four Courts, even though it is a little blurred, was a treasure to find in the boxes of negatives.

The 50 Francis Street Photographer

'I remember the wait felt like ages, we seemed to be on that pavement a lifetime. All myself and Patti wanted to see was Jackie Kennedy's dress, but after all that wait, his car just drove past and we waved the American flags that Mam had got for us especially for the day.' PAULINE

My granny Suey waiting patiently outside St Anthony's Church to see her idol. My aunt Patti is wearing the headscarf and Pauline is peeping at her father as he takes the photo. Suey loved John F. Kennedy and she would record his speeches on reel-to-reel tape recorders and play them back in the kitchen again and again.

Acknowledgements

Sincere thanks to everyone who has supported and helped me turn boxes of negatives into a beautiful book.

A special thank you to Ciara Doorley and everyone at Hachette Books Ireland for their patience and guidance through the whole process, and to Claire Rourke and Claire McVeigh for the beautiful layout and design of my granddad's photos.

Special thanks to Michael for answering the 'noble call' and providing a tale or two and always believing I could do this.

Thanks to Donal and Joe for their input and knowledge, and to John for keeping the tea coming while I was on the computer – your support is truly appreciated.

I would also like to mention and thank the beautiful McQuillan family – Collette, Gerard and Virginia – who kindly allowed their photo to be used on the front cover.

Thank you must go to the many friends and supporters on the Facebook page who never stopped supporting this venture.

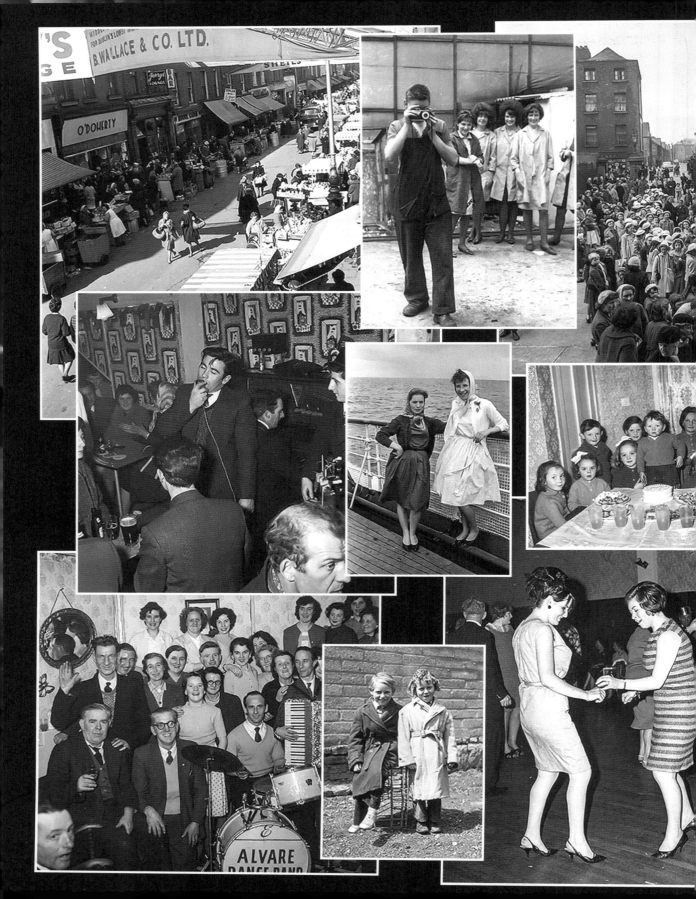